EVOLUTION

BECOMING A CRIMINAL

BOOK 1

D1515574

CHAS ALLEN

M**O**tivational PRESS®
LEADERS IN GLOBAL PUBLISHING

Published by Motivational Press, Inc.
1777 Aurora Road
Melbourne, Florida, 32935
www.MotivationalPress.com

Manufactured in the United States of America.

ISBN: 978-1-62865-538-4

Contents

To my family and to my love Michelle

PREFACE

To understand my own story, I had to dive into who I was and how I perceived myself as a younger man. Though I've come to understand that my rapid evolution as a person was a result of complex, confusing, and often hurtful events – many of which happened in a relatively short period in my life – I've come to one abundantly clear conclusion about myself at that time: I was an arrogant, little shit.

This is the book that I didn't have the courage to write years ago. Fears and doubts from my past restricted my ability to express my full truth. However, as you may have come to discover on your own, truth is subjective. I submit this book as my most authentic effort to share my experience; it is my best attempt to recreate the aggrandized perspective with which I viewed the world and my place in it at the time. One thing I have come to learn about human nature is that we all instinctively seek meaning and purpose in our lives. As the protagonists of our lives, we often believe we are the heroes of our own stories, even if, in actuality, our actions are more akin to that of anti-heroes.

In respect for those involved who I believe prefer to remain anonymous, I have changed names. Others I included with gratitude for our shared experiences, albeit from the only perspective over which I have any authority: my own.

I'm not proud of my actions detailed in this book, but the misguided choices of my youth allowed me to grow into the person I am today. Writing this book has been a blessing to me because it has helped me express and, consequently, accept responsibility for all of my weaknesses, faults, failures, struggles, strengths, and triumphs without the paralyzing effects of permanent shame. This process has reaffirmed for me that, even when we fall, we can choose to stand again. We all have moments in our lives that would mortify us if they became public knowledge, or let alone made

into a film, or a book, as mine have. However, rather than feeling afraid, I feel liberated because this book has allowed me to expose my former shame, helping me to heal from it, and giving me hope that this story may resonate with others in need of similar healing.

Our past does not have to define our future. We can accept responsibility for our choices and grow beyond our former selves. We have the ability to shape our lives one decision at a time and become the people we want to be. Ultimately, it matters far less who we were yesterday, as long as we are proud of who we are today. Today I am grateful to be able to share my journey with you. It is my sincere hope that, as you read this book, you see the humanity within the story and within us all.

BOOK 1

"If the youth are not initiated into the village, they will burn it down just to feel its warmth."

- African Proverb

PART 1

HIGH SCHOOL

SCHOOL

"Who wants to be a millionaire?" A young professional in his early thirties asks.

Students within the private school classroom raise their hands. I size-up the man standing near the dry erase board, wondering if he knows the answer to his question. I raise my hand with hopeful skepticism.

"That's exactly what Mr. Jakowski asked me to come teach you today. So, who's ready to become a millionaire by learning the amazing powers of compounding interest?" He asks enthusiastically.

I look to Mr. Jakowski for reassurance. We make brief eye contact. His beleaguered expression only confesses his unfulfilled entrepreneurial dreams.

The man at the front of the classroom continues, "Time is the key. You're all young. If you start a 401K or an IRA today, adding five thousand dollars each year, earning an average annual return of ten percent, you will be a millionaire in only 31 years!"

I scan the faces of my classmates, expecting them to share my disbelief, but they seem excited by his talk. They eagerly await his next words.

"Professionally managed mutual funds are the best investment you can make to guarantee a high yield return whether the economy goes up or down." The smile plastered on his face leaks with inauthenticity.

I raise my hand and speak, interrupting his talk.

"Hi, I'm sorry, but I just have to ask, are you here to sell us your mutual fund?"

The banker laughs, caught off guard. Then he calculates his next words with a smile.

"As a matter of fact we offer exceptionally managed funds, but I'm just here to teach you how it all works so you can make educated choices in the future."

He nods his head, assured that I am satisfied with his answer, and then continues.

I raise my hand again. "I'm sorry. One more question. How much do you get paid for each account you sell us?"

He looks to Mr. Jakowski, unsure of how to respond. I follow his line of sight to find Mr. Jakowski glaring at me with eyes bulging, insistent that I drop the subject.

I can't take it anymore. I call the teacher's bluff and plow forward with another question, without raising my hand.

"You said you're here to teach us, then just tell us the truth. You're selling us a pipe dream."

The banker clenches his jaw, and before he can speak I continue. "You say we can become millionaires in thirty-one years. Don't leave out inflation. That devalues the worth of the million dollars by three to four percent each year. That drops your ten percent down to six or seven. And let's not forget capital gains tax. Take off another twenty percent from the top. And mutual funds, the banks don't mention the funds that lose money or fail. Those funds get terminated and rolled into the winners. And when the winners start to lose you do the same thing over again. At best I'll give you four to six percent returns each year, at best. And then they would have to pay your fees to manage their money on top of everything else. But now the ten percent you promised them dropped down to around zero percent. And what's the compounded value of that after thirty-one years?"

Mr. Jakowski stands from his desk chair, seething with resentment.

"That's enough, Chas! I don't want to hear another word out of your mouth."

The banker calmly attempts to diffuse the situation, motioning for Mr. Jakowski to sit down.

"It's okay, Larry. I'll handle this. What's your name, son?" The banker asks as he stares me down.

"My name is Chas Allen, sir."

"Well, if you think you have a better solution, by all means, let's hear it." He says, challenging me.

My classmates turn in their seats to watch me, and I feel warmth rise in my cheeks.

I clear my throat and respond. "I don't think I have all the answers, but I'm not the one trying to claim I do."

"Since you don't have a solution, Mr. Allen, then I suggest you just sit there, shut the hell up, and let me finish."

I hear a few snickers scattered throughout the classroom at my expense. A fire ignites inside of me along with the feeling that I have something to prove.

I exhale deeply and then project my voice toward the front of the classroom. "Alright fine. Real estate is a better option then. Single-family rental homes. Buy two houses a year for ten years. Sell the first ten properties, pay off the second ten, and after ten years own ten homes free and clear. Keep renters in the homes providing a monthly cash flow income of about ten thousand dollars per month and a net equity value of more than a million dollars." I say in one breath hoping that will get the banker thinking.

My classmates turn their attention back toward the banker as he blusters over his words trying to retaliate with a response.

"Well you're a little smart-ass, aren't you? That all sounds fantastic, but it's not realistic. Where did you hear that?"

"A book called Creating Wealth. I presented the business plan to my dad, and he agreed to co-sign on our first loan when I was sixteen. We now own five properties and have renters paying the mortgages."

I see Mr. Jakowski seething with anger out of the corner of my eye. I turn my back on him and the banker at the front of the room to address the class.

"If you want to become a millionaire like this guy says you can, don't listen to him. Figure it out on your own. All this guy wants to do is make money off of us so he can make himself rich."

Mr. Jakowski jumps from his seat to lean over his desk as the veins of his neck pulse rhythmically with rage. I distinctly feel his urge to strangle me from across the room, if only he could reach far enough. Since his hands can't crush my windpipe, he yells at me. "Get out! Now! Go to the Dean's office!"

I stand up and throw my hands in the air. "He asked me a question!" I shout making my way through the rows of students and desks toward the door. "I see how it is! You can push me, but I can't push back? Fine." I open the door, but turn back to look at the other students, "I'll leave, but whatever you guys do, don't take advice from these idiots."

AUCTION

Two auction house employees in white shirt and tie uniforms carry a painting onto a raised stage. I turn to the familiar faces of wealthy patrons who sit among rows of folding chairs observing the new item with mild curiosity. They are wearing their Sunday afternoon best, clutching their buyer cards; everyone poised to buy a gently used possession to add to their first or second home.

The auctioneer, my dad, Tom, sits behind a podium and rattles an auctioneer's fast-paced ramble into a microphone. He appears tall even while seated in his white oxford shirt and dark-hued Garcia tie. A pistol hangs on his right hip strapped within a brown hide leather holster. His dark hair belies a touch of grey that he pretends doesn't exist. Tom speaks with

a smooth southern charm. His piercing hazel and green eyes observe the audience as he controls the room with a presence that to me feels homey, but somehow larger than life.

"Up next we've got an original work of art."

A voice pipes up from the crowd.

"Is it a Picasso?

Several patrons in the audience chuckle at the joke.

Tom's eyes light with excitement as a smile emerges on his lips. "I don't know if it's a Picasso, or not. But it may be a Pi-queso."

The laughter from the audience doubles at his cheesy, crowd-pleasing humor.

"Let's start this off with a five-hundred-dollar bid! Do I hear five hundred? Got to bid to buy! Five to buy! To buy to buy to buy! Get it now! Let me get five! Do I hear five?"

A stern gray-haired man slightly nods his head.

I shout toward the auctioneer's stage.

"Yep!"

Tom accepts the man's bid with a quick squint of his eyes.

"We got five! Do I hear six? Let me get six! Six hundred dollars! Got to bid to buy! Would you give six! Let me get six!"

I spot a bejeweled woman nudging her husband with a sharp shoulder. The man flashes his bidder card in the air.

"Yep!"

"We got six! Let me get seven! Do I hear seven? Let me get a seven-hundred-dollar bid! Would you give seven?"

"Yep!

"Eight! Let me get eight! Got to bid to buy bid to buy would you give eight! Let me hear eight! Any bids at eight hundred? Looking for an

eight-hundred-dollar bid! Any takers? How about seven fifty? Do I hear seven fifty?"

The grey-haired man pauses. I scan the room. No other bidders. He nods his head, yes.

"Yep!"

"Seven fifty! Let me get seven seventy-five! Seven seventy-five! Seven seventy-five! Do I hear it? Do I hear it? I'm talking to you, sir! I know your wife wants it!"

The man blushes as the audience around him laughs. He looks to his wife who demurely smiles and gives him a slight nudge with her shoulder.

"Yep!"

"Seven seventy-five! We've got seven seventy-five! Do I hear eight hundred? Let me get eight hundred! No takers? How about seven eighty? Would you give seven eighty? Got to bid to buy bid to buy would you give seven eighty?"

Tom and I both turn our attention to the grey-haired solo bidder awaiting a sign from him.

"Going once! Going Twice! Last chance!"

The man looks at the painting one last time. He stiffens his upper lip, then nods his head, no, and looks away.

"Sold! To the happy couple in the third row! And this brings us to our intermission for the day. If anyone has any questions during the break, please see my son, Chas, he'd be happy to help."

Tom steps down from the stage and exits the room. The patrons of the audience leave their seats to meander through the showroom filled with merchandise; furniture, lamps, desks, collectibles, art and peculiar auction house knick-knacks.

I approach two of my friends, Luke and Ryan, sitting on one of the couches. Luke's chest puffs open and his arms sprawl to occupy more

space than his body allows. Luke coolly nods his buzzed, dark-haired head and Ryan's friendly face brightens with a smile as I approach.

I plop down onto the couch between them, forcing Luke to scoot over.

"Not too bad, huh?"

Luke shrugs.

"It's alright. Other than carrying the heavy shit."

"Just wait, it gets better. After the auction, people pay us to help load their cars. That's where we make the best money. They can't carry all this stuff out by themselves, you'll see."

Ryan leans in. "One guy tipped me fifty bucks one week." Ryan agrees and then looks to me with regret. "Hey, Chas. I meant to talk to you. I hate to say it, but this is my last auction."

"What? Why?"

"I got another job. I work weekend mornings from now on for Taylor Made Farm. Going to be working with the horses. I wish I could do both, but my parents told me I have to pick one."

"Does that mean you're dropping out of the lawn-care business too?"

Ryan's face contorts into a pained expression. "No. I mean, I want to do both. I guess we'll see when the weather warms up again."

"Come on, man. Don't be so wishy-washy. I'm counting on you." I say, encouraging him to change his mind, "and what about our plans for college? Are you backing out of that too? We're going to be the only freshmen with a house on campus!"

Luke's interest is piqued.

"You're getting a house?" He asks.

"Already got it. Just closed the other day."

Ryan's face softens to a warm smile.

"That's so awesome, Chas! Just like we've always talked about and now

look at you, you're really making it happen! Just give me some time to work it out with my parents. They want me to live in the dorms, ya know."

"Are you kidding me? You turn eighteen next week. Are you always going to do what they want, or are you going to be your own person? Grow up, Ryan." I say.

"Whatever, man. You just don't understand what it's like. Your parents always give you whatever you want." Ryan stands from the couch with a huff and walks away.

I watch Ryan walk away, feeling frustrated and misunderstood.

"Ryan, come on, man. You always going to try run away from your problems like that?"

No response as he walks further away.

"Come on, Ryan. I'm sorry, alright? Did I hurt your feelings? We're still on for Allison's party though! You're not the only one with a birthday this week!"

Luke chimes in, "If you have an extra bedroom open for me, count me in."

"That's what I'm talking about Luke!" I look in the direction of Ryan who is long gone.

AUCTION HOUSE WRAP UP

"Is that the last one, ma'am?" I ask, wiping perspiration from my brow as I stand on the bumper of a box truck.

"Yes. I believe so." A plump elderly woman replies.

Luke and I hop out of the truck with exasperated relief. I lower the steel gate of the box truck and fasten the lock.

She approaches and hovers behind my shoulder to ensure I lock the truck to her liking. "That will do just fine, boys. I don't know what I would have done without the help of such fine young men."

She reaches into an oversized purse slung over her shoulder and churns the contents.

"George!" She hollers to her husband in the driver seat of the truck.

"I can't find anything! Do you have something for them?"

"No, dear. I thought you said you did."

"Well, I can't find it!"

Her husband opens the truck door and approaches.

Her hand lands on something substantial inside her purse and her arm cranes out from the bag like a claw-machine arcade game.

"Never mind!" She yells, stopping him in his tracks.

He shakes his head without a word and returns to his seat in the truck.

She proudly produces a five-dollar bill and awards it to me.

"Here you go. Thank you for being such help."

I make eye contact with Luke as he turns to glare in her direction. I maintain a stiff upper lip and place the five-dollar bill in my pocket. "You're welcome. Have a good night ma'am."

Luke and I walk around the corner of the auction-building warehouse to the parking lot.

Luke grimaces. "Five dollars? We loaded half the auction onto that truck. And you hear how she called us the help. Who does she think she's talking to?" Sweat drips down his furrowed brow.

"At least that one guy tipped us ten each." I hand Luke the five-dollar bill. "Here. Consider yourself an extra two dollars and fifty cents richer."

"What about your cut?"

"It's okay. I always get paid a little extra after the auction anyways."

Luke slips the bill into his pocket with a quick shrug.

I look back over my shoulder toward the auction house and then turn to Luke. "I'm going to go catch up with my dad. See you at school tomorrow?

"Yeah, that's cool."

Luke hops into the driver seat of his hunter green sedan and drives out of the parking lot.

I reenter the auction house through the rear door. The sound of my dress shoes against the concrete floor echoes through the now empty warehouse. I enter a corridor adjacent to the showroom where a dim light glows from behind a door. I ease the door open.

A single desk lamp illuminates the room as Lynne sits in front of a computer. Her strained eyes are focused on the screen. She lifts her gaze from the computer screen noticing me in the doorway.

"Hi, sweetheart." She says. Her voice and southern drawl drip with earnest sincerity, betraying her ordinarily professional workplace disposition. Each syllable rolls from her mouth and stretches like warm molasses.

I step inside her tiny workspace, feeling comforted by her presence. "Hey, Mom. Have you seen Dad?"

"No, honey, I don't know where he is. No one else seems to want to work around here. But here I am, slaving away." She breathes a sigh.

I hurt a little to hear my mother's frustration. "Then don't do it. Just go home," I urge.

"I can't do that. These buyer forms have to be finished by tonight."

I shrug. "Just saying, you could always let someone else do it. But I'm going to see if I can find Dad."

"Okay honey. Did you eat yet?"

"Not yet, Mom. But I'll be fine," I assure her.

"Well, there are leftovers in the fridge at home. By the way, you look so handsome in your outfit," she says with a smile, clasping her perfectly manicured fingers under her chin.

I try to not be affected by the compliment but give in with a childish smile.

"Thanks."

DAD'S OFFICE

Rows of metallic shelving racks stacked with personal property for future estate auctions line the storage room. I hear the sound of indistinct voices on the other side of the room and then recognize Tom's familiar southern tone, followed by laughter.

I turn a corner beyond a row of shelving. Tom, his business partner, Jamie, and the office secretary, Lisa, mingle in a clearing amidst couches and home furnishings. Jamie leans his wiry frame against a tall Victorian cherry dresser as he puffs on a cigarette. Lisa sits on a tan leather couch with her shoulders drawn back, wearing a form-fitting red blouse and her full-figured chest thrust forward like a proud mother hen. Tom leans against the armrest of the couch.

Lisa is the first to notice me, followed by Tom. He announces my entrance as if he likes the way it rolls off his tongue.

"Hey there, Chas Allen."

I join the group, sharing in their relaxed demeanor. "Hey, what are you guys up to back here?"

Jamie stubs out his cigarette and unflinchingly flicks it onto the floor, turning everyone's attention. Jamie shrugs, "What? Someone will clean it up later."

No one speaks. Jamie's anxious energy causes him to react first. "Alright, alright. I'll pick it up."

Tom shakes his head and laughs as he dismisses Jamie's action. I watch my dad with admiration and smile.

Lisa stands from the couch and flattens her blouse, "That's enough excitement for me for one day."

Tom leans toward her, "You leaving?"

Jamie returns with a cigarette butt in hand. "Yep, it's quittin' time for me too. I've got a wife to get home to. 'Til next time, gents." He leaves the group with a quick wave. Lisa gives Tom a glance goodbye and nods in my direction as she struts behind Jamie toward the warehouse exit door.

"What about it, huh?" Tom says with a wink and a slow smile. "Is this a business you could see yourself running one day?"

I look at the personal property stacked floor to ceiling among the shelves. Each item once belonged in someone's home. The owner of the property expired long before all of their accumulated stuff. Now the personal property holds no sense of belonging. Without a permanent residence, the property waits in a sort of cold and lonely grave of its own.

I feign disinterest as I turn back to face him. "There's always something new. That's for sure."

Tom leans back and takes a deep breath of momentary satisfaction. "It beats a mule kick to the head." He chuckles at his own nonsensical joke and then pokes me in the ribs to goad me. "Oh, before I forget, I've got something for you if you want to come over to the office with me."

We lock the heavy steel doors to the storage warehouse, and Tom arms the security system. We stroll through a hallway in the office; paintings of past Kentucky Derby winning thoroughbreds adorn the walls.

"Have you ever had an issue with anyone stealing?" I ask.

"Why?"

"Just curious, I guess."

We pass a conference room before entering Tom's office through an open doorway. He flicks on an overhead chandelier light then steps behind his antique mahogany desk. Shelves filled with collectibles and autographed sports memorabilia decorate his walls. He pulls the chain of a desk lamp illuminating a name placard and mounds of unkempt paperwork littered across the desk surface.

"We've had a few incidents over the years. A bookkeeper embezzled some money from us. That's when your mom first got involved in the businesses."

"How much did she take? Did you file charges against her?" I ask all in one breath.

"A lot more than a little, less than a lot."

A confused expression clouds my face. "What do you mean? You didn't do anything about it?"

"What was done was done," he says with a serious face as he continues working.

My eyes widen in surprise as I look to him; they linger down to the pistol strapped on his hip.

"You just let her steal from you?"

He stops sorting through papers and meets my eyes. "She must have needed it more than we did." Tom follows the trail of my eyes to the gun at his waist. He unbuckles the holster and frees a chrome double-barreled antique Derringer with a swirled wood grain handle. He opens a drawer within his desk and places the pistol inside the drawer.

"Sometimes people have to make tough choices," he states as he sorts through the paper mounds on his desk. He withdraws an envelope.

"I could either be stuck in the past fighting to get back what we lost, or I could move forward and focus on all the good we have to be thankful for."

He passes the envelope to me from the other side of his desk. "Here, happy early birthday."

He passes me a gold-plated letter opener. I break the seal of the envelope to find a six-thousand-dollar check addressed to me. A rush of excitement pulses through me. I beam with pride as I look to my dad for acknowledgment.

"It's your half of the closing. Don't spend it all in one place," he says with a wink.

My heart swells with accomplishment as I look at him across his desk. "Just trying to be like you one day."

He sorts through another stack of papers on his desk collecting envelopes, without looking up. "Say your prayers at night, be a good boy, and good things happen."

I sit in one of the two green leather, high-backed chairs in front of his desk and watch him return his attention to the piles of paperwork scattered across the desk surface. Despite my admiration, watching him work feels like watching paint dry or watching the antiques within his office age.

He notices my impatience. "Why don't you go check on your mom? She should be leaving soon. I've got some work to finish up."

"She's back there working too. Are you going to be able to make it to the game on Friday?" I ask as I look up at him. He turns his gaze and attention toward me.

"Your mom and I are going out of town. We'll be in the Bahamas this time next week," he says without enthusiasm. "Our deal is still on though. Double since we won't be there to watch."

My gaze drifts around the room. I feel the dust gathering on the collectibles lining the shelves. The air smells staler than I remember ever noticing.

I stand from the chair and say, "Okay, sounds good. I'll leave you to it," then reach across the desk and shake my dad's hand. I stride purposefully toward the door.

Over my shoulder, I hear him say, "Congratulations on the closing. Find us another one!"

SCHOOL HALLWAY

I spin the dials on a combination lock. One, two, three clicks. The lock opens. I remove the lock and pull the handle to open my school locker. Breathing a sigh of redundancy, I hang my backpack on a hook above a large stack of long untouched books and binders.

Students scramble to their lockers in a last-minute rush before the homeroom bell calls us to class, all of them wearing versions of our bland school uniform. Ryan approaches his locker, two down from my own. I watch him out of the corner of my eye as he unloads his backpack and hangs the bag on a hook. I sneak up behind him and tap him on the right shoulder. He turns to find no one standing behind him as I slide to his left and drop an envelope inside his locker.

He turns to find me standing next to him. He laughs and playfully shoves me, "Not funny."

"You missed all the fun parts of the auction the other night. Got something for you though."

He notices the white envelope sitting on top of a binder. "What's this?"

"Open it and find out."

Ryan tears open the seal.

I look over his shoulder at the contents of the envelope and continue, "As a wise man once said to me, happy early birthday."

Ryan's face broadens into a smile as he withdraws two hundred-dollar bills.

"Since it was your last auction I asked if they could pay you out in cash."

He looks down, holding the bills firmly between both hands, then back up again. "This really helps. Thanks."

"Just means drinks are on you this weekend." I nudge him with an elbow. "By the way, my parents are out of town this weekend. Let's pregame at my house before Allison's party."

Ryan waves the money in his hand. "I've got the beer money right here! How many people? Can I bring Mary Beth?"

"Whoever you want. Claire will be there, me, you. I'll say something to Phillip, maybe Luke and Devin. Do your thing and get a few other girls to come too."

He grins mischievously.

I feel someone bump into my hip. I turn to see Claire standing by my side. She clutches a stack of books in her arms. The weight of the books draws her slender shoulders forward as she rests the books against her small waistline. Her straightened, coal-black hair falls beyond her collarbone like strands of silk. A small cluster of freckles gravitates around her nose and high cheekbones like tiny drops of paint flicked onto a canvas. Her blue-green eyes flash with each strong-willed bat of her eyelids.

"Did I here you guys talking about me?"

"Only if you heard the good parts." I lean forward to kiss her cheek. She turns and catches my lips with a quick kiss. "My parents are out of

town this weekend," I say, heavy with insinuation of time alone together without the prying eyes and ears of parents or younger siblings.

Her eyes squint then brighten with recognition as I continue, "We're going to pregame at my house before Allison's. Then whoever wants to stay over for the night can stay too."

"Don't you have an away game Friday night?"

"Yeah. We'll be back early enough though.

She rolls her eyes and looks to Ryan. "Are you and Kate still talking?"

Ryan shifts his weight from one leg to the other and crosses his arms. "Yeah, kind of. I found out she hooked up with Phillip, so we're on a break. I've been talking to Mary Beth."

My face erupts with surprise. I nudge Ryan's shoulder with an open hand. "Phillip hooked up with Kate! Why didn't you tell me?"

"We've been trying to work it out, so I didn't want to tell anyone," he says uncomfortably.

"I can't believe Phillip would do that to you! He's *knows* how much you like Kate."

Claire huffs. "I can. You guys say he's one of your best friends, but Phillip only cares about what's good for Phillip."

A quick movement flashes through the hallway, catching my attention. Devin speeds toward us wearing a bright yellow polo shirt with the collar popped. His brown hair with frosted blonde tips stands gelled atop his head. He bolts inside of our huddled conversation with devious intention.

Devin flings his lanky soccer goalie arm and punches Ryan in the groin. "Nut shot!" he shouts, laughing hysterically.

Ryan doubles over, sputtering in pain.

Devin streaks away, weaving through the crowd like a banshee, cack-

ling in a fit of wild laughter as Ryan's face turns a bright shade of red.

He grumbles under his breath, "Damn it, Devin. That one really hurt."

Claire watches in disgust as Devin speeds around a corner and disappears from sight. "What's with you guys and your obsession with hitting each other in the balls?"

I shrug my shoulders and share in her bewildered expression. "Don't look at me. I don't play like that."

Claire pats Ryan on the back. "Ryan? You okay? We should get going. The bell is about to ring."

"Go ahead. I'm going to need a minute."

I offer my support with a pat on the shoulder. "Hang in there, buddy."

Claire and I stroll through the hallway, side by side as students gather their belongings and migrate toward their first classes of the day. She hefts her books as I walk empty handed.

"Here, let me carry those."

She shrugs away my reaching arms. "I can carry it."

"Okay, fine. Just trying to help."

I notice two bodies lingering close to each other by the lockers and point them out to Claire. "Look, there's Phillip and Kate."

Phillip's tall and lean frame lounges with one shoulder against a closed locker. He carries himself as if he's perpetually in transition from the front nine to the back nine on a country club golf course.

Claire wrinkles her nose in their direction. "Oh my God. That's so gross."

I turn and walk backward. Phillip catches my glance in his direction. His face flushes red as if he just got caught stacking the deck in a card game. I smirk and shake my head with disapproval.

LOCKER ROOM

Coach Carney strides into the locker room flanked by three assistant coaches and a strength coach. The smell of sweat, concrete floors, and rusting cage-metal lockers hangs pungent in the air. Coach Carney, a tall and prideful man with narrow features and short blond hair, stands in front of a whiteboard observing his team.

Conversations quiet and the tension among the team rises with pre-game nerves as we await his words.

He projects his voice. "They're icing us. The game is delayed a little bit. So what? That doesn't change who we are, or what we came here to do? Does it?"

I look at the solemn faces surrounding me.

"No." A few of us murmur.

"I said... that doesn't change who we are or what we came here to do does it?" He shouts a little louder.

"No!" We all yell in unison.

Coach Carney paces before us, searching our eyes. Feeling for our intentions walled behind our silence.

"That's right because we are Lexington Catholic. We are the Knights!"

A phone vibrates within someone's gym bag. All eyes scan the room in search of the intrusion. The buzz persists, over and over. My heart sinks. The bag containing the phone belongs to me. My teammates all turn toward me, awaiting coach Carney's wrath at the distraction.

"What have we said about phones in the locker room, Chas?"

"Sorry, coach. I thought it was turned off."

The buzzing stops, and I breathe with relief. Then the phone buzzes again.

"Don't just sit there staring at it! Turn the fucking thing off!"

I hustle across the room red-faced and embarrassed at being scolded like a child in front of my friends. I unzip the gym bag and find my phone. Two missed calls from Ryan. A pang of guilt tugs at my heart. The late game ruined our plans. I need to let Ryan know. I glance over my shoulder as coach Carney resumes talking.

"Now, let's get back to what's important. We are not going to be distracted by their tactics! But they're already on their heels. They're already playing defense! And what do we say? Come on now, say it with me!"

We all repeat the words together in unison.

"The best defense is a good offense."

"That's right! The best defense is a good offense!"

I huddle over my phone and accept the risk. I open a text message with Ryan.

"Allen! What the hell are you doing over there?"

I snap the phone closed. "Coming. Just had to do something real quick."

"Whatever it is, it can wait! That's five suicides next practice!"

I bite my tongue, fighting back the rising anger flushing through my face.

Coach Carney stares down his nose with a hand resting on his hip. "Do you want to make it ten?"

I power off the phone and return it to my bag, then sulk back to my seat on the bench.

"This is exactly what we need to get a grip on men!" He points a stern finger in my direction. "It's not all about you."

My jaw clamps down quelling the fires raging within my body.

He turns his pointed finger to my friend Chase. Then to Brian. Duna, Willie, Mark. Joe, John David, across the room to Harrison. Then Drew.

"It's not about any of you. Take a look at your Jerseys. What's it say on your chest? Go ahead. Take a look. It says Lexington Catholic Knights."

We all drop our heads and observe our jerseys and the jerseys of one another.

"It's on the front for a reason. Now take a look at the back of your jerseys. What's it say back there? That's right, your name is back there. You know why?"

My teammates and I share befuddled looks with each other as we scan the room.

"Your name is on the back because when we walk through that door and walk out onto the court, you check your ego at that door. You put your name and all the baggage that comes with it behind you. Because when you drop that ego, you become something greater. Something more. You become part of a team. We play as one. We move as one. And when we all do that, nothing can stop us!" Coach Carney inhales deeply, his eyes trained on his team. "And we're not just any team. We are the defending state champions. Who are we? Let me hear you!"

"Knights."

"I said, who are we?"

"Knights!"

"That's right. Now let's huddle up and pray."

My teammates stand to form a circle in the center of the locker room. I stand to join them, leaving my concerns for Ryan and Claire zipped away in my gym bag on the floor. Even coach Carney, the assistant coaches, and the strength coach join the circle. We each place a hand in the center and bow our heads reciting the Lord's Prayer in unison, as one.

WAKE UP CALL

A loud noise startles me. I open my eyes and slowly begin to wake. The doorbell sounds throughout my family's house. Then again.

I shout impatiently toward the door. "Okay! I'm coming!"

The bedside clock in my parent's master bedroom reads 7:15 A.M. The house to myself, I stretch my arms wide in the king-sized bed. The day's first light streams eagerly through the window blinds of the second story bedroom. I struggle to move, still exhausted after arriving home in the team van well past midnight.

I throw the bed covers back and get out of bed.

"Great way to start my birthday," I say, grumbling to myself.

The doorbell sounds again, insistent.

DING-DONG.

And again.

DING-DONG.

I rush down a flight of stairs wearing only pajama pants shouting, "Alright, already! Hold on!" I open the door to see a mixture of frost and dewdrops covering the front lawn on this brisk January morning. My friend Hart stands on the porch. His hands in his pockets, face solemn. Strands of black hair protrude above the snap band of his well-worn backward hat.

I swing open a glass security door that divides us.

"A little early, don't you think, Hart?"

"Sorry, man. I've got bad news. There was an accident."

A feeling of dread creeps through my thoughts and manifests within my body. My throat tightens. I swallow hard and feel a hollow pit in my stomach as Hart continues.

"I don't know how else to say this, but Ryan was in a car wreck this morning."

The walls of my chest feel like they slam shut. I can't breathe. My sinuses burn and my eyes well with moisture. "Where is he? Is he okay?"

"I was just with him." Hart clenches his square jaw and hangs his head. He looks back up to me as tears tremble in his eyes. "He didn't make it."

A feeling rips through the lining of my chest cavity, tearing me down from the inside out. My proud exterior crumbles as I lose control.

"What do you mean he didn't make it?"

"They did everything they could. He hit a patch of black ice this morning and swerved off the road. They found his car wrapped around a tree. They had to pry him out with the Jaws of Life. A helicopter brought him to the hospital as fast as they could, but he just didn't make it."

My face contorts in anguish as I struggle to take my next breath. Air gasps from my lungs in spurts. I barely manage to speak. "He just called last night. How is he gone?"

Hart shakes his head. His tear-filled eyes search within mine for some kind of meaning, some kind of understanding for why this would happen. Hart and I both find only emptiness and sadness within each other's eyes.

We reach out to each other and embrace with a hug as if holding on for dear life. We hold tightly to the connection that we both share while memories of Ryan flood through my mind in torrents. I see and feel moments that I shared with Ryan as if it is happening, all over again. I see his face smiling beside my locker. I feel the warmth of his laughter. I feel the depth of his disappointment when sadness clouds his expression. I experience the joy that crosses his face when he feels hopeful and excited for the future, a future that we both felt hopeful for. I don't want to believe that he is gone, irrevocably. Tears form in my eyes, and I wipe them

away before they can fall. I step back from Hart, not wanting to let him see me cry as the cold winter air callously grips us both in an unyielding, merciless, and inevitable embrace.

FUNERAL

I stare blankly out the tinted window from the backseat of a limousine. The sky streaks with grey clouds like smoke from a fire on the horizon. A long funeral procession of cars trails drearily behind for more than a mile. My shoulders slouch within my black suit and heavy overcoat. I look away from the dark clouds and stare at my hands instead. They seem fragile, insignificant. I vaguely hope the solemn journey to the graveyard never ends, that somehow the procession will just keep driving along the twists and turns of the road and never stop.

The limousine makes a sharp left turn. Rolling hills of winter-frozen green grass emerge in the window. The hills are marked with headstones scattered atop the knolls. Some graves appear fresh. The loosely packed earth recently upended to bury another death. Other graves bear adornments of flowers and small tokens of remembrance from survived loved ones. Still others rest unadorned and unkempt with tall grass overwhelming the lonely headstones.

The limousine slows to a stop. I look to the other men who share the darkened back seat of the limousine with me. Ryan's dad, once a cheerful and passionate man sits red faced and slumped beside the window. His eyes gaze off in some faraway place I cannot see. Ryan's grandfather, a statuesque and proud man, who I know to always be quick to tell a joke and make others smile, sternly observes his surroundings. He holds his upright posture with a sense of determination. Ryan's relatives sit alongside us, but I do not know them. Without words of introduction, we share a silent bond.

The driver opens the door. Each of us reluctant to exit. Ryan's grandfather wraps an arm around Ryan's dad, infusing him with strength to stand and do what must be done. Ryan's dad places his head in his hands one last time, takes a deep breath of courage, and then steps out of the car. The remaining men follow suit and step into the cold winds of the day.

Six of us lift the casket high. I position my right shoulder beneath the back left corner of the box as each of the other men assumes similar positions around the handles of the box. I look ahead to the thirty paces of earth that we must bear Ryan's body to deliver him to his final resting place. The weight of the casket and the weight of his death crush down on me.

The funeral director nods, so we begin our march stepping forward with hesitant yet purposeful strides. Our steps progress slowly, each of us knowing that our next step brings us closer to a goodbye that we are not yet ready to say.

I meet the eyes of my classmates within the crowd of onlookers. Devin and Luke nod reverently as we pass. Phillip stands beside Kate. I meet his eyes. He looks down to the earth and away. My steps falter under the heavy burden; feet struggling to find traction on the cold damp ground.

I search for Claire. She holds a tissue to her eyes to wipe away the tears. I look to her for strength to help me continue moving forward. Pleading with my eyes, I project with my soul the words, "*I need you.*"

She meets my eyes with a nod and a soft smile, lending me strength. "*You can do this. Be strong.*" The unspoken words reassure me and embolden my steps forward.

We approach a green velvet overlay that cloaks a six-foot hole in the ground. We hoist the casket down from our shoulders and place it onto a lowering device that sits above the grave. The weight of the casket no longer rests on my shoulders, but I feel no relief.

A funeral director hands me a red rose as I step away from my friend. I join the crowd and find my place beside Claire. She leans her body into mine as we embrace each other against the cold wind.

A priest and schoolteacher at Lexington Catholic, Father Mark, steps forward in front of the crowd. He wears a white collar and a vestment robe of white, royal purple, and gold. He traverses the grassy hill with long steps and broad shoulders, his full body expansive under the priestly ritual garments. His well-known and beloved presence inspires heads to turn from the cold and grief stricken crowd. He pauses at attention in front of the grave, scanning the gloomy faces before him.

"Today we lay to rest our son, grandson, nephew, dear friend, loved one, and for some of us such as myself, our student. We must remember that in the eyes of God we are all but his sons and daughters. And we all too shall join him one day in the ever after."

Father Mark takes a deep solemn breath and bounds forward with arms wide, embracing the crowd. "We must not fear the unknown of death. To the peaceful soul, death is but the ultimate mystery, and merely the next great adventure. The Lord, our God, gave us Jesus to show us the way. For Jesus said, I am the way, and the truth, and the life. No one comes to the Father except through me. So, let us all now bow our heads as we pray, in Jesus' name."

The faces of the crowd turn downward toward the empty hole in the ground. I see the sadness among the downturned faces. The pain and the grief in the bowed heads of Ryan's mom, his dad, and his sister tug at my heart. My own pain radiates throughout my being. I dig a hole within myself and I suppress the pain, pushing it down.

"Our Father who art in heaven."

I refuse to bow my head. I brace my posture and throw my shoulders back. I hold my head high and open my eyes to the sky in defiance.

"Hallowed be thy name. Thy kingdom come. Thy will be done. On earth as it is in heaven."

Grey clouds roll across the landscape. My eyes water against the cold breeze and the veiled light of the morning sky. The pain of loss burns cold like ice inside my chest, but to let go of the pain would mean to let go of my friend. I push back against the rising pain and the tears trying to escape my eyes.

"Give us this day our daily bread and forgive us our trespasses. As we forgive those who trespass against us."

I scan the bowed heads of the crowd. My eyes rest on Phillip as he quietly mouths the prayer.

"Lead us not to temptation. And deliver us from every evil. In Jesus' name we pray. Amen."

The crowd repeats, *Amen*, and lifts their gaze to rest upon Ryan's casket, hovering above the earth.

"And now we ask those who wish to say a final goodbye to please approach the casket."

I wait my turn among a line then approach the casket. I look down at the box that will forever hold the body of my childhood friend.

I whisper almost inaudibly on the wind.

"We had so many plans. What were you thinking?" I force myself to laugh as I wipe my eyes and the running sinuses from my nose. "I miss you, man. But I want you to know that you'll still be right here with me. As long as I live you'll live inside my heart. I promise you that. So I'm not going to say goodbye."

I drop the red rose onto his casket.

HOME COOKING

The smell of home cooked Italian food fills the kitchen of Claire ‹s family home. Comforting warmth radiates from the oven and stovetop.

"It just needs another minute. Would you guys mind setting the table?" Claire ‹s mom, Mary, a rosy cheeked Irish woman asks.

I step forward, glad to be useful. "We'd be more than happy to."

Claire and her younger sister, Kelly, and my little brother and sister, Blake and Sydney all take to the task. Claire passes colorful pastel Fiestaware plates and bowls down the assembly line of helping hands.

"Thank you again for having us Mrs. Foster." I offer.

"We're more than happy to have you guys over. I know how hard it must be with your parents gone right now."

The table set, the five of us kids take seats around the dining room table. Tall windows open to a back lawn of healthy green grass and a wooden jungle gym and swing-set leftover from Claire and Kelly's childhood.

Mary hefts a large pot off the stove and approaches the table. She grips the handles carefully wearing bright red oven mitts and places the delicious smelling pot of homemade Italian noodles in the center of the table. She repeats the process piling more delicious made from scratch dishes onto the dining table.

We each take turns serving ourselves. I load a massive pile of my favorite homemade noodles onto my plate, along with a towering chunk of lasagna, accompanied by a small side of salad and a piping hot breadstick. Claire is sitting next to me. She portions out a small salad on her plate and adds only a few noodles to the side.

"John, it's Ready." Mary calls to the next room.

Claire ‹s dad, John, a tall Italian man, strides into the kitchen brandishing a bottle of wine. He takes his seat at the head of the table and uncorks the bottle of pinot noir to pour himself a short glass.

"This is a treat. So glad you all could join us tonight." He says.

I look across the table to him and smile warmly. "Thank you, Mr. Foster. We really appreciate you and Mrs. Foster having us."

Blake and Sydney pipe up in chorus. "Yes, thank you."

Mary takes a seat next to John and proceeds to fill her plate. "We are so sorry to hear about Ryan." She says touching her hand to her heart, "such a sweet boy."

I nod thoughtfully at Ryan's memory and smile. "He was actually the one who introduced Claire and I."

John takes a sip of the pinot noir and looks down his wine glass in my direction. "How have you been holding up? I know you and Ryan were close."

I try to swallow a mouthful of lasagna. "I'm doing okay."

John twirls a fork within his bowl of pasta scanning my expression. I slide my hand under the table and hold Claire ʻs leg. She lowers a hand to hold mine. John notices the subtle exchange. He lifts the fork to his mouth and continues. "I lost a friend when I was about your age. Kevin Donaldson." John's eyes look off into a distant and lonely place in the past where we can longer join him.

"It could have just as easily been me, but as fate would have it, here we sit enjoying this lovely meal. Thank you, Mary."

He raises his wine glass. "Here's to good food, good health, and to the love of family."

We raise our water glasses. I look to Blake and Sydney across the table, thankful for their presence, and thankful to share in the warmth and love of the Foster's home. We all touch glasses, each pausing in turn to look briefly into one another's eyes. The connection that I feel with everyone surrounding me chips into the ice of my cold exterior. I sniffle and swallow hard to push down the rising tears, but deepen my smile as I embrace

the warmth.

I feel a weight begin to lift from my shoulders. Inhaling deeply, I feel my lungs open and expand. Shaky at first, I exhale and feel lighter, but somehow stronger. A sense of relief washes over me and I touch a quick glimpse of what it might feel like to let go of the pain that grips me.

HOMECOMING

Dogs bark in the backyard, jolting me from a nap. I wake in a cold sweat as I hear the garage door open, followed by car doors being slammed. I wipe the sleep from my eyes and stretch my arms wide as the glow of the TV illuminates the otherwise darkened home. My body feels heavy and my thoughts distant.

My parents enter a darkened corridor, unbothered by the lack of light within the room. I turn on a small reading lamp beside the couch.

"How was your trip?" I ask.

Lynne approaches me with open arms, holding me tightly.

"I'm so sorry we weren't here for you. We should have been here. Tell me about the funeral. Are you okay?" She relinquishes the grip from her hug to lean back and observe my face. Her eyeliner blurs around her eyes as if she's been crying. Tom brushes past us into the living room.

"Take the tit out of the boy's mouth. He's fine Lynne. He just turned eighteen. Let the boy be a man."

The comment hits me like a jab to the stomach. My ego flares and I toughen my masculine resolve. "I'm fine, Mom. Everything went okay. Ryan's family got the flowers you guys sent. They thought it was nice of you."

Lynne scans my face and then turns to Tom. "We should have canceled the trip and came home early, Tommy."

"He said he's fine."

I withdraw from my mom's embrace. "Yeah, I'm okay."

Tom and I hug briefly, and then he steps away as he speaks, "Good. Alright, good night to you both. It's been a long trip. I'm off to bed." Tom strides through the living room with a suitcase in tow.

Lynne calls out to him. "Tommy, hold on a second. We need to talk."

He stops in his tracks and slowly squares his body to face her. "Not now, Lynne. We don't need to do this here."

"Yes, we do. And I'd prefer if our son he stays. This affects him too."

I look back and forth between them, confused. "What are you talking about?"

Tom stands like a cowboy preparing for a gunfight with hands akimbo on his hips. Lynne's eyes well with tears. She squares her shoulders and faces him in strongly willed defiance.

"Your dad is having an affair."

His eyes flare with rage as Lynne continues. "I put up with it as long as I can. I've asked you to stop. And what do you do? You rub it in my face!"

"You've lost your damn mind. I don't know what you're talking about."

"Really, Tommy! You're going to lie straight to my face! Straight to your son's face!"

"He doesn't need to be here for this, Lynne. Just let it go. Chas everything's fine. Your mom and I will talk about this later."

I watch my dad and wonder if the accusations could be true.

Lynne slams a stack of printed documents onto the coffee table. "No, we won't! We'll talk about this now!"

"What the fuck is that?"

"You tell me, Tommy."

He shrugs his shoulders incredulously. "Well I'm looking right at it, and I don't know what it is. So why don't you tell me."

"It's emails, Tommy. Emails between you and your whore!" She picks up the stack of papers thumbing through the pages, fumbling in a furious rush.

"Emails where you tell her you love her!" Her arms drop down to her side, and the papers scatter across the sprawling woven wicker rug. Tears race down her cheeks to join the papers on the floor. "You love her?"

Tom holds his face rigid, straining to show no reaction. He clamps down his jaw as the whites of his eyes flare wide in the dim yellow glow of the reading lamp. He takes a step closer to Lynne. I instinctively inch closer to them both.

"So what if I do? She makes me happy. What's so wrong about that?"

"What about your kids, Tommy? Are you even thinking about them? We're a family. You have a family. You can't do this to us!"

Tom narrows his eyes at her. "Why can't I have both?"

Lynne's jaw drops, nearly joining the papers and the tears on the floor. "You can't have both! It doesn't work that way."

"We haven't been happy for years! And if I can find a little happiness with her, then that's what I'm going to do."

"You just can't dammit!

Lynne reaches to me for support. She wraps her arms around my arm and pulls me close resting her head on my shoulder. Her eyes look at Tom, pleading. Tears soak into my shirt. I don't know how to respond and don't want to choose one side or the other. Hopelessly torn between them both. I feel my mom's insistent pull on my arm. Reflexively I return her affection and wrap an arm around her to lend her my support.

Tom scoffs. Turning to retrieve his suitcase from the floor.

"Tommy, where are you going?"

He leaves the room. "I'm not going to do this anymore."

My mom and I look at each other unsure of what he means. We listen

in silence as his footsteps tramp up the staircase. Heavy step after step. Closet doors fling open and slam shut.

"Everything's going to be okay, Mom. He's coming back."

Her lip quivers and her tears turn into sobs.

Footsteps return, coming down the stairs. My mom and I both brace for impact.

Tom enters the room carrying two suitcases and a bag strapped over his shoulder. He crosses the living room without a word then exits through the corridor and out into the garage.

I stare into the dark corridor beyond the living room, into the emptiness, listening to the sounds from the garage. A car door opens then closes. My dad returns through the corridor and enters the living room. He walks with a purpose in our direction. My mom unwraps her hold from around my arm, ready to embrace him and take him back. He looks beyond her and directly into my eyes, and then extends his hand to me.

I hesitate, again feeling my allegiance torn between them both. I cautiously reach my hand forward and accept my dad's handshake. He holds my hand in a firm grip as he speaks.

"I'm sorry, Chas. I never meant for it to turn out like this. This doesn't change anything between us. You're still my son."

My eyes burn. I feel the warmth of tears struggling to break free, but I refuse to show weakness in front of him. I refuse to shed a tear. I nod my head with a clenched jaw and let him know I understand.

"And nothing changes with CTA Investments. We're still business partners."

I swallow hard. "Dad, you don't have to do this. Don't go."

"I have to go. Take care of your mom and your brother and sister."

I tighten my grip and shake his hand in affirmation. I don't want to let his hand go, but he withdraws. Then turns his back and walks away.

LET IT BURN

A towering fire of brushwood, logs, and tree stumps roars and blazes high into the starry night sky. I hover near the edge of the bonfire soaking in the warmth of the crackling flames. Claire is standing beside me. I stare blankly into the fire, watching the bright dance of the flames on the wind. I tip up my cup and down the remainder of my drink.

Claire watches me with concern, "Don't you think you should slow down?"

"I'm fine. I'm going to get another one. I'll be right back." I say as I step away from the orange and yellow glow of the bonfire and into the dark of the open field. I pass groups of friends from school and approach a crowd gathered around the keg, as they shout chants of a keg stand. Lincoln dangles his heavy-set body upside down, held by the legs, as he gulps beer straight from the tap.

"Twenty-four! Twenty-five! Twenty-six!" They chant, egging him on to drink more.

Lincoln spits the beer tap out of his mouth, spewing beer all over his face. The two guys holding his legs lower him down to the ground and help him stand. They heartily pat Lincoln on the back as he struggles to regain his bearings. He stumbles forward in a drunken stupor.

Emerging from the darkness like a streak of lightning Devin runs into the crowd. "Watch your nuts!" Devon shouts as he smacks Lincoln in the groin. Lincoln drops to his knees, crawling on all fours. He retches in pain as if he's about to vomit. A fit of laughter erupts from the crowd. Devin laughs harder and louder and wilder than any of us.

Luke steps forward from the rough circle surrounding the wounded soldier on the ground and slyly approaches Devon. "Hey, Dev…"

Devon turns to Luke just in time to see Luke swing his arm and land

a punch in his groin. "Nutshot!" Luke shouts. Devon doubles over while still laughing harder than ever. He attempts to retaliate and throw a punch back in Luke's direction, but Luke dodges the blow.

Nick, a tall, jovial and light-hearted guy joins in the game and flicks his wrist, surprising Joe, a stocky farm built football player with a shot to the groin. Everyone only laughs harder as hands start dangerously flying among the crowd.

Devon stumbles in my direction and throws a punch toward my groin.

I cover myself, avoiding the impact, and then grab him roughly by the shirt. I draw my fist back as the whites of my eyes flare wide with fury.

His laughter contorts to appalled shock. "Whoa! Easy killer!" He pleads.

I take a deep breath and let go of Devon's shirt. I feel my face flush hot as everyone within the crowd now watches me.

"Damn, looks like someone peed in Chas' Cheerios this morning." Nick jokes to lighten the mood.

Devon takes a step away from me to regain his space. A wide grin exposes his teeth, and I catch a wild gleam in his eyes. Relentless as ever, he flicks his wrist and throws his arm, trying to hit me again. I barely dodge, avoiding the punch. I reach out to grab Devon, but his all-state goalie reflexes help him duck away from my grasp. He scampers away from my retaliation. His laugh trails behind him as he runs through the field.

"I'm warning you, Devon! I don't play that shit!" I shake my head and step to the keg. Joe passes me the spout of the beer tap. I wipe the spout and pump the valve. Luke approaches me as I pour a full cup of beer.

"You want another?" I offer.

"Sure," he places his half-empty cup under the pouring spout. "Chas, you okay man?" He asks.

I let out a slow deep sigh. "I'm okay, I guess. Just have a lot going on."

Luke scratches the five o'clock shadow on his chin. "I know you and Ryan were close. It must be hard."

"Yeah." I nod my head and take another drink.

"I don't know if you're looking yet, but Devon said he would pick up the extra shift at the auction house. If you need someone."

I hear the cold grass crunch as footsteps approach behind me. I turn to see Devon walking forward. I point my finger at him. "Don't fuck with me right now," I say with a half-smile, now cooled down from my earlier burst of anger.

Devon extends a hand, and I take it. "You know it's all for shits and giggles boys. No hard feelings?"

We make eye contact, and I shake my head knowing that I can't stay mad at him, or his antics for long.

"Luke just asked about an extra spot at the auction house for you. There's not much I can do right now. I'm not working there anymore.."

Luke puffs his chest. "What about me? Does that mean I have to quit too?"

"I don't care. You can still work there without me. I've just got stuff going on with my parents, and I don't want to be in the middle of it."

A few attentive ears linger toward the keg for refills as we talk. Phillip approaches the beer keg attempting to make eye contact. I begrudgingly hand him the spout but refuse to look in his direction. Lincoln follows behind Phillip waiting his turn at the keg.

Luke persists. "You're just going to leave me hanging like that, Chas? I thought we had a good thing going there."

Devon nonchalantly adds his two cents before I can respond. "My parents are always fighting too. What's going on with Lynne and your pops?"

"My dad moved into one of our rental properties the other day. They're talking about getting a divorce."

Devon smirks. "My parents say that all the time. They never really do it though. But if your parents do split up, I call dibs on Lynne."

I punch Devon in the shoulder. "Shut the fuck up."

Luke chuckles and throws an additional cheap shot at Devon, hitting him in the groin. Not enough to take him down, but enough to hurt. "Marriage doesn't work anymore," Luke professes. "My parents fight a lot too, but they're old school. My mom doesn't work, so I don't know what she'd do if they ever split up."

Phillip shoulders into the conversation wearing a tattered hat that I recognize once belonged to Ryan saying, "The divorce rate is over fifty percent in this country now. Did you parents get divorced, Chas?"

I look at Phillip in disgust and say, "No, they're fine."

Lincoln staggers into the small circle on wobbly legs muttering, "I fucking hate my dad."

I take another swig of beer, seething with unresolved animosity toward Phillip.

"Where'd you get the hat, Phillip?" I ask.

"I got it from Kate. I know it was Ryan's." Phillip confesses

"Obviously. So what gives you the right to wear it?"

"Kate and I broke up. But I stole Ryan's hat back first. She doesn't deserve it."

I shoot a cold glare at him. "Neither do you."

Phillip removes the hat from his head and hands it to me. "I know. That's why I want you to keep it."

I accept the hat with open hands, then resize the snap-back to fit my smaller head and put it on. My eyes close briefly in remembrance of Ryan as I pull the hat down to fit snugly on my head. A sense of gratitude washes over me. The grudge I feel for Phillip drops from my shoulders.

Meeting his eyes for the first time in weeks I reach out with an extended hand, and Phillip accepts it. I pull him in close for a long overdue hug. We don't exchange words, but none are needed. The best friend bond between Phillip, Ryan, and I, still lives on, even after Ryan's death. Bruised and tattered like the hat, but surviving and cherished nonetheless.

We step back from one another, and I place both hands on the hat atop my head, "Thank you."

Luke grumbles, "That's great for you guys. But I need to know if I'm going to work on Sunday. I'm trying to get paid."

"I don't know what to tell you, Luke. You can show up, but I won't be there.

Luke drops his arms with a heavy sigh but then smiles. "I guess I'll just have to take over your job then and take home that paycheck of yours."

I smile at his comment.

Phillip leans into the circle and speaks in a hushed tone. "You guys should try blackjack. It's an easy way to make extra money. All cash."

Luke looks at Phillip with loathing. "Easy for you to say, rich boy. I don't have daddy's trust fund."

Phillip snaps back at Luke with calloused precision, "don't be mad at me because I have loving parents who made smart financial decisions."

I lean in, interested, "where do you play, Phillip?"

"A place in Patchen Village. They gutted an apartment to turn it into a full-blown casino. They've got poker too. It's like something out of a movie. Like Rounders, Chas. You'd love it. I can get you guys in. I think the guy who owns it thinks I'm older than I am."

Luke smiles condescendingly at Phillip. "Or maybe he just wants some of that daddy's money you've got."

Phillip smirks and raises his eyebrows with a wry grin. "Luke, that attitude is why you're always going to be poor."

"At least I don't have to be daddy's little girl all my life," Luke fires back.

Lincoln mutters something under his breath, turning our attention toward him. His eyes slant as he throws a hand up in declaration. "You should rob my dad. He's fucking loaded. He's always out of town anyways. He leaves a bunch of cash lying out when he leaves. Not like he'd even notice it's gone."

"Why would he leave money out?" Phillip asks. "That's just irresponsible."

"He leaves it for the prostitutes and to pay off his gambling debts. He just leaves the door unlocked. They walk right in and take whatever he owes for the month. I fucking hate him." Lincoln rings his hands, his eyes cold in reverie.

Luke and I look at each other in shock. I pat Lincoln on the back, not knowing what to say. "Hey man. It's going to be okay."

Lincoln looks to us all, pleading. "No really, somebody should walk in there and just take it. You'd be doing me a favor. He fucking deserves it! I'll even go with you. He doesn't care about anything except his money and his fucking whores!"

Devon scans each of our faces with wide eyes. "Sooo, what's his address?" He laughs, goading us to join him with a few nudges of the elbow.

Lincoln sighs heavily and takes another gulp from his beer. "I don't even care anymore." He sloppily tips the bottom of his drink up and swallows the remainder of his beer. Our eyes follow him as he stumbles away towards the fire.

MONEY STACKS

I quickly thumb through a stack of hundred dollar bills. I count five bills and then stuff them into my pocket, returning the remaining bills to a lockbox stashed between two ceiling panels.

I climb the basement stairs and enter the first-floor living room. Blake and Sydney sit at the kitchen counter eating an afternoon snack. A fast-paced action cartoon with high-flying hand-to-hand combat flashes on a small television across the kitchen. Sun streams through the window blinds in streaks, bouncing against Blake and Sydney's suntanned skin from our recent getaway to the white sand beaches of West Palm, Florida. The casual monotony of the return to our daily routines makes us keenly aware of the emptiness we all feel. Our home feels only like a house without our dad here with us.

I step further into the kitchen, and I can feel the heaviness weighing on Blake and Sydney's thoughts as I try to ignore my own. Standing beside them, their tans seem dull and fading in the flashing glow of the cartoon. The characters dance in mid-air combat, screaming as they release mountains of rage-fueled energy. My mind drifts in fantasy, visualizing what it must feel like to destroy whole mountains to rubble with only the force of my own will.

Blake loudly crunches a mouthful of tortilla chips and salsa, snapping me from my reverie. Sydney snacks on a piece of warm buttered cinnamon toast fresh from the oven. Feeling hungry as well, I mindlessly scan the cupboards in search of an after-school snack.

Blake shovels a mountain of salsa that rides on a single frail chip into his mouth and smacks his lips, making slurping sounds. "Do you want some of my salsa?" He asks.

I look across the kitchen at him in disgust. "That's so gross. I don't know how you just eat it like that."

"Mm, but it's so good though." He says as he shovels another spoonful into his mouth.

My lip curls as I watch him inhale the soupy bowl of diced vegetables. So, I turn my attention toward Sydney who watches TV and eats her toast in silence. She stares blankly at the TV with little expression.

"How's school, Syd?" I ask.

"It's okay."

"Just okay?"

"Yeah."

I frown, unsure of how to connect with her. Her sadness makes we want to somehow reassure her that everything is okay. I lean over the counter to where Sydney eats her cinnamon toast, and I waft the delicious aroma to my nostrils.

"Mm, just like Granny makes. If you're making more, will you make me some?" I ask.

"Sure." She says without enthusiasm.

The garage door groans in the attached two-car garage. A car door opens, then closes. Moments later, Lynne pushes open the doorway to the living room and struts into the room with dark shades over her eyes toting shopping bags in both hands.

"Looks like you had a good day," I observe with a hint of sarcasm.

"I did." She says as her southern drawl spills out like warm molasses. "There was a sale going on at Neiman Marcus. I just bought a few things. I might take some of it back, though." She looks down at the bags with an uneasy look on her face.

I glance at the bags in her hands with confusion. "Don't you think that might be too expensive after all the money we spent on the trip?"

Lynne unloads her shopping bags onto the couch. She removes her

sunglasses to make sure I see her eyes as she glares in my direction. "You're starting to sound like your father."

"It just seems like a lot, that's all."

"Don't you worry about that." She floats into the kitchen on high heels and gestures down to a tall stack of envelopes on the counter. "Did you see you got a letter?" She asks, raising her eyebrows in my direction.

"No, whose it from?"

She makes her way down the kitchen counter hugging Blake, Sydney, and then me.

I sift through the mail on the counter, not finding any letters addressed to me. Lynne reaches across the countertop and snatches the mail from my hands. She withdraws a note and hands it to me.

"It's here. What would you ever do without your mama?"

I tear open the envelope to reveal a letter on fresh white paper stock. I read the contents aloud.

"Dear, Mr. Allen. Congratulations on your admission to the University of Kentucky!"

Lynne huddles close reading the words over my shoulder in silence as I continue reading the notification aloud.

"We are excited to welcome you to the historical tradition... blah, blah, blah. I'm going to be a Wildcat, guys!"

Blake pauses mid-bite. "So, you'll be staying in town?"

"Yep! It's official!"

Lynne wraps her arms around me. Her cheeks flush red with a rosy smile. "That's so wonderful. I'm so proud of you!"

"Thanks, Mom. You know I wouldn't leave you guys."

A cloud falls over her, and her cheerful tone darkens. "What about the house on campus? Have you talked to your dad about it lately?"

I suddenly feel defensive. I take a step back creating a barrier of space, "I'm planning on living there. Why?"

She reacts gently, noticing my defensive tone, "I just wanted to make sure he's still living up to the deal you two made, that's all."

"Why wouldn't he? That's the whole point of me staying in town. Other than being here with you guys, of course." I notice Blake no longer eating the salsa with chips, but now licking the bowl. He places the bowl triumphantly on the counter. "I want to start buying houses like you guys. Dad said I could start soon."

Lynne sorts through the remaining mail on the counter. She opens an envelope and reads the contents. The color drains from her face.

"What is it, Mom?" I ask.

She shakes her head in disbelief and waves my question away with an idle hand. She lifts a hand to cover her mouth as it opens in surprise.

Blake leans forward on the counter. "Mom, is everything, okay?"

She touches her throat as her face contorts and she closes her eyes in pain. "I can't believe him. The nerve of that man! How could he do this to us?"

Blake, Sydney, and I all watch with concern, unsure how to respond. We wait for her strength to return and her words to continue. Eyeliner creates streaks of black down her sun-kissed cheeks. She musters the will to open her eyes, albeit wide with shock.

"I can't believe he would do this! Not just to me, but to his children!"

I step closer to her and pull the papers in her hands closer to see for myself. "What is it, Mom?"

"The credit cards, Honey! He canceled them! And he closed our bank account!"

My heart softens for a moment as I watch her fume with indignant anger and frustration. Then I place a supportive hand on her shoulder. "Dad wouldn't do that."

She shakes the bank notice in my face, "He already did it!"

Blake stands from the chair at the counter, "Why would Dad do that?"

Lynne stares at the notice in her hands. Her face contorts in anguish. The depth of the bond between her and Tom lasted more than twenty years and brought three lives into the world. Now shattered in an instant by the cold, impersonal touch of a bank notice.

Lynne shakes her head and looks across the counter at Blake. "We're getting a divorce, honey. He's really going through with it. "Sydney looks from Lynne to me, confused. Her lip quivers and her eyes dance between each member of her family within the room, searching for support. "We're going to be okay, though, right?" She asks. Tears linger on Sydney's eyelids as she forces her tiny voice to rise, "What did we do wrong?"

Lynne sniffles and pushes back her tears. She moves closer to Blake and Sydney with love in her eyes. "Sweetheart, no. No, no, don't say that." She wraps her arms tightly around Sydney's small frame and smothers her head with kisses. "You didn't do anything wrong. None of us did. And we're going to be just fine. Your father is just trying to prove a point. That's all. He wants me to sign some deal that his attorney drew up to screw me over. But we're okay."

I hold the bank notice in my hand and glance over the details. "What are the terms?"

She rubs Blake and Sydney lovingly on the back. She takes a willful breath and lengthens her posture.

"It's not important, honey. I want half, and he doesn't feel like I deserve it. After I gave up the most precious years of my life, of your kid's lives, to work in his businesses. I just can't settle for anything less."

I withdraw the five hundred dollar bills from my pocket. I drop them on the kitchen counter. "Do whatever you have to do to get what you deserve. We can make it through this. I've got some money saved up."

Lynne pulls her hand to her heart. Her chest swells with love and pride. She lifts the bills from the counter and returns them to me. "Honey, no. That's your money. You know your mama; I have money tucked away for a rainy day too."

I take a long look at her. My heart grieves for the pain she feels. The sight of Blake and Sydney's pain touches me somewhere even deeper. At young, impressionable ages their lives stand to be the most affected from the uprooting of their foundations. I stuff the money back into my pocket and shove my own pain down deeper with it. The three of them huddle together in a loving embrace. I step forward and wrap my arms around them, sharing in the pain.

During the embrace, I make a silent resolution within myself that if I can prevent their suffering, or at least lessen the damage done by my Dad's actions, I will.

"We're okay." She repeats as we rock side-by-side, together. "We're okay."

AGAINST THE HOUSE

I drop five hundred dollars onto the plush green velvet table. Phillip waits impatiently in the seat next to me. A mound of recklessly stacked chips sits idly in front of him on the table.

A tall man with the bone structure of a scarecrow swipes the bills from the table. His long black hair falls to his shoulders in thin, oily strands. The shirtsleeves of his flannel are rolled in bunches to his elbows revealing forearms covered in jailhouse tattoos. He sniffs and wipes his nose with the back of his hand then exchanges the bills for five stacks of casino chips. He pushes the chips across the table to where I sit.

Phillip watches me with unbridled exuberance. He rubs his palms together as his excitement spills over into his actions.

"What do you think? Pretty great, huh?"

I pat him on the back with a little laugh, "I don't know yet. We'll see how the cards fall."

Phillip refocuses his excitement on the dealer and the cards awaiting us in the blackjack shoe. "Let's move it along, Slim. We don't have all day."

Slim grunts and wrinkles his nose. The skin on his face looks worn and sags with lines like the pocket in an old stretched-out baseball glove. His hand slides in a fluid motion toward the card shoe. "All bets in?

I drop a twenty-five-dollar chip into the betting circle. Then the cards slide into place on the plush fabric of the table. A jack and then five drops into position in front of me. The dealer shows an eight. Tapping the felt, I signal the dealer to draw me another card. He slides a three atop my cards. I wave my hand over the table to stand with the hand dealt.

The dealer flips over his hidden card to a reveal a nine to go with his eight. Then he drops his palm to the table in defeat. "Seventeen." The dealer stacks a twenty-five-dollar chip on top of my original bet

A smile edges into the corner of my lips.

Phillip rubs his palms together, feeling the heat from the friction. He inhales deeply through his teeth in excitement. "Yes! A win on the first hand! That's good luck! Don't you love it! What a rush!"

"It's great. Let's hope it's not just beginner's luck." I say nudging him.

Phillip leans over to me and speaks in a hushed tone, "You know where we could make real money."

I look to Phillip confused, then to the dealer across the table as he prepares the next hand. I add two twenty-five dollar chips to the betting circle and look back to Phillip. "No, where?"

"You know where! The story about the dad... remember?"

My eyes widen with recollection. "Yeah. You're not serious though. We can't do that."

The dealer drops the cards in a sweeping motion onto the table. My cards show two jacks. Phillip's cards land with an eight and a three. The dealer shows a nine of diamonds.

"Of course not." Phillip scoffs as he picks up a short stack of chips to double down on his bet.

I wave casually over my cards, choosing to stand with the hand dealt. We both watch Phillip's additional card sweep across the table. The dealer drops a nine onto Phillip's cards, making a total of twenty.

The dealer reveals the other card hidden beneath his own nine of diamonds. A seven, totaling sixteen. The dealer draws another card. A king of spades, for a total of twenty-six. The dealer busts, over twenty-one. Phillip and I both win the hand.

Phillip claps his hands and furiously rubs them together. He turns in my direction with a slanted grin.

DAD'S HOUSE

I knock on the front door of a quaint two-story brick house in a quiet neighborhood. The sound of crickets and cicadas chirping under the shelter of night reminds me of home. Warm yellow lights from within the house spill from the front windows onto the shadows of the well-kept front lawn. I knock again.

The door swings open and Tom stands in the doorframe with a welcoming smile.

"Well hey, Charlie. Long time no see."

"Hey, Dad. Mind if I come in?"

"Course not. It's your house too."

We shake hands briefly as I step past him through the doorway. Mis-

matched, but comfortable furnishings adorn the hardwood-floored living room. I take a seat on the cream-colored leather sofa. He sits in a green leather reclining chair and leans back with ease. He seems grateful for the company as he smiles in my direction. "What do you think of the place? Not too shabby, is it?"

"It looks good, Dad." I sit forward on the edge of the sofa. "I got my acceptance letter from UK the other day. So I'll be staying in town… and I'd like to move into the Beaumont house this summer. If that's okay?"

His face brightens with joy, "Congratulations. Yeah, that sounds like a plan. It'll be good to have you around. Even though I haven't seen you much lately."

"Look, Dad, I'll get straight to it. I'm mostly here because I know what you're doing with Mom."

His head rocks back as if I landed a punch on his chin. He thrusts his chin forward with determination. "Here I thought you were just coming to visit. I don't see you in weeks, and then you show up with this. Did your mother send you over here?"

"No. I just wanted to talk to you about everything."

"Well, here I am. Let's talk."

I shift my position uncomfortably on the couch and suddenly find an itch to scratch on my face.

"You canceled her credit cards and closed her bank accounts. I know you want her to sign the deal you gave her, but Dad, it's just not right."

He scoots to the edge of his seat. "She maxed out one of the cards! I wasn't going to let her drain the bank accounts too." Tom shakes his head and sits back in his chair again. "Son, let me tell you something. You're not old enough to know this yet, but there is nothing in this world like a woman scorned. She's pissed off and wants to take everything I own. And I'll tell you this right now. I'm not going down without a fight." He

stares down the bridge of his nose toward me. His nostrils flare with each determined breath.

I speak with an even tone to calm his rising anger. "Dad, what is she supposed to do?"

"She could get a job like the rest of us. And what about you? You're done with the auction house now?"

"No, I'm not done with it. I just don't want to be in the middle of this."

"Then stay the hell out of it!" He rolls his eyes toward the door. "You say you don't want to be involved, but here you are, telling me what I need to do. You know what? You're starting to sound like your mother!"

"Whatever, Dad." I stand and brush past where he sits, hurrying toward the door.

"There you go! Run away from your problems, son, and you'll be running your whole life."

I ball my fists and turn to face him with repressed fury flowing through my veins. He stands from his seat and squares his shoulders to confront me like a boxer in the ring. I breathe slowly, sizing my father up from head to toe. Everything in my body screams for me to release the anger I feel. "I'm not the one who ran away!" I shout. "You did!"

He doesn't back down. Cornered and confronted, he strikes back with words. "I put up with more than you know! And I'm done! I'm not going to do it anymore, and I'm not going to have you showing up at my house telling me what to do! Or anyone telling me what to do for that matter!"

I take another step forward, shortening the gap between us. "It's not your house! It's our house! And after graduation, your fifty percent ownership becomes mine too!"

He steps forward recklessly, invading my personal space. I can feel the heat from his breath on my face as we stare eye to eye. "If your mother

keeps this up neither one of us will have any of this! Her fucking attorneys will take it all!"

My body shakes with pulsing rage. My breaths come in short, quick bursts. I take a step back. My body still boils with anger and spills out through my gritted teeth. "Maybe Mom should take over your half of CTA Investments. She could hold it for safekeeping until after I graduate."

He looks at me with a pained expression. His hurt ignites something inside of him, and his eyes open wide with shocked anger. He stares at me like a wild animal in fight or flight mode after being prodded in a cage. The fear in his eyes burns into me, and the intensity of his anger freezes me where I stand. He raises a pointed a finger at my face. "You listen to me, son. If you do that, you will be dead to me!"

My head rocks back from the force of his words. A pain streaks across my face like a fissure in the earth as I fight to hold my head high and keep my expression strong. I stare blankly at him, feeling a numbness creep into my chest.

His tone cools from white-hot to a seething yellow as he continues, eyes ablaze, fear fueling the fire. "Do you understand me? If her attorney's go after that and they win, you will never get another penny from me as long as you live."

My eyes widen as I begin to feel small and insignificant in his presence. I can feel tears searching for a home as I watch his determined expression. My eyelids close, and I swallow the pain down, down as deep as it will go. My eyes open and I stare back at him conveying no emotion, only emptiness. "Okay, Dad. I hear you loud and clear."

HOUSE GUESTS

The indigo clock on the car dash reads 3:16.

I pivot in the passenger seat to face Luke in the back, "You sure about this?"

His determined expression is masked by dark shadows cast from a distant street lamp. "Yeah, I trust him."

Phillip rubs his hands together in anxious excitement as he sits in the driver's seat. "We're really doing this."

My heart beats against the wall of my chest. My body dances internally with a mix of nervousness and anticipation as my blood pulses hot through my veins. I feel entirely present within the moment—attuned to every sensation on my skin; every sound drifting on the air; every movement in my field of vision; The rise and fall of my lungs; the pounding beat of my heart; and every action of every muscle within my body. For the first time in months, I feel alive.

I extend my hands out in front of me and observe them. They don't shake, not even a small tremor. I tilt my head as I stare at my hands, unsure why they never shake. "Check your hands," I say.

Luke and Phillip both extend their hands. Their hands don't shake either.

"At least we're all steady," I say with determination.

Phillip inhales sharply through his teeth. "We're really doing this. No turning back if we go through with it. You guys know that, right?"

"You going to back out now, rich boy? Don't be a pussy." Luke says as he pulls a black ski mask over his head.

"I'm not rich," Phillip says defensively. "My parents are rich. My trust fund kicks in when I'm twenty-five. Who knows, I might not even live that long." Phillip pulls a ski mask over his head to conceal his face.

Phillip and Luke both turn toward me. Luke watches me impatiently, "you coming, or not?"

With a slow deliberate exhale, I pull a black cotton ski mask over my

face. It hides my outward identity but tells the truth of my intentions. My green eyes peer through the eyeholes scanning our environment one last time. "I think it's late enough now. Seems dead outside." I say withdrawing a pair of black leather gloves from my pocket and pull them over my hands. I ball my fist, feeling the leather stretch taught. "Everybody got your gloves on? And no names when we're in there. No fuck ups. We're in, and we're out. Alright? If we're going to do this, we can't afford to fuck this up."

Luke squints his eyes at me as they protrude through the slits in the mask. "Yeah, no shit. You're not the only one with something to lose here."

We exit the SUV and close the doors softly behind us. I reach within my black hooded sweatshirt and grasp the Saint Christopher medallion hanging around my neck and kiss it for good luck and in remembrance of Ryan. I silently ask him to watch over me from above, to protect me, and keep me safe.

The three of us walk without words as we trek through the dark front lawns dressed head to toe in black. Our silhouettes cling to the shadowy areas beyond the reach of street lamps and the silvery touch of the moon's glow. We trample through gardens and jump over fences until we reach a wooded area overlooking the back entrance to a massive three-story brick house.

Luke points from a crouched stance toward a sliding glass door on the second story balcony of the house, "that's where we go in."

Phillip stands from his crouched position and asks, "Lincoln said the door's unlocked. Shouldn't we go through the front door?"

I nudge Phillip with a gloved hand. "Shh. This is fine. This is better. Did he say anything else?"

Luke speaks in a hushed tone, "yeah. We have to find the master bedroom. He said the money is in a closet."

I pull my mask down securely over my face, "let's go."

Phillip and I lock hands beneath the balcony as Luke steps into our basket grip. We heft his legs upward, and he clings onto the ledge of the balcony. We boost him higher as he climbs over the railing.

Luke pulls the handle on the sliding glass door. The door glides open with ease. He leans over the balcony and waves us upward, "it's unlocked. Come on."

Phillip places his foot in my hands. I thrust his legs up, and he scrambles over the railing with a hand from Luke at the top. I take a few steps backward, clearing my space. With a running start, I throw my arms upward, leaping as high as my lifetime spent in basketball gyms allows. My outstretched fingers snag onto the rough edge of the tiled balcony flooring. I pull my body weight up onto the balcony with the helping hands of Luke and Phillip. Then, the three of us slip silently through the open doorway and into the house.

We step cautiously into a high vaulted-ceiling room. Grand antique furnishings tower and sprawl within the expansive living area. Shadows loom menacingly over us. A thick, musky scent hangs heavy in the air. Plush fabrics throughout the space seem to smother the sounds of our footfalls within the house to an eerie muffled silence.

Luke clicks on a flashlight, and a white beam of light shines to guide our way forward. We pass through one room, then another. Our steps land on the hardwood flooring of the entrance foyer. Luke scans with the flashlight and illuminates a staircase. The steps lead upward and turn into an even darker expanse within the house. We trudge forward, eyes and ears perked, as the wooden stairs creak beneath our weight.

We reach a carpeted hallway. The light pans to reveal multiple closed doors and more halls.

I point toward a hallway leading further into the recesses of the house and whisper as soft as my voice will allow. "It's probably in the back. Let's go this way."

Thick carpet crunches under our steps as we crouch toward a door at the end of the hall. The door hangs open slightly on its hinges, revealing a sliver of light beyond the door. We freeze and strain our ears listening for any sounds coming from beyond the door. Brief eye contact through the slits in our masks affirms what we all know. We have to walk through the door.

Luke covers the flashlight with his hand, and our eyes adjust to the darkness. With a gloved hand I nudge the door open, it swings open silently to reveal a large bedroom. We linger behind the doorframe, staring into the dark room, hesitant to cross the threshold. A small light from a bathroom glows dimly, casting long-fingered shadows throughout the bedroom. Luke uncovers the flashlight. The beam of light cuts through the room to expose an unmade four-post bed.

We step into the room trudging on unsure footing. The flashlight sweeps through the bedroom revealing dressers, a seemingly empty work desk, and a tall, dark-paneled wardrobe. All appear tidy.

Reaching the end of the bedroom, we turn a sharp corner toward the bathroom. We pause within a massive walk-in dressing room with tiled floors, exposed wooden racks of clothes, shoes, hats, shelving, and dozens of pullout drawers. A sliver of bright gold light shines beneath a closed door beyond the dressing room. I hear a faint sound humming behind the door.

I step toward the light. Luke stops me short with an outstretched hand. "Don't do it," he whispers as softly as he can. I meet his eyes in the dark and nod my head. He sweeps the flashlight through the dressing room, "he said it's in here somewhere."

We rummage through drawers, careful to maintain an untouched appearance of every clothing item that we paw through with our gloved hands.

Phillip's pace becomes frantic. His gloved hands flip wildly through clothing, his eyes darting from place to place. He looks back over his shoulder to whisper. "This is taking too long. We have to get out of here."

I pull a step stool toward the shelving and stand on it to reach into the back of the highest ledge. I feel something—a large cardboard box. Pulling it to the edge, I heft it down to the floor.

Luke shines his light on the contents of the box. My eyes flash wide with shock—black leather garments. Panties. A red ball gag. Tasseled whips. Handcuffs. Dildos and butt plugs. Beneath the accessories VHS tapes show through exposing white labels with incoherent writing and legible dates scrawled across the surface in dark permanent ink.

Phillip takes a step backward. "Oh shit. What is all that?"

I heft the box and push it back within the furthest reaches of the closet.

Luke grabs Phillip by the shoulder, "Forget it. Just find what we came for and let's get the fuck out of here."

I begin to step down, but a small box on a lower ledge catches my eye. Picking it up with gloved hands I step down holding a repurposed cigar box with the top removed as Luke shines the light on the contents.

"Happy early birthday," I mutter.

Two unsealed white envelopes stuffed and stretched from within sit atop poker chips from various Las Vegas casinos. I remove the impregnated envelopes and return the box to the shelf.

"Hey! What about the chips?" Phillip whispers.

"That's not what we came for. He'll know something's up." I fold open the top of one of the two envelopes to expose a massive stack of cash. I thumb through the bills, to my surprise, all one hundred dollar bills. Much more money than I can count in the moment.

Phillip pulls his balled fists in tight to his body and convulses with

unbridled excitement. "You're right, fuck the chips! We got the money! Let's go!"

Luke sweeps the flashlight through the room. The coast is clear, "Alright. Let's get the fuck out."

I stuff the envelopes into the oversized pocket of my hooded sweatshirt. We move swiftly through the memorized pattern of hallways and stairs within the house. Then out through the balcony door and out into the moonlight, sealing the sliding glass door closed behind us. We climb over the balcony railing and then drop down to the pavement below. My heart races with exhilaration. I can hear the drum of my heart beat loudly in my ears as we rush under the shadowy cover of the trees toward the safety of Phillip's waiting SUV.

A wild mixture of emotions courses through my body. Euphoria, excitement, the pang of guilt, and the small but persistent voice of fear for my own safety each vie for dominance within my thoughts. I touch the bulge of envelopes filled with cash inside my oversized hoodie pocket. My fears of the unknown fade away and a dark feeling of hope for the future climbs into my thoughts.

But mostly, I feel the thrill of the heist.

PART 2

FRESHMAN YEAR

NEW BEGINNINGS

I lean out from the open rear gate of the auction house box truck. A summer zephyr blows through the two dogwood trees on the small front lawn. The sweltering sunlight falls heavy with southern humidity, deepening my reddish brown tan. The insects of the neighborhood buzz loudly with life and activity, swimming in the swarthy heat. Growing impatient, I yell toward the house. "Hey, Luke. Where'd you go? Can you give me a hand with this?"

Luke moseys through the front door of the one and a half story yellow brick bungalow. He passes a wooden two-seater swing on the porch as he cuts through the overgrown grass in the front lawn. The box truck sways gently as he ambles up the walkway to join me inside the box truck.

"I thought we were done already," Luke huffs.

I mock his exasperation with a huff of my own. "Come on man. This is the last couch we'll have to move for a while. I promise."

We both find amusement with the inside joke, knowing that no one other than Phillip knows how financially free we recently became.

Luke chuckles as he continues the joke. "All I'm saying is nobody is calling me the help anymore."

"Nope! Not anymore," I pat Luke on the back with a grin. "Alright, buddy, why don't you be a help and grab the other end of this couch." We each lift an end of the cumbersome piece of furniture.

I scramble my feet backward with effort onto the unloading ramp. Luke smiles and playfully nudges the weight of the sofa forward.

"I'll show you how much help I can be!" He says, nearly pushing me off balance.

I regain my footing as we carry the sofa through the front lawn. A red SUV pulls into the driveway. Claire sits behind the steering wheel wearing

oversized sunglasses. She folds up the sun visor and steps out of her SUV.

I tilt my head in her direction as I shuffle my feet up the porch stairs. "Hey, Baby. Come on in. We're almost done."

Luke and I heft the sofa through the front door and into the living room of my new house on the edge of the University of Kentucky campus. Phillip sits casually with his legs crossed in one of the two beige leather armchairs. Maui Jim sunglasses hang on Croakies over his white button-down shirt with the sleeves rolled up. He tosses a beer to Luke and another to me.

I crash down onto the couch and crack open the cold beer. Ice crystals melt on the outside of the can and the drops of water spill down into my lap. Luke flops downs on the opposite end of the sofa.

"Looks good in here," Claire says as she steps into the room. She removes her dark sunglasses and pauses to observe the new additions to the house. A lightweight t-shirt hugs her thin frame. High-legged running shorts show off her long shapely legs.

Phillip looks over his shoulder at Claire with a wry glance, "Yeah, perfect timing. You missed all the moving."

Claire and I meet with a kiss, then I take her hand and walk with her to join me on the couch as she snaps back at Phillip, "I had to go for a run, Phillip. Doesn't look like you did much either."

Phillip leans deeper into his chair and coolly ignores her comment with a sip of his beer. I turn in my seat on the couch and look toward the kitchen, then back to Phillip. "Where'd Devon and Ethan go?"

"They went downstairs."

"Hey, Dev! Ethan! Where you guys at?"

Their footsteps thud loudly against the wooden stairs of the unfinished basement. Devon bounds to the top of the stairs and makes a quick turn into the living room. Blue-lense aviator sunglasses mask his eyes.

His buzzed head now back to his usual brown color, letting the fad of the frosted blonde tips fade with the end of high school and the Justin Timberlake, NSync era.

Ethan, a childhood friend of Devon's, follows closely behind him. He stands a head shorter than Devon as he walks in his shadow. Ethan's mid-length wavy brown hair stands with volume like Patrick Swayze in the eighties.

"There's beer in the fridge," I offer.

Devon's angular face lifts in a toothy smile. "No. Trust me. We're good."

"Okay, I see what's happening here. No wonder we couldn't find you. Doesn't UK drug test the soccer team?"

"Maybe at some point. But not today!" Devon laughs as he and Ethan turn chairs at the oak dining table to sit backward facing the couch. Ethan squints his eyes against the veiled sunlight streaming through the slats of the window blinds. His bloodshot eyes look red like twin coals from a fire glowing above his high-cheeked grin.

Luke throws his arm over the back of the couch as he turns to confront Devon. "And you didn't invite me?

Devon shrugs as though such a thought never occurred to him. He withdraws a lighter from his pocket and a small plastic baggie of marijuana. He flicks the lighter and waves the flame under the baggie. "You know I've always got something up my sleeve. You want to blaze right now?"

Claire scoffs. "Why do you guys always have to get high? Why can't you just drink beer like normal people?"

Devon leans forward in his seat, craning his neck until he nearly drops from his chair. He tilts the blue-lense aviators down the bridge of his nose with a finger to reveal his eyes. He stares at Claire in mocking disbelief, holding the awkward silence as long as he can. Claire glares back at him

from the couch as the awkwardness grows with each silently passing second.

Suddenly, Devon's face contorts, and he explodes with laughter, spittle flying from his mouth. He drops to the floor in an uncontrollable fit of deep bellowing laughs mixed with high-pitched cackling. His infectious laughter catches on, and Phillip, Luke, and I laugh with him. Ethan chuckles quietly to himself, and Claire holds her glare, not amused.

As I continue laughing, she angles her glare toward me. I throw up my hands in self-defense. "What? Don't look at me. It's funny," I concede, not wanting to make her feel bad.

Claire crosses her arms in a huff, "Whatever. Do what you want then. Why don't you get high with them? I don't care."

Devon explodes into a fresh wave of laughter. He coughs, clearing his throat, and then his laughs turn into deep lunged hacking coughs.

I turn toward Ethan, "Hey, Ethan. You move into the dorms yet?"

He rests his elbows on his knees, leaning forward in his chair as Devon's coughs and laughter dies down to a hacking chuckle. Ethan speaks with a soft voice, devoid of enthusiasm but rich with pointed intention like Clint Eastwood in one of his early films. "Not yet. We move in next week."

Phillip projects his voice across the room, "Transy's a good school. My parents considered sending me there."

Ethan watches Devon return to his seat as he pushes a few stray strands of hair back into place above his ears before responding to Phillip. "Yeah. Seems cool. I like the art program. We had orientation this week."

Devon picks his aviators up from the floor and returns them to cover his eyes. He looks at Ethan sideways through the tinted lenses. "Ethan's just modest. He's got a scholarship for the art program. And he calls it orientation, but really, they gave him a private tour around campus. Didn't they Ethan?"

Ethan leans back in his chair, no longer interested in being in the spotlight. Devon takes Ethan's silence as an opportunity to continue talking.

"Ethan said they have a special collections library that no one gets to see, other than art students and people interested in studying the collections. He said they have paintings in there worth millions."

Luke scratches his beard, "Millions? At Transy?"

Ethan clears his throat and speaks up, "It's true. The woman who gave us the tour said they just sold one of their collections for over ten million last year."

Devon's eyes light up with excitement, "And they're just sitting there, stuffed away in some room somewhere that no one even knows about! What a waste." He shoots Ethan a sideways glance through his blue-tinted frames, "What. A. Waste."

GIVE US A MINUTE

"Claire. I have something I want to say."

Candlelight glows warmly on her face as she looks at me over the top of a Merrick Inn menu. I dig into my pocket and pull out a small box. I toy with the square shaped box, hesitant to break the silence.

I continue. "First of all. This is for you." I reach the box across the table to her. She shows little reaction. I almost notice a wince flash across her placid smile. A hint of sadness shows in her aquamarine eyes as she looks down at the box.

"Chas, you shouldn't have. Really." She opens the box to reveal an intertwined silver and gold David Yurman bracelet.

I reach across the table and prompt her to try on the bracelet. "Do you like it?"

She removes the bracelet from the box, watching the candlelight dance against the jewelry. Then she carefully places the bracelet back inside the box. "Chas, we need to talk. I'm really sorry, but I can't do this anymore." She says in one breath.

My heart sinks in my chest, "What do you mean? Are you saying you want to break up?"

Claire drops her hands into her lap and hunches her shoulders as she leans closer to the table. "We're about to start school soon. You're busy with your friends. And I want to have the college experience, you know? Meet new people and make new friends. I just think we should take a break. At least starting out."

I stretch my arm further across the table to hold her hand. She sits motionless. Her long thin fingers feel cold within my grip. Her expression drops low with sadness as she sniffles then wipes her eyes with her free hand.

"Claire, you can't mean this. Not now. Things are just starting to get better. I know how hard it's been lately. Trust me. I know." I ball my other hand into a fist on the table. Emotion bleeds into my words as I feel my heart begin to rise. "Ever since Ryan died I've been distant. And then everything with my parents, you know? I just feel lost. But I'm trying here. I'm really trying to make everything right. And you are the only part of my life that just feels normal and right and good."

She sighs and breaths slowly as her hand slips out of mine. "I know it's been hard, Chas. It's been hard for me too. But I can't just stay in this relationship because it's comfortable. This is an important time in our lives. I love you, but I just can't."

Tears crawl down her cheeks streaking from freckle to freckle. She dabs her eyes with the linen napkin from the table. I reach toward her and hold her hand in both of my own. I watch her eyes, willing them to look up with that light blue brilliance and meet my gaze.

A waiter approaches the table with a rehearsed grin. "Hi, there. Can I put a drink order in for you? Or get some appetizers started."

I continue holding Claire 's hand as I turn my eyes briefly in his direction. "Not yet. Just give us a minute, please."

He backs away from the table apologetically, "Of course. Sorry to interrupt. Just let me know when you're ready."

My eyes return to Claire as she patiently waits, "Claire, do you remember when we first started dating?"

She shrugs with a sniffle, her patience wearing thin. "What about it?"

"Remember when I called you for the first time?"

She nods, and I laugh recalling the memory.

"I was so nervous. Ryan told me that you liked me, so he gave me your number and talked me into calling you. I didn't know what to say because we had barely talked. Maybe once at that freshman dance when you punched me in the shoulder."

A smile creeps onto her lips. She playfully pushes my hands away and then returns her hand to hold mine.

"But from the first time we talked, I felt that connection. That excitement, you know? The kind that makes you have no idea what to say next or to just say something stupid, but you want to keep talking anyway. I remember I was so scared to ask you out. So I kind of said it in a way that made me feel like you'd say yes."

She laughs as a new kind of tear drops from her eye. She lifts her other hand to the table, placing it on top of our bound hands. "I remember you said you wanted to ask me a question, but you made me promise I'd say yes."

I laugh then shake my head with a smile and look deep into her eyes, searching for the girl I once fell in love with. "That's it. And then I said, well since you have to say yes, will you be my girlfriend?"

Claire's smile lights up her face and then darkens with sadness as she looks down to our intertwined hands on the table. Her eyes lift to meet my gaze as she answers, "I said yes."

"Being with you has been the happiest part of my life, Claire. I love you. I want to ask you a question, but I'll only ask it if you promise your answer will be yes."

Her smile hesitates for an instant but relents. "Okay."

"You promise?"

"I promise."

"We're high school sweethearts, and there's something special about that. We've made it this far. I know college is starting, but we can do this. Will you be my girlfriend, still?"

She sighs allowing her eyes to close. The tension within her body seems to melt away, and her shoulders rise. She opens her eyes to look within mine, brighter than ever. "Okay. Yes, I will."

A smile stretches triumphantly across my face. We draw closer to each other over the table, and our lips connect by the candlelight for a kiss packed with remembered passion. Our mouths dance and linger within the warmth.

As we part I retrieve the bracelet from the box. "Do you want to try it on?" I offer.

She extends her arm for me to slide the bracelet around her wrist. "It's beautiful, Chas. This is too much though."

"Don't worry about it. All that matters is if you like it. Do you like it?"

She admires the jewelry as it hangs on her arm. "I love it."

"Good. I love you."

I catch the waiter walking across the room from the corner of my eye, then flag him down with a subtle wave, "Over here. Yeah, we're ready now."

WELCOME TO THE CLUB

A blindfold covers my eyes as I walk with my hands on the shoulders of the person in front of me. Luke follows my footsteps, guided by his hands on my shoulders. Phillip walks somewhere within the line of connected bodies, along with several other friends from high school. An active member of the fraternity leads our long procession of blindfolded pledges down a flight of stairs.

The darkness thickens behind my blindfold. The temperature drops. The air feels cold and stagnant on the raised hair of my arms. The pledge trainer, Thomas, shouts orders with a heavy southern accent, leading us deeper within the recesses of the fraternity basement. "Hurry the fuck up! Walk faster! We ain't got all night!" He pauses, then shouts, "Well, actually we do. We'll be here until dawn if we have to, but hurry the fuck up!"

The human centipede of pledges slinks forward, deeper and deeper into a cement-floored room.

"Alright, that's far enough." Thomas commands and the forward motion slows to a halt.

"There's a wall on your left. Put your back against it. And keep your goddamn blindfolds on!"

Footsteps of more active fraternity members clod against the cement floor as they gather within the room. They laugh and sneer at the line of pledges against the wall.

Another active, Taylor, speaks out with a low growl and a bit of a slur from too many drinks and what sounds like a dip of tobacco hanging in his lower lip. "You pieces of shit ever hear of bows and toes, and wall sits?"

The group of unseen actives snicker to themselves at our expense. Thomas retakes the lead, "You boys are about to know all about it after tonight. You all claim you want to become members of our fraternity. The

only things in life that have any worth are the things you earn. And we want you to earn a spot in this brotherhood. But look here. It doesn't have to be hard. If every single one of you can recite The True Gentleman, verbatim, we'll stop this hazing right here, and we'll even throw you a party to celebrate. How's that sound?"

"Hell yeah!" One of the overzealous pledges yells as the rest of us mutter whispers of disdain to our nearest blindfolded neighbor. Taylor lurches down the line inspecting each of us, in search of his first victim.

"I don't want y'all to know it. I want y'all to fuck it up so we can toughen you little pussies up! We don't want any little bitches in our fraternity. So who's going first?" Taylor steps slowly past me, too close for comfort. I can smell the plastic of his Columbia jacket and the stench of whiskey and chewing tobacco in his wake. He stops at a pledge to my left.

"How about you. You look like a dumbass. Step forward. What's your name?"

A stocky football-playing son of a surgeon steps forward and says, "Andrew."

"What's that, Andrew? Did you really fuck this up already."

"Andrew, sir."

"That's more like it. Now let's hear that beautiful True Gentlemen just like it was written by our founders in 1899."

Andrew hesitates and sputters the words out in staccato.

"The true gentleman. Is the. Man. Whose conduct. Proceeds. From the. From. From. From the."

Taylor screams into Andrew's blindfolded face, "From, from, from. From the fucking retard factory is what you sound like!"

Thomas shouts an order at us as the rest of the actives watch and enjoy the show.

"Wall sits! Slide your back down the wall and get those butts down! Hold it. Let's go. We're going to make men out of all y'all."

Taylor marches down the line as we drop into position. We each flex our legs to hold a ninety-degree bend at our knees and press our backs against the wall. I laugh to myself at how easy the exercise is for me after years of basketball practice. Taylor notices my chuckle to myself and screams in my direction. "The fuck you think is so funny? Nothing funny here except your goddamn face. Now lock arms. All of you!"

Thomas casually strolls down the line as I link arms with Andrew and Luke beside me. "Within our fraternity, we are all brothers. We are all connected. Just like you are now. How does it feel, right about now?"

Some voices in the dark wince against the pain rising in their legs.

"That's right. Sometimes one of us wants to fall, to give up, to just quit and take the easy road in life. But when you're connected to your brothers, they're right there on either side of you. Holding you up. They're strong for you when you're weak."

I feel Andrew's legs start to tremble through the link in our arms. Groans of pain and grunts of struggle resound through the basement. A voice calls out in pain, "I'm trying! I'm trying!"

I peak beneath my blindfold now that my eyes adjusted to the low light, nudging Luke as he peeks beneath his blindfold too. Thomas and Taylor rush toward a heavyset pledge whose body slid to the floor, and he can't get up. Taylor yells in the boy's face, spit flying from his mouth. "Get the fuck up you worthless fat sack of shit! Get up! Now!"

Thomas stands by the boy's side with encouragement, "Listen to me. You can do this. Don't listen to Taylor. Use the support of your pledge brothers next to you. And you guys next to him lift him up, even if you have to carry him. Don't puss out! Stay strong!"

The boy regains his motivation and resumes his spot on the wall as Thomas paces down the line. "You boys struggle now, but we're making men out of you. You're not with your families anymore and you gotta know it's not all about you. You've entered the next stage in life. This hazing sucks now, but you'll understand it later, and you'll thank us for it!"

Taylor chimes in with a disgruntled growl, "Damn right you will."

My legs grow heavy and thick with pulsing blood as they begin to tremble. Andrew's body slides lower onto the wall, and I strain to support his sagging weight. Luke's body trembles next to me, but his legs from years as an all-state soccer player remain upright.

Thomas steps toward me. For an instant, we make eye contact as I peek underneath my blindfold to watch him. A flash of recognition that I'm breaking the rules crosses his expression, but he smirks and continues addressing us all. "Everything we do together serves a greater purpose. You suffer right now, but you suffer together. Shared suffering forges bonds stronger than anything else in this world. Don't you ever forget that. Shared suffering is what bonds you all as pledge brothers, and it's what connects you to our brotherhood. We all suffered just like you are now, and because of it, we're all connected to a greater whole. There's a reason we are the biggest and best fraternity in the world. We are a community of shared beliefs, and we want you to earn your place among us!"

Several of the active members cheer at Thomas's words.

"That's right!"

"Hell yeah!"

"Come on guys! Earn it!"

Thomas calls out another pledge linked in our chain, "Next up. Phillip. Let me hear our creed!"

Phillip projects his voice with confidence leaning toward arrogance. "The True Gentleman by John Walter Wayland. The True Gentleman is

the man whose conduct proceeds from goodwill and an acute sense of propriety, and whose self-control is equal to all emergencies; who does not make the poor man conscious of his poverty, the obscure man of his obscurity, or any man of his inferiority or deformity; who is himself humbled if necessity compels him to humble another, who does not flatter wealth, cringe before power, or boast of his own possessions or achievements; who speaks with frankness but always with sincerity and sympathy; whose deed follows his word; who thinks of the rights and feelings of others, rather than his own; and who appears well in any company, a man with whom honor is sacred and virtue safe."

The active members cheer with satisfaction. Taylor runs up to Phillip and shouts in his face, "That's what the fuck I'm talking about pledge! Did the rest of you hear that? He just True Gentleman'd all over the fucking place!"

The collective groans of aching bodies and shaking legs grow louder, more urgent.

Thomas strides proudly down the line, "Phillip just earned y'all a rest! Take a breather!"

Our collective bodies crumble to the floor. I stretch my legs trying to force my blood to circulate again. Taylor doubles his intensity and leaps toward our broken line of bodies.

"Don't get comfortable. We're just getting started! Drop down to the floor! Now! Bows and toes! And we got something special for you. You ever done a plank on bottle caps?"

With a collective sigh, we all drop down into a plank. The weight of our bodies grinds into the cold cement floor on our elbows and toes. We all suffer, but I am thankful to not be suffering alone.

A COLD DAY IN HELL

I look over my shoulder ensuring that no one followed me into my bedroom. Crouching on my hands and knees, I push on a false wall that connects to the attic through a storage closet. I squint against the darkness to open my lock box. A pile of tightly bound stacks of hundred dollar bills greets me within the lining of the box.

Some nights my guilt and my fear prevent me from falling asleep as my thoughts race. I imagine Lincoln's dad discovering the truth about what we did, and retaliating against us with brutal violence. I lay awake at night picturing hired thugs breaking into my house with led pipes and baseball bats like in the Val Kilmer movie, Wonderland. Or when I do fall asleep, small noises in the darkness wake me, sometimes in cold sweats accompanied by a pang of guilt in my chest. When the remorse rises I fight it back with reason. I tell myself that if given a choice between Lincoln's Dad paying off his dirty debts with the money or my family and I feeling hopeful for the future again, I choose my family and myself every time.

I fold a stack of hundred dollar bills into my pocket and close the lockbox. I crawl out of the hidden space and return the panel to the false wall of the closet. Posters of gangster movies, smooth operators, and criminal icons like Al Capone, Ocean's 11, James Bond, and The Usual Suspects hang on the walls of my bedroom. I hurry down the straight set of stairs into the living room below, locking the door behind me.

I climb into my Jeep and make the drive down Tates Creek road to my mom's house. Dark thunderheads loom heavy in the sky, painting the landscape with ominous shades of grey as I park in her driveway.

I walk through the courtyard and enter the house through the side door in the sunroom. Opaque and dreary light shines through the skylights in the vaulted room. The connected living room feels dark and empty. A faint light from the cloudy sky drifts in through the kitchen

windows as I open the refrigerator. The interior light glows white to reveal cold and barren shelves.

A door creaks open behind me in the dark, followed by Lynne's voice. "Charlie, what are you doing here?" She looks as though she just woke from a nap, wearing no make-up and a purple silk robe with slippers. She has an effortless beauty and carries herself with dignity and class, even in the low light of afternoon sadness.

"Hey, Mom. I didn't know you were here. All the lights are off."

She dismisses the comment with a wave of her hand, content to let the glow from the refrigerator illuminate the room. She rubs her eyes and yawns as she approaches me for a hug. "I try to keep the lights off during the day."

"Why? And what's up with this fridge? You guys don't have any food."

She tightens the belt on her silk robe and approaches, "Sure we do. What do you want? I'll fix you something."

I swing the refrigerator door open to prove my point. My mom frowns, but persists, "Well, you have to check the cabinets too. There's plenty to eat. You just have to look around."

I swing open the six-foot cabinet doors that once held row after row of food; it too looks barren. "Mom, there's no food in here either. What have you guys been eating?"

"We've been eating fine. We must have just run out." Pain strains through her words like a wire net holding back the natural sweetness in her tone. Her words don't ring as true as she wishes they did.

I close the refrigerator door leaving both of us content to stand in the darkness. "Then go to the grocery store, Mom."

She tucks a hand onto her hip in dismissal, "Don't worry about it. I will."

"No. How about this, let's go right now." I nudge her elbow in the direction of the doorway. "Mom, come on. It's too late in the day to be laying around here in the dark. Go on up to your room and get dressed. I'll take you out to lunch, then we can go to the grocery."

She resists my pull like a stubborn mule, standing firm and leaning away from my insistence, "Charlie, stop it! I can't."

I continue to pull, not willing to relent, "Yes you can! We're going!"

She forcefully breaks her arm free from my hold and stands to face me in defiance. I watch her body break down from within. Her strong-willed, dignified posture slumps and she drops her face to her hands in shame. Sobs rack her shoulders as she blurts through her hands, "I can't go! I don't have any money!"

I take a step toward her, "It's okay, Mom. Everything is fine, okay?"

She raises her head from her hands to yell with wide eyes, leaking with tears. "It's not okay! It's all gone! Everything I worked for! Everything I had saved up! It's all gone!"

Embarrassed and ashamed, tears burst from her eyes. I stand next to her feeling helpless as I look around the dark, empty, lifeless house. I pat her on the back for support, then ask, "Is that why all the lights are off?"

"Yes, I keep them off during the day to save money while Blake and Sydney are in school. Don't tell them though. I don't want them to worry."

My hands clench into fists, and my jaw tightens as anger rises furiously within me, "Didn't the court order Dad to pay for things until the divorce is final?"

She tightens her lip with a hopeless smirk, "They did. But your father refuses to pay it. He still wants me to sign a deal to let him keep everything. He wants to give me this house and enough money to pay our expenses for a few months, but he's mad at me because I want half. I want half of the businesses too. I have to think of you kids! I have to think about my future, our future!"

I wrap my arms around her shoulders and hug her. She drops her forehead into my chest and lets her tears flow free. "It's okay, Mom. We're all going to be okay."

She sniffles and leans back to look into my eyes with a deflated voice, "Charlie, I'm too old to start over. I didn't want this. I've worked half of my life helping your father build his dreams, and now he just doesn't want me anymore."

I look into her eyes, and I can feel a glimpse of her pain—her hurt, abandonment and loneliness after a lifetime spent loving someone. The emotions that come with bringing three lives into this world and raising them with another person, only to be betrayed and left alone. She must face a profound struggle to trust again and to risk the vulnerability it requires to love and to be loved. Every day must be a new search for meaning and purpose, where every step is new, untrustworthy, and terrifying. It hurts me to even touch the razor-sharp edge of such profound pain.

Tears build behind my eyes. I smile at her in admiration for her strength.

The spark of life within her eyes looks like an abandoned child with arms outstretched pleading for the warmth of her love to return. "What did I ever do to deserve this?" She asks as my jaw clenches with anger.

"You didn't do anything to deserve this, Mom. No one did. But I know that you deserve better than this." I gesture around the dark room with an extended arm, "Walking around in the dark until Blake and Sydney get home." I dig into my pocket and remove the wad of folded bills, offering her the money. She takes a step back from me, unsure of how to respond.

Lynne blinks in the low light and stares at the wad of money as is if looking at a corpse, "Charlie, where'd you get all that cash?"

"Don't worry about it. I've been saving up for emergencies too." I gesture for her to take the money from my hands. She refuses to accept the

cash and gently pushes my hand away. I insist again, holding it out to her. Reluctantly, she opens her hand and takes the money from me.

As if by a stroke of magic, I flick the switch and the overhead lights turn on in the kitchen.

"Charlie, that's a lot of money to just be carrying around," she says eyeing me suspiciously.

"It's no big deal. I told you we're going to be okay. The four of us are going to get through this. You just do whatever you have to do to get what you feel you deserve in this divorce. But for now, just go put some clothes on and let's go get some lunch."

She hugs me with a newfound sense of hope and speaks through a sniffling nose, "I know we will. You're right. We always do." Lynne leans back with a soft smile to observe my face briefly, then walks past me toward her bedroom holding the stack of money to her heart as she walks to the stairs. Her footsteps linger up each step then fade away into her bedroom. I exhale deeply against the rising heartbeat within my chest. When I know I am alone I turn off the overhead kitchen lights welcoming the darkness.

PARTY

I turn in the driver's seat of my car to face my little brother, Blake, in the passenger seat and his friend Jake in the back seat. "If anybody asks, especially girls, you tell them you're a freshman in college, not high school. Got it?"

They both laugh nervously then slide out of the car to eagerly join the party.

"Have fun!" I yell at them as they vanish into the crowd of coed bodies, booze, and cigarette smoke on the front porch. I walk through the

front lawn weaving through conversations as funk music electrifies the atmosphere. The pledge trainer Thomas and his less likable sidekick Taylor stand atop the porch stairs. They raise their cups, and I greet them with a head nod as I step past them and through the front door to my yellow brick bungalow house on the edge of campus.

Luke and Devon stand huddled in conversation across the room. Luke flags me down with a lift of his eyebrows and chin. He meanders through the maze of sorority girls and fraternity guys congregating elbow to elbow with drinks in hand. I meet Luke near the door to my bedroom with a quick one shouldered hug.

Luke raises his red plastic cup, gesturing the drink in my direction, "You're already two drinks behind. Catch up man."

I peek inside his cup, wafting the scent to my nose, "You cracked open the Crown and Sprite?"

"Don't worry. I'll get the next one. Hey, listen to this shit. Devon got kicked off the soccer team."

My eyes jump in shock, "No way! Why? What happened?"

Luke leans back with a broad-armed gesture, "Get this, he was stealing checks from his roommate. Ya know, fifty bucks here and there. But then it started to add up, and his roommate caught on. Told the coach and the coach told him to pack his shit. Lost his scholarship and everything."

"Whoa! What's he going to do now? Soccer was everything to him."

Luke laughs, "He's like a cat. I don't know how he does it, but he always lands on his feet. He could use a place to crash though."

I scan the room in search of Devon's ostentatious presence, and then turn back to Luke with a shrug, "I'll talk to him about it. Maybe we can work something out."

"Hey, Chas!" Someone shouts my name over the rumbling of music and voices. Blake stands in the kitchen looking across the room in my

direction. I glance at Luke briefly and then move past him toward my brother.

"Hold on. I'll be back."

Blake greets me in the doorway to the cramped and crowded kitchen with a big smile. Jake grins at him like a kid in a candy store as a group of girls pass by wearing tight blue jeans, brown leather boots, and tops leaving little to the imagination. Blake glances over his shoulder toward the room beyond the kitchen, saying, "We were going to play beer pong, but we don't have any beers. Do you have some?"

I walk them through the kitchen and swing open the refrigerator door, saying, "Of course. Help yourselves. Mine is on this bottom shelf." I point them in the direction of a thirty pack of Coors Light.

"Thanks!" Blake digs into the box of beer with relish and passes a few cans back to Jake.

I smile as I feel a big-brotherly sense of pride inflate my chest. "Have fun! Let me know if you guys win. I'll come play you in a little bit." I open the freezer to find a glass gallon jug of Crown Royal whiskey frosting under the icemaker.

Devon peeks his head over my shoulder and stares into the freezer with thirsty eyes. "Hey, you have enough for me to bum a drink? Luke said I could have some."

The jug sloshes as I search for a clean space on the sticky kitchen counter. The kitchen reeks of spilled beer and liquor. "Luke didn't buy it, but sure. Grab a cup, I'll pour you some."

Devon smiles like a wolf in a costume. He pulls a used cup from behind his back and sheepishly grins, "It's not my first drink. And from what I hear, you can afford it."

The comment hits me like a jab to the gut. I stare back at Devon trying to assess the grin on his face, then turn to pour the drinks. "What makes you say that?"

"Oh, nothing. I just hear things, that's all."

I mix the drink with Sprite and then drop a hand full of ice cubes into the cups. I shove the mixed drink across the counter to Devon.

He quickly snatches the cup with a free hand. "Don't look at me like that! I'm on your side!" Devon scoops the drink from the counter and lifts his cup in cheers.

I hold my cup steady on the counter, "I heard some things too. Something about stealing checks?"

His broad grin sags as he lowers his cup, "Shiza! Who cares! That's in the past. It's time to look forward to bigger and better things!"

I lift my drink and take a swig, "And I hear you need a place to crash? I've got extra space in the basement if you want to turn it into a room."

Devon's eyes spark with excitement, "You'd let me stay for free? You're a lifesaver!" Devon lifts his glass in cheers.

I laugh, nearly spitting my drink on the counter, "No, you can't stay for free! You have to pull your own weight. You can split rent and utilities with Luke and the rest of us. But I'll cut you a deal though since I know money is tight for you these days with your parents' divorce and all."

Devon brushes the comment aside and leans in close with a curled lip, "I'm working on something big right now. Don't you worry about me. You're going to want in on it." He steps past me, patting me on the back as he takes a long deliberate swig of the drink. He looks over his shoulder at me as he smacks his lips relishing the refreshing taste of the free alcohol.

I sip the mixed drink, shaking my head in disbelief at Devon. I squeeze my way through a hallway where a long line of people lingers outside of the bathroom door. I step into the laundry room where another line waits outside the entrance to the second bathroom.

I grunt in frustration to myself then knock on the door, "Hey, you've got people waiting out here. Come on. Hurry up."

Phillip catches my attention from the corner of the room where he stands hunched over the washer and dryer. Luke and Andrew huddle close to him in the same manner. "Hey, Chas. Check this out," Phillip says flagging me over.

I bang one last time on the bathroom door with a heavy-handed fist and shout, "Hurry it up. Let's go!" Then I join the huddle near the washing machine. Phillip holds a razor blade in one hand and a chalky white rock in the other. He shaves the powder off the rock and down onto the washing machine, then he looks at me with a wide grin. His pupils expand as his eyes dart to read my expression. His words race frantically as he says, "This stuff is the greatest, Chas. Chas, you have to try it. You'll love it. Here. I got extra. You want one?" Phillip hashes out a thick white line. He motions toward a hundred dollar bill rolled tightly into a straw that sits atop the washing machine.

I look over my shoulder at the line waiting for the bathroom, then turn back toward Phillip, Luke, and Andrew. "No, Phillip, I'm good. Don't be doing this shit out in the open though. My little brother is here. He doesn't need to be seeing this kind of shit."

Phillip's body jolts in surprise. "Oh, it's not cool if we do it here? My bad. Here. Don't worry." He drops his face down to the surface of the washing machine and lifts the straw to his nose. Holding one nostril closed he snuffs the line of powder through the straw like a vacuum. The cocaine hits his sinuses like a punch making his eyes water, and he scrunches his face in pain. He swallows hard and snorts through his nose like an aardvark. Then a calm washes over his face, and he no longer feels any pain or much of anything at all.

Phillip licks his finger then wipes the powder residue from the top of the washing machine. Rubbing his finger on his gums, he smiles a toothy smirk at me. "There. All gone. I love college. And I love you guys. But I could seriously kick all your assess with one hand tied behind my back right now."

Luke chuckles, "Let me get a bump of that, Phillip. Or we'll see whose ass is going to get kicked."

"You heard Chas. We can't do it here anymore. Plus you need to pay me for a bump. I don't have time for freeloaders."

"Fuck you! You want money from me? I'll show you where you can stick your money." Luke forcefully grabs at Phillip's pockets, but Phillip kicks at Luke's legs and guards his pockets with hands like vice grips. Luke grows tired of the back and forth and shoves Phillip against the washing machine. "Fine, rich boy. I've got the same money as you now, so go fuck yourself. You want money from me; I'll go get you some. How much you want? A thousand? Two thousand? I don't give a fuck." Luke shoulders past the lines of people waiting for the bathroom who stare at him.

Phillip swipes a finger over the surface of the washing machine and rubs his finger on his gums again. "Chas, you saw that. He went crazy, right? What was I supposed to do? Just let him reach into my pockets?"

"He'll get over it."

Andrew shrugs, unconcerned. "Have you guys paid dues yet? They're more expensive than I thought. Like eight hundred bucks a semester."

Phillip flexes his hands into fists, "I could have taken him. You guys know that, right?"

I scoff and laugh at Phillip, "Pfft. Yeah, those kicks were vicious. I thought you said one hand tied behind your back!"

"I didn't want to cause a scene. Plus my legs are powerful. I could have taken Luke... If I wanted to."

I shake my head dismissing Phillip's over-ambitious belief in himself due to his recent boost of ego, and then turn my attention toward Andrew saying, "Yeah, I paid the dues. They say it all goes into a huge party budget, but I'm always throwing our parties anyways. They talk about connection and brotherhood and all that, but I feel like we make our own connections anyways. Are you guys going to stick with it?"

Andrew looks down at the washing machine surface, then back up to me. "That's true. My parents pay for it, so I figure I might as well if they're the ones paying for it."

Luke rushes through the laundry room doorway in a panic. "Chas, did you go in your room?"

My body reflexively tenses, "Why? Is someone in there? Everyone knows my room is off limits."

Luke shakes his head furiously. His lungs heave into his chest as he tries to catch his breath. He looks like he could smash a hole through the wall.

Phillip slides a few steps further away from Luke into the corner of the room.

Luke drops his head then lifts a balled fist to the air. He looks up at me with rage in his eyes, "Someone stole my money."

"What do you mean, someone stole your money? From where?" I demand.

Luke clamps his jaw down hard, fuming with rage. I step away from the huddle and pull Luke to the side, away from prying ears. "Someone stole the money?"

Luke scans the room, searching for answers with fury in his eyes. "Yeah, Chas. It's gone."

"All of it?"

Luke sighs. "No. Just some of it. I stashed a couple grand in your room tonight. I'm so fucking stupid!" Luke spits through gritted teeth.

My eyes widen in recognition. "Shit. What about my money?"Luke and I shoulder through the crowd and rush up the stairs to my bedroom. Luke points to an open dresser drawer where clothes lay scattered across the floor.

"I stashed it in the drawer, but I can't find it anywhere!"

I race across the room to where I stash my money. I remove the false wall in one of the closets. I fumble with the keys on my keychain and open my lockbox in a panic. The box opens to reveal an undisturbed pile of rubber-banded stacks of one hundred dollar bills. I breathe with relief.

Luke stands behind me looking over my shoulder. "Is at all there?" He asks.

"Yeah. I'm sorry man. I thought my room was locked. Did anybody know you hid it up here?"

A pained expression contorts Luke's face. "Fuck... Devon."

LAKE HOUSE

My Jeep coasts down the steep driveway leading toward my family's get-away home in Russell Springs Kentucky. The two-story vinyl sided house sits nestled within a golf course community on the bluffs overlooking Lake Cumberland. Tall, towering trees shade the house with autumn-tinted shadows as a soft breeze blows the last warmth of summer before the season's cold takes hold of Kentucky. The last flourish of life buzzes within the thick foliage and underbrush that enshrouds the house in privacy.

We step inside the house and unload our bags on the couches. Floor to ceiling windows along the back wall entices us to step outside to the back deck where the swaying breeze blows through the surrounding trees.

Devon steps to the railing and looks down toward the dark water below the cliffs. "What a view!" He exclaims.

I join Devon to admire the view. "I love it down here. We used to spend weeks here in the summers," I say reminiscing about the old memories. "Did you guys see those trees next to the driveway? Ryan and I planted those years ago."

Luke plops down in a reclining chair to enjoy the view in his own style. He touches the hand-rest of the chair, feeling the comfort, then observes the three-story deck system, each showcasing a new angle of the lake below and the autumn coated mountains beyond.

"I want to have a place like this one day," Devon says. He smiles broadly gesturing toward the view. "This is what life is all about. Being with your friends. Enjoying life. Living. Loving every second of it, because there is nowhere else you'd rather be. Do you get what I'm saying?"

I look out over the railing and into the sway of the trees as the light dances among the branches bouncing between dazzling, bright brilliance and the dark depth of the shadows. "Yeah, that's what it should be. But it isn't always fun and games, Devon."

Devon smirks and extends two closed fists toward Luke and I, "But what if life becomes whatever we make it?" He unfurls his fists to expose four colorful pills inside one of his palms. He gestures for us to take a closer look.

Luke stands from his chair to inspect what Devon holds.

Devon raises the four pills to the light, "Pure MDMA. The substance of life, energy, and light compressed into a single pill. Scientifically manufactured happiness. Come on boys. Let's live a little."

I take a step closer. Devon holds four round pills with imprints of little green aliens out towards us.

Luke picks one of the pills from Devon's palm. "How's it going to affect us?"

"You know that painting by Michelangelo? The one where God reaches down from Heaven." He explains reaching one of his hands high into the air and arches a pointed finger down toward us, "And man reaches up toward the touch of God?"

I shrug, "Yeah, what about it?"

Devon smiles and offers one of the remaining pills to me, "It's kind of like that."

I take one of the pills from his hand.

Devon tosses the remaining two pills into his mouth and swallows them whole, "See you boys on the other side."

THE PRECIPICE

Our feet dangle over a cliff. The water sparkles down below. The rock bed beneath me embraces my body as I lay back and look up to the canopy of swaying trees. Kaleidoscopic colors of autumn swirl through the breeze with multi-textured, tangible warmth on the wind. "If you could have any superpower, what would you guys choose?" I question.

Luke scratches the thick scruff on his jawline. "Superpower, or a wish?"

"Superpower. Like one special thing about you that no one else in the world has."

Devon's eyes flicker to life ruminating with imagination. "There are so many good ones. Teleportation would be useful. Or invisibility. But to fly..."

Luke interrupts, "I'd rather have a wish."

I sit up to glare at Luke eye to eye. "Well, fine. You get one wish, and the only thing you can wish for is one superpower. So what would it be?"

Devon projects his voice as he looks out across the distant hills beyond the open water below. "I'd fly. Definitely. But I wouldn't have just any wings. I'd have the wings of Hermes because they do so much more than just fly."

Luke's thick eyebrows crunch together in vehement objection, "You can't have the wings of Hermes. That's not fair. That's more like a wish!"

I laugh and lay back returning my gaze toward the canopy of trees. "If I could have any super power I'd teleport. Sometimes I'd love to just be able to zap myself somewhere else. Anywhere else. You know?" My voice trails off as I stare at the trees and the blue sky beyond. "Luke, what's your power?"

"Fuck, I don't know. I don't want to play this game anymore. Maybe the power to go back in time so I could go back and stop you from asking this dumbass question." We all laugh, and Luke drops his shoulders back to lie against the rocks. His eyes drift toward the trees.

Devon looks out over the rippling water below and the picturesque mountains beyond like an explorer surveying the land. "What if life could always be this way? What if we never had to worry about money again? But really though. I'm serious. If you had that chance, would you take it?"

I loosen the focus of my eyes and let my mind sway with the wind in the trees. "Yeah, I guess so."

Devon turns to face us with a mischievous grin, "What would you say if I told you we could make twelve million dollars in one day?"

I sit up, shifting my attention to consider his words.

Devon takes a deep breath and leans back, carefully planning his thoughts, "I don't know how to tell you this, boys, so I'll just come out and say it. About a month ago I came across the opportunity of a lifetime, but I know I can't do it alone."

Luke grows impatient, "Do what? Just spit it out, Dev. What are you talking about?"

Devon throws his head back and laughs wildly. "Okay, okay. You remember that tour they gave Ethan? The one for the art program? Well, I did some research. He's right. Transy has books and paintings in this special collections museum worth millions."

Luke returns Devon's excitement with a blank-faced stare, "Yeah, so what?"

"So get this. There's this collection of books called, Birds of America by John James Audubon. Like the Audubon society. The bird watchers group, you know? They're these huge elephant folios filled with paintings of birds from all over America in the early eighteen hundreds."

I prod Devon to continue, "Okay?"

Devon takes a deep breath filling his lungs with the confidence to carry on. "I went through a few of Ethan's connections in the art world. People he sold some paintings to at one point. It took some digging, but I went through a connection of a connection and eventually found an art dealer on the black market in Amsterdam that wanted to buy the collection. So I flew over there."

Luke and I both lean forward in surprise. I shove Devon on the shoulder, "You did what? You flew over there? To Amsterdam?"

"Yeah, it was like something out of a movie, these black market guys. Ponytails, suits, bodyguards, and everything! They were European Underground all the way. It was wild!"

Luke pressures Devon to continue, "So, then what?"

Devon leans into the story with renewed vigor, "I met with a few different buyers, but I think I found the right one. It's this guy who called himself Terry. I had a hard time finding the place. His office was this little hole in the wall hidden in an alleyway. You'd never know it was there, but the inside was really cool; the room was like, circular." His thoughts drift off, and he loses the thread of the story.

I prod him again, "And?"

Devon snaps back into focus, "Oh, yeah, so then I cut a deal with him! And guess what he agreed to pay for those paintings? His voice races with speed and rises with excitement, echoing from the hills surrounding us. "Twelve million dollars! What do you think about that boys? Just let it sink in for a minute. Twelve. Million. Dollars." Devon's body nearly

vibrates from the excitement rushing through his breaths as he waits for our reactions. I look out over the glimmer of the water, considering the magnitude of the tale Devon told us. He can't stand the silence and breaks through the quiet, "We have a chance here. We can make our lives what we've always wanted them to be. We just have to reach out and grab it!" Extending a hand out over the glory of the view he closes his grip as if the endless expanse of the colorful mountainsides and the glistening ripples of the water could be snatched within one grasp. "Everything that happened up to this point is in the past. All of it. But it makes us who we are. Every experience of our lives up to this point serves a purpose to help us moving forward. We can do this. We can steal these paintings and become millionaires. What do you say, boys? Are you in?"

Luke and I turn to each other, examining the look behind each other's eyes. My thoughts drift to my family and the difference in their lives that a significant amount of money could bring to us all. Then I consider the idea of getting caught. The embarrassment alone would destroy me.

Luke speaks first, "We can't all have our fortunes handed to us on a silver platter like some people." He cuts his eyes in my direction. "I'm going to have to see what we're working with. But yeah, I want in."

Devon jolts toward Luke in excitement, "That's what I'm talking about!" They lock hands and seal the deal with a one-shouldered hug. "And Ethan's already in, of course. That makes three of us. We got to have four to pull this off. Chas, we need you, man. Can we count you in?"

I release a long slow sigh as the ripples roll across the water below. "I've got too much to lose guys. You both know things are messed up with my family right now, but I still have ownership of those rental properties. Worst-case scenario, I'm still way ahead. To do something like this would just be stupid."

Luke scoffs at me, offended, "Don't be an asshole, man. What, are you too good for this, or something? You didn't act that way at Lincoln's Dad's place."

I shift my weight and pull my feet away from the ledge, "That's different, and you know it, Luke. Look, you guys do what you want. Your secret is safe with me. You know I won't say anything to anyone. And you don't have to completely count me out, but don't count me in."

Devon's expression of defeat curls into a one-lipped smirk. "So, you're not saying no. You're saying maybe?"

"Sure, Devon. Maybe."

Devon throws his arms wide in victory, "Maybe works! We'll take that!" He and I lock hands and embrace in a one-shouldered hug. Then Luke and I pull each other in to make amends. Devon gazes out across the water and to the colorful expanse of the hillside and clouded blue sky beyond. "Maybe. What a powerful word. Can't you just feel the possibilities?"

INTO THE PIT

The sun's rays drift golden and lazy above the distant mountainside. Luke, Devon, and I hike down from the cliffs near the house toward the water below. Each step pulls us down, lower and lower, and down further still. The falling autumn leaves drop from the trees to obscure our tracks. The house vanishes through the veil of trees beyond the twists and turns as we climb deeper down.

We drop over an earthen ledge onto a staggered rock shore. The limestone rocks stack like uneven stairs along the water's edge as we amble along without aim, other than to immerse ourselves in the possibilities that arise anew in front of each step. The sound of buzzing life from the forest fades as the sounds of the lake lapping gently against the shore overwhelm the soundscape enveloping us.

An unseen force draws us toward the belly of the cove where a water-

fall trickles fresh spring water down onto the rocks before us. Water spills from above gliding over the rocks and past our feet to sink down into the lake below. The two become one, bringing new life to the ecosystem.

I pick up a flat stone from the stream and fling it across the lake. The stone skips, skips, and skips, then plops down into the depths. "This is weird. I used to come down here with Blake a lot when we were younger. But the water level used to be a lot higher back then. We used to fish off those ledges up there."

Devon hefts a heavy rock and hurls it down into the lake. Water rips upward from the lake, splashing the shoreline. Something substantial and brown bobs along the surface of the water in the wake of the splash. It looks like matted fur. The musky stench of death hangs stale in the air.

Luke tilts his head examining something beyond the splash, "Hey, do you guys see that in the woods?" A set of beady eyes stares unblinkingly out from the underbrush of the woods above us. Luke turns to me by his side, "Are there bears in these woods?"

I point to the floating ball of fur as it bobs against the shoreline, "Of course there are bears. That might be a dead one right there."

Devon picks up a baseball-sized rock and takes aim at the eyes that watch us. "I don't know what it is, but I'm going to fuck it up."

"Devon, don't!" I shout.

He flings the rock toward the eyes that watch us from above the shoreline, only ten yards away. The rock misses by several feet. The eyes remain cold and unflinching.

Luke growls in Devon's direction, "Stop fucking with it. Whatever it is, leave it alone, man."

Devon bends down to retrieve another rock. He finds a golf ball sized stone and rears back to throw. Luke hops over a gap between rocks and lunges to grab Devon who lets the rock fly. Luke stands helplessly by

Devon's side as the stone soars through the air. It smashes into the unsuspecting animal's face. The creature rears its head back unleashing a wild hiss. Dry leaves shutter beneath the animal's body as the skinny face emerges from beneath the foliage onto a fallen tree along the shoreline. A collection of pale green and brown spots slithers behind the animal's head; the skull as big as my hand and the body as long as I am tall. The massive snake races down the fallen tree then slips onto the rocks and careens straight for us. The wild animal crawls like a cold-blooded killer in camouflage.

We turn tail and sprint across the shoreline. Our feet splash across the rocky stream.

"I fucking hate snakes!" I yell over my shoulder as I stride past Devon and Luke, knowing that I don't have to outrun the snake. I only have to outrun them. Latching onto the nearest ledge leading up into the woods I pull myself upward. My head pops above the rock shelf. A massive green and brown body coils tightly in a ball. Beady unblinking eyes stare cruelly back at me from only two feet away. My body freezes in shock. I muster the courage to move, pushing my body backward. I tumble down the staggered hill of rocks onto my back.

Devon and Luke rush to help me to my feet as I point in terror to the ledge above us.

"There's another one! Up there!"

We search the shoreline for a path to lead us up the mountainside and safely back to the house. Dozens of beady eyes stare back at us from cracks and crevices all along the rocky shore. Necks crane curiously out from their hiding places into the open air. Tongues flick outward soaking in the last warmth of the autumn mating season dusk.

Luke shakes his head with a huff and pushes Devon by the shoulder, "Shit, Devon. I told you not to throw it!"

Devon squirms in his stance. He peeks over Luke's shoulders at the shoreline of eyes that watch us. "Don't blame this on me! I didn't put the snakes here!

"Yeah, but you fucked with them. I told you to leave it alone!"

I grab them both by the arms. "Guys, shut up. It doesn't matter. We have to get out of here before it gets dark."

Luke shrugs my hand away from his arm, "This is your house. How do we get back?" he follows my eyes as I look beyond the waterfall and up the cliffs. A steep hillside and rock separate us from where the house sits atop the mountainside, obscured by thick leagues of half-naked trees.

My eyes turn toward the rocky shore squinting against the quickening dark. The staggered staircase of limestone and shale writhes with movement as more scaly bodies emerge and bask in the last of the day's warmth. I point toward the end of the cove, "We came down over there. That's the only trail I know of to get back up."

Devon doesn't hesitate, "Here I go!" He jumps from one rock to the next, then on to another, leaping over an unsuspecting wiry neck that stretches out from a crevice.

Luke and I quickly follow his trail. We lunge from rock to rock as the daylight dims with each step. The last of the sun's rays slither away behind the mountains on the far side of the lake. Darkness crawls across the horizon consuming the sky.

IN THE PIT

A cold breeze sweeps across the water with chilling fury. Luke, Devon, and I huddle close together like penguins in the arctic seeking shared warmth and security. We stand hopelessly trapped against the water's edge and the sheer mountainside. Our light jackets and jean pants do little to combat the cold creeping further into our bones.

I whisper softly into the crisp night air, "Hey, guys. Look around. See if you can find some sort of stick or something."

The variety of snakes stir and adjust their positions, agitated by the noise, inching closer to our shared warmth. Small black and wiry cold-blooded bodies slither in coils near our feet. Fat, bloated brown snakes lounge scattered along the rocks. Red serpents with black and yellow bands glide down from the ledges onto the boulders below and cross paths with black snakes with thin red stripes. Long and lean black bodies glimmer in the pale light and ripple with muscle as they dance along the waves with heads like a fist. Tan and brown-scaled bodies sulk coiled within crevices and observe us coldly, with little concern. While the monstrous green and brown camouflaged serpents stare intently down from the ledges, hovering over us as their eyes glow bright green against the silver light of the moon.

I squint to scan the dark shore. Devon locates a piece of driftwood within reach and pulls it close to him. I notice a small tree limb behind a brown snake with a short, stout body. Extending my arm over the resting snake, I lift the limb from the rocks with a scuffle. The stubby snake contracts its muscled body and raises its head from the earth, poised to strike. Slowly and cautiously, I ease the limb higher into the air. My breath comes in strained bursts as I stare into the snake's eyes, pleading it not to strike.

I lift the tree limb higher and higher and finally over the snake's watchful eyes. I clutch the branch close to my body and instantly feel safer with the fragile protection of the tree limb in my hands.

Devon's eyes flash in the moonlight with primal purpose as he whispers, "You want to fuck these things up?"

Luke grabs Devon by the arm, "Are you stupid? That's how you got us into this shit in the first place. Don't do it."

I motion with my eyes toward the snakes near our feet as they adjust their positions. They draw closer with each flex of their wire thin black

bodies. "We have to, Luke. We have to do something. Dev, don't hit them. Throw them. Use the sticks. Like this." I demonstrate a flicking motion with the limb in my hand.

Devon nods his head vigorously, "Yeah, let's do it. On three?"

I flex my grip tighter around the limb and nod. My heart pounds in my chest and my breath comes hot from deep within my constricted lungs. I whisper, "One... Two... Go!" I drop the limb in front of an unsuspecting snake at my feet. I scoop the tree limb under the snake and launch it like a catapult out across the water. The small black cord slaps onto the water's surface as the moonlight pushes toward us in waves. Devon frantically flings snakes into the open air as I lunge forward for another slithering serpent. It dodges the limb and wraps itself around Luke's sneaker.

Luke breaks our developed code of barely audible hushed whispers. He screams with a deep-lunged groan of raw fear, "Ahh! What are you doing? Get it off my foot!" The noise and the movement further agitate the snakes in our periphery. Luke shakes his foot madly, but the snake refuses to release him. I scrape at the snake with the tree limb, and the snake drops to the rocks with a hiss. It slithers toward the safety of the rocks, but I slide the tree limb under its body and fling it high into the air. The tiny reptilian body soars across the water, crossing the brilliance of the round-faced moon for an instant like the bicycling boy and the alien in E.T.

Rocks crack and crumble, tumbling down into the water below. I search the stones around us wildly like a caveman with my stick in hand scanning the earth for danger. I see no movement, but I feel a presence. I look over my shoulders to search the ground behind me. Something catches my attention.

Slivers of moonlight that strike the shoreline seem to vanish within a black void where a point of thick darkness gathers nearly four feet from my knees. My eyes follow the dark trail that winds up the rocky slope,

over the ledge, and disappears within the root system of an ancient and gnarled tree.

The tumbling pebbles and rocks slow to a halt. Silence consumes the cove again.

Devon stares over my shoulder gripping his piece of driftwood like a baseball bat. He speaks through a clenched jaw, "We have to kill it."

My breathing quivers loudly against the growing quiet as I fight the pressure gripping my lungs. I whisper in a hushed tone, nearly miming the words on shaky lips, "I'm going to take a closer look. Don't move." I twist my hips to turn and crouch lower. My face inches forward. I hold my breath to still my racing heart as I squint to capture more light.

The darkness meets the rock in a diamond-shaped knot, then disappears.

I turn my head back toward the group to whisper excitedly, "False alarm guys. We're okay. It's just a root." A gut-wrenching deep-throated hiss rips into my ear. Chills of pure fear run through my body, taking control. I can only react on an instinctual level as I turn my head to stare face to face with that awful sound. Two glossy black eyes like stones of onyx stare back at me. Jaws open revealing the pale color of soft flesh.

I can't move. I stare blankly into the face of death, frozen.

The hissing grows louder, more violent. The jaws unhinge, stretching, reaching. Black pits gather in the lining of the flesh. The dark circle in the center of the throat quickly increases in size, expanding and devouring like a black hole in deep space.

Something touches my shoulders, grips around them and wraps them tight. "Chas! Get away from it!" Luke yells as he pulls me by the shoulders away from the open jaws of the serpent.

I snap to as if waking from a dream. "Holy shit! It's a snake! It's a fucking snake!"

The three of us huddle closer together. We inch cautious step by cautious step away from the monstrous snake. The snake's maw silently closes as it watches us through its black onyx eyes, threatening to move closer.

Devon clutches his driftwood log and prepares to strike. "We have to fucking kill it! I can't take this shit anymore! Get me the fuck out of here!" He raises the log above his head, poised to attack. The black beast shifts further down the slope. Only three feet away. Other snakes surrounding us atop the rocks inch closer as if inspired by their leader.

My eyes scan the rocks and trace the source of the snake's agitation back to Devon. He jabs the log into the air then toward the ground. His attempts to scare the snakes away only further embolden their cold-blooded actions, as if they taste our fear with every hungry flick of their tongues.

I grab Devon by the shoulders and squeeze him in silent rage as I struggle to shake his body back to awareness of the present moment. "Shh! Shh!"

Devon refuses to relent. He resists my grip and swings the log in the air. "We gotta kill it! Get off me! We gotta get out of here!"

Luke cuffs Devon's mouth to silence his screams down to muffled groans. He whispers furiously in Devon's ear as we both hold him still, "If you don't shut up I'm going to throw you in the goddamn water. I'm serious! Don't make me do it!"

Devon quiets his voice and shakes Luke's hand away to free his mouth. Devon's body trembles with fear. His wide eyes flash around the rocks as he maintains a death grip on his driftwood log of protection.

Luke and I make eye contact as we silently will the noise and movement from the snakes around us to calm and slow to a steady hush. Minutes pass achingly slow as Luke, and I share a knowing look beyond words. I nod my head, and then look to Devon, "He has to go."

Devon glares at me in appalled surprise.

Luke agrees with me, "If he doesn't, he's going to get us killed.

Devon's head jolts back wildly, trapped in an inescapable situation. "Where can I go? What are you saying? I can't go alone! We can all go."

The will to survive steadies my voice to speak with conviction as I look into Devon's terror-stricken eyes. "You have to go. It's the only way."

Luke attempts to comfort Devon with a reassuring tone, "Devon, all you have to do is get to the house and call 911."

Devon's voice reduces to a defiant whimper. Then a soft plea of disbelief, "Someone else can do it! I can't do this!"

I lock eyes with Devon, refocusing his attention, "Devon, listen to me. We've been friends for years. Sometimes we have our issues like anyone does, but you've always been there for me when I needed you most. When Ryan died, you were the first person to have my back. I love you like a brother. And I know Luke does too. And right now we need you. We both do. We're not getting out of here alive unless someone climbs up to the house and calls 911. I can't do this. I would freeze up. I know I would. But I know you can do this, Devon. You can do this. You have to."

Devon shakes his head in defiance. He clamps his jaw down hard as heavy breaths filled with the weight of life and death struggle to escape through his nostrils.

After a long silence, he lets go of the words, "Okay. I'll go." His tall, thin figure shivers against the cold night air.

I glance over my shoulder and lock eyes with the black beast. It stares back with only passive interest. I unzip my jacket and stealthily slide my arms out from the sleeves. "Here, Dev. Wear this. Luke, give him yours too. It might help... In case they bite."

Devon glares at me but accepts the gesture. He pulls my jacket atop his own and ties Luke's jacket around his waist. He looks out across the water in the pale moonlight. Black snakes writhe in the waves beneath us. New

hordes of serpents swim on the water's surface swarming in the direction of the pit. Devon grabs the bill of his hat. A movie promotional giveaway from the film, The Rundown. He tucks it down tight to shelter his face as he stares up the rocky path ahead of him. Snakes coil and sprawl along the staggered staircase of shale. A ledge hangs above the rocks where three sets of glowing green eyes watch us. They stalk our every move, waiting, watching. Beyond the foliage of the ledge, the hillside climbs upward and disappears into the thick darkness of the forest.

Devon's eyes face the direction of the forest, but he stares face to face with something I cannot see. His breathing deepens. His jaws clamp down tight, and his eyes begin to water under the internal strain that he struggles against. I share his suffering, but I don't face his demons. I rest a heavy hand on his shoulder. His body trembles with fear beneath my touch. Luke places a hand on Devon's other shoulder. The three of us stand together, connected by our shared suffering and our mutual will to survive.

The trembling in Devon's shoulders slows then his body steadies to the pace of his breath. He whispers in a goofy western accent through clenched teeth, "Welp. Guess it's time for me to hit the old dusty trail." His anguish turns to frightened laughter as he wipes the tears welling in his eyes with a jacket sleeve. "If I don't make it, tell my family I love them."

I rub Devon's shoulder, "You're going to make it, Dev. You have to. You're our only hope to get out of here."

Luke pats Devon on the back, "You can do it. Don't stop. No matter what happens. Don't give up."

Devon nods his head sternly in acceptance of his reality. He tucks the bill of his hat low to protect his face again. He clenches his jaw and crouches into a sprinters stance. His breaths grow louder, more furious as he crushes the fears down inside of himself.

My fingers reach under the collar of my t-shirt to touch the Saint Christopher medallion hanging close to my heart. I tilt my head toward the inky black sky illuminated by the glow of the moon and lift the necklace to my lips silently uttering a prayer. "Ryan, if you can hear me, please watch over Devon. Guide his footsteps and carry him upward to safety. Please, if you're there if anyone is there, please help us survive this night." I tuck the medallion back under the collar of my t-shirt.

Devon breathes violently against the cold night air. His breath rises in puffs of steam billowing from the fury within him as he mentally prepares himself for the run. His eyes focus inward toward his soul and outward to a place a thousand yards before him to the unknown of the void that ultimately awaits us all. With a final deep breath, Devon springs forward. He strides upward, climbing and clawing up the rocky shore. His feet trample over unsuspecting bodies. A cacophony of hellish hisses fills the air. Snakes snap and lunge in his wake as he climbs higher. He scrambles his squirming figure up over the lip of the rock ledge.

Glowing green eyes track him from both sides. He scrambles upward wildly on all four like a mangy dog. Leaves crumble, and limbs crack as the ground shutters beneath the movement of dense bodies slithering toward his feet. Devon jumps and latches onto a tree root. Pulling against the root, he thrusts his body upward and away from immediate danger closing in on him from below. The root snaps shattering the air with a pop and the crackle of upturned earth sprinkles softly back to the ground as Devon's body falls back onto his back. He lands on top of the three monstrous snakes with the glowing green eyes. Violent deep-throated hisses electrify the air. Darkness conceals the frenzied movement and the sounds of pain, struggle, and fight for life and survival.

Luke and I watch helplessly as the dark figured bodies lift from the ground, alien in their movement, and lunge ferociously at Devon. Green eyes flash with cold-blooded callousness. The sound of baseball

bats striking meat echoes down the hillside. We hear the awful scratch of powerful bodies slithering against the rock, leaves, and earth. Then the muffled sound of bone striking against flesh. Again and again.

"Go, Devon! Get up!" I shout.

"Don't stop! Keep going!" Luke yells.

Devon's arms and legs flail wildly in search of solid ground and a sure footing. He scrambles to his hands and knees clinging to the earth with his bare hands and thrusts his body upward. He climbs higher and lifts himself over another ledge. He heads deeper into the darkness of the forest. Luke and I watch his silhouette climb higher and higher. Then his shadow disappears, and the sound of his movement silences as the dark consumes him completely.

THE LIGHT SHINES

Darkness sprawls thick and heavy over the cove. The moon hides behind a veil of clouds like a shy pale-faced bride. The wind carries the humidity of early winter as moisture clings to our exposed arms and necks.

I nudge Luke gently with an elbow as we hover closer to each other for warmth and the facade of safety.

"Hey, do you hear that?" A shiver runs down my spine, and my teeth chatter as I whisper in the cold air.

Luke shushes me, "Be quiet, man. No, I didn't hear anything."

An icy cold wind sweeps across the lake. I wrap my arms tighter around my body to hold on to what little warmth remains within me. I whisper again, losing my resolve to fight against the quiet that holds the snakes at bay. "I think I heard something. Maybe Devon made it to the house."

"It's been hours, Chas. Forget it. He didn't make it back. He's lost in the woods. Alright?" Luke huffs.

I crane my neck to listen in the direction of the hills. The wind buffets through the trees and disappears into the dark. Waves lap rhythmically against the shoreline. I hear no sound of warm-blooded life other than our own. "We have to do something. We can't just wait here until dawn. There's a dock in the next cove over. It's a pretty long swim. But I think we can make it."

"I'm not swimming in this water. It's fucking freezing. And look at the size of those snakes." Luke motions with a subtle head nod toward the black-bodied water moccasins that slither along the waves near the shore.

I stare blankly at the water below then say, "The water is warmer than this air right now."

He shushes me again, "Just be quiet. Let's wait it out until morning."

A wave gathers on the far side of the lake; it rolls forward black and heavy atop the water. The clouds glide silently across the sky, and the moon shines down on us again. The light from above shines on the lake, revealing the giant wave rolling across the surface. The wave pushes closer.

Closer.

I nudge Luke, "Is that what I think it is?"

Luke turns to face the water. He groans in defeated anguish, "Oh shit. No. No. No!"

I cup my hands over my mouth and shout into the darkness of the forest, "Devon! Hey, Devon!"

Luke cups his hands over his mouth and adds his voice to the effort, "Devon! Anyone! Can you hear us? Please help! Someone!"

The wave rolls closer. Thirty yards away dozens of black bodies shimmer against the rippling water and slither across the surface of the lake en masse.

"Help! Please!" I scream.

Twenty yards away the wave pushes forward. Ten yards. Each body weaves its own path. Each body slices closer. Thin, wiry necks crane out

from the water and grip the shore. Their bodies gain traction, and they climb onto the rocks. Black serpents slither all around us, each searching for a home within the rocky shoreline.

Luke violently shakes his leg. Then he stomps his foot as resting snakes around us stir to life.

"Luke, stop! What are you doing?"

"A snake's on my leg! Fuck! I can't get it off!"

I squint my eyes and scan the ground. A dark tail pokes out from the leg of Luke's jeans. I lunge to grab the serpent by the tail. My fingers graze against the smooth scales, and I hesitate in fear. The snake slips through my fingers.

"Oh shit! It's crawling higher!" Luke groans

A bulge circles its way up Luke's pants as it wraps higher around his leg. "Shit! Shit! It's going for my balls!" He shouts. Luke instinctually covers his groin with both hands.

My eyes scan Luke's body and search the rocks below us for an answer of how to help him. I whisper in an attempt to calm him, and more importantly to me, to soothe the agitated snakes around us, "Hang in there, Luke."

Luke screams back at me, "Hang in there? I've got a fucking snake in my pants! Do something! Help me!"

"What do you want me to do? I'm not reaching in there!"

Luke groans, exasperated and scared, "Fine. I'll do it myself." Holding his groin with one hand he unbuttons and unzips his fly, then cautiously pries it open. The snake stares back at him and flicks its tongue searching for warmth atop his thigh. "Shit. I can't do it. It's looking right at me!"

I force a half-hearted smile on my face, "Hey, Luke. Is that a snake in your pants or are you just happy to see me?"

He groans and grows antsy as he taps his other foot impatiently on the rocks. "Shit! This isn't funny man!"

Rocks crumble from above us tumbling down the rocky slope plunking into the water that laps onto the shore. My heart floods with fear as I turn my head to trace the origin of the sound. Two green eyes flash against the glow of the moon as a massive body slides down from the ledge and onto the rocks beside us. The serpent slows and then pauses. Its forked tongue licks the air, wetting its appetite.

I stare at the pair of glowing eyes that watch us. The void stares back at me emotionless, cold, and hungry. My body stands frozen, trapped beyond hope of escape as I watch the eyes and my muscles tense to fight. I clench my jaw straining against the fear that grips me like a vice. Gritting my teeth at the serpent, I lift my head toward the light of the moon. Against the endless expanse of darkness and the distant stars beyond, the moon shines brilliant in its purity, magnificent in its glowing glory. Silvery white light beams down from above to illuminate the whole world against the dark of night. A beacon of hope when no other hope exists.

My heart pounds against my chest and lifeblood pulses through my veins. My nerves tremble with fear and my skin braces tight against the cold moisture in the air. Muscles contract ready to fight. Every fiber of my being screams survive.

I lower my eyes to face the serpent at my feet. It stares back unflinching and unmoved.

A strange noise drifts through the air. I hold my stance and strain my ears toward the night sky. The sound builds louder, more insistent against the silence of the cove. It cuts through the still of the night like a rusty chainsaw and grows louder and louder until it seems to vibrate the hills themselves.

A beam of light cuts across the vastness of the lake. I squint my eyes to see more clearly. A boat skims atop the water and races across the waves.

I nudge Luke softly, "Luke."

He watches the boat slice through the water, "I know."

The boat engine roars triumphantly against the hills. The rocks we stand upon vibrate against the sound as a searchlight pans the darkness surrounding us.

A tiny black head emerges from the base of Luke's pant leg, and then a thin, wiry body slips onto the rocks and slithers away to find a dark crevice.

The searchlight pans across our shore. Luke and I stand frozen as the light finds us. The engine roars louder, doubling in speed toward where we stand. I shield my eyes against the blinding bright. The boat approaches the shore and slows to drift forward on the waves. Luke and I don't hesitate. We leap head first into the open bow of the small fishing boat.

"Go! Go! Get us out of here!" I yell.

A man wearing a Carhartt jacket and a Bass Pro Shops hat stands above a manually steered motor. He cranks the motor in reverse, and then revs the engine in full throttle, carrying us away from the shore. The searchlight pans across the rocks that housed us for more than nine hours. The camouflaged bodies hide beneath the foliage atop the ledge. The slits of their green eyes reflect a sliver of the light back at us. The figure of the black beast trails down from a root system of the ancient and gnarled tree above. The black onyx eyes gleam and then disappear.

Another man wearing overalls and a jean jacket stands behind the shining light as he scans the shoreline. He looks over his shoulder toward the captain, "I cain't see no snakes."

PART 3

SOPHOMORE YEAR

VISIONS

A cloud of marijuana smoke lingers in waves on the air. Bed sheets hang from the exposed ceiling beams of Devon's room in the unfinished basement of my campus house. The threadbare walls enclose the drafty space with vibrant colors of yellow, green, pink and black fabric. Devon, Ethan, Luke, and I lounge in thrift store armchairs. The fall air gathers with condensation against the small window pain set in the concrete block basement wall of the yellow bungalow. A print of an old film, Life is Beautiful, hangs near the window.

We huddle close together in the warmth of our deepened connection that grows tighter as the world outside becomes more distant and cold. Our bare feet rest atop the Astroturf flooring that covers the concrete basement floor. We hover around a wooden coffee table and pass a red glass bong around the circle that Devon calls The Red Dragon.

He hunches over the tabletop and lights the bowl. The tall water bong bubbles to life and Devon inhales the brownish grey smoke like a vacuum. He dramatically drops the lighter on the table and crouches his body down to the floor. He flexes his lanky frame into a tight ball.

Luke stands from his tangerine colored armchair to take the bong from the table.

"Are you serious right now?" He asks.

Devon holds a stern finger in the air and violently shakes his head against the smoke trying to escape his lungs.

Luke lights the bowl and hits the bong. He passes it to me.

I shake my head in disgust at Devon crouched in the fetal position on the floor. "I'm starting to think he needs drugs to feel normal." I light the bowl and inhale a deep-lunged hit from the bong, then exhale and a gust of smoke billows above the coffee table, adding to the fog that hangs in

the air. I pass it to Ethan who accepts with a polite nod. A thick mustache grows like a fat caterpillar above Ethan's lip. His coiffed hair puffs above his head.

Devon emerges from the ground triumphantly. He exhales, and only clear air escapes from his lungs, the smoke trapped and consumed within his body. He laughs at his accomplishment then his laughter turns to hacking coughs and a desperate plea for air.

Ethan squints his eyes and stares at a ray of light streaming in through one of the small basement windows. "If you look at the light you can refract the beam to bend it with your eyes." He widens his eyes, and then squints again, "It dances like a snake."

I uncomfortably adjust my position in the matching tangerine armchair beside where Luke sits. "Don't remind me of snakes."

Luke leans forward in his armchair.

"You still fucked up about it? You missed out on the hiking trip this summer."

Devon passes a soccer ball atop the Astroturf between his bare feet. "Ethan was like one of those reality show hosts. A rattlesnake would pop up on the trail and Ethan would play with it!" He flips the ball with his foot to Ethan.

Ethan catches the ball with casual ease then rolls it back to Devon on the floor. He shrugs off the compliment. "It wasn't a big deal. They don't want to hurt us. Only if we bother them."

I hold my hands out to signal for Devon to pass me the ball. I turn to answer Luke as I watch Devon flick the ball swiftly between his feet in my periphery. "Yeah, I guess I'm not all the way over it yet. The nightmares don't come as often as they did for a while, but I still have one every now and then. Devon, you got us out of there. I still don't know how you did it, but we're here now."

Devon flips the ball in my direction, and I catch it with an extended hand. He laughs with a chuckling cackle, "I don't know either! Those woods were terrifying! Everything was pitch black, except for every now and then when I could see the moon through the trees. I groped around in the dark for what felt like forever. You guys have no idea some of the things I saw in the dark." Devon shivers with distaste for the memory. "Fears I thought I forgot about. I'm talking childhood nightmares! Everything I've ever been scared of. It was there in the woods with me. Like right next to me. Even chasing me! I thought a fucking wolf was chasing me. I hid under a bush hoping this thing would go away, but I think it was all in my head. Well, I'm pretty sure it was in my head." He laughs again, dismissing the memories.

I toss the soccer ball into the air with a twist and the ball lands spinning on my finger. "I have this dream every now and then that snakes surround me everywhere I look. Even the ground is made of snakes. Big ones and small ones. And I'm falling. Snakes grab me and try to wrap around me and pull me down deeper. And it just keeps getting darker."

Devon takes the bong from Ethan and lights the bowl. Devon inhales deeply then lays the Red Dragon to rest on the table, holding the smoke in his lungs. Puffs of smoke escape through his mouth and nostrils as he speaks. "It's cashed. You should have come hiking with us though, Chuck. You missed out. We got a lot of work done on the trip too."

"Smoking weed and walking on the Appalachian Trail for a month doesn't count as work." I laugh and toss the ball back at Devon.

Devon traps the ball with his foot and juggles it into the air to bounce on his knees. "You can laugh, but we're going to be the ones laughing all the way to the bank!"

Luke scratches his thickening five o'clock shadow. He sits low in the armchair like Al Pacino in Scarface with a wide-legged sprawl. "You

should really think about it, Chas. It's all coming together. We need you, man. We could use the help."

I glower at Luke in response.

Devon seconds Luke's comment. "Yeah, Chuck. We could. We're locked and loaded. Going to be ready to go before winter break." He steps behind several slats of wood near the exposed furnace that serves as a makeshift wet bar for his room. Devon disappears in search beneath the wooden slats and then appears with a pill in one hand and a stack of papers in the other. He drops the stack of papers onto the coffee table and fills his lungs with pride. His face gleams with mischievous enthusiasm as he taps the pages, "These are the plans that will make us millionaires. We're talking three million dollars for each and every one of us! Do you understand how much money that is? That's life-changing money right there!"

I lean forward in my tangerine colored thrift store armchair to observe the plans. Sketches that were drawn with a careful hand and an attention for detail highlight the floor plans of Transylvania University's library, the special collections room, and the campus parking lot. Four Xs, each of a different color, mark locations throughout the map.

Luke and Ethan lean forward in their seats to hover atop the coffee table and watch Devon break down the plan. He drags a pointed finger across the sketch toward a group of Xs. "All four of us go through the front door to the library right here. We need disguises though. Ethan, you're still working on that, right? Any progress?"

Ethan twiddles the end of his mustache and nods his head in agreement, "Not really."

Devon rolls forward building on his own momentum. "Okay, that's okay. But you will soon though. I know you will. So, we walk in the library wearing our disguises." His finger glides across the paper.

"The special collections room is on the third floor. That's where the Audubon collection and our twelve million dollars are too. We need to make it through the library undetected then up the spiral staircase. There's a glass wall and glass security door at the top of the stairs. But, here's the catch. The only way in or out of the special collections room is to have the librarian on duty enter a code to disarm the security system and open the door."

I interrupt, "And how do you plan to do that?"

Devon's eyebrows lift with excitement. A crooked smile lights across his face as he raises a finger to the air. "Ah! That's where we have to set an appointment with the librarian ahead of time. I've already been talking to her about that."

"You what? What do you mean you've been talking with her? Are you insane? Are you trying to get yourselves caught?"

Devon gestures with his hands for me relax.

Luke taps me on the arm with a hand to reassure me, "Just hear him out, Chas."

Devon props bare feet with overgrown toenails onto the coffee table, "I've been sweet talking this old lady. But don't worry. It's all through email through a fake name from a public computer. Everything is under control." A crooked smile stretches across Devon's face. His cheek twitches as if his smile might crack with a sudden movement.

I sit back in my chair. "Okay, so even if you do all that, then what? How do you get her to disarm the security code and let you in? And beyond that, to let all of you in?

Devon casually tosses the soccer ball in one hand. "Child's play. Ethan will disguise me as an elderly and established businessman named Walter Beckman. Trust me. This woman already has a crush on me. She's going to let me in."

I hold a hand in the air to stop him from continuing, "Okay, I've heard enough. This is just ridiculous."

Ethan interjects, "Devon, tell him what her name is."

Devon tosses the ball to Ethan then smacks his knee for emphasis, "Anita Bonner! Can you believe it?" He cackles wildly at the thought. Luke and Ethan add their laughter to the chorus.

I look around the coffee table trying to understand their laughter. "So, what? What's wrong with that? Is this some kind of inside joke from the hiking trip I'm missing out on?"

Devon pronounces her name slowly and deliberately, "Anita Bonner... A need a Bonner. I need a boner!" He erupts into a fresh fit of laughter, and I catch myself chuckling with him as Luke and Ethan redouble their own amusement.

I motion for Ethan to pass me the ball. He tosses it, and I palm it with a one-handed grip. I wave the ball in the air maintaining a firm grip as my words cut through their laughter. "Look. You guys do what you want. Maybe the drugs have fucked up your brains or something, or maybe you've been watching too many movies because this just sounds crazy! Do what you want, but don't count me in for it."

Devon reaches for the soccer ball in my hand, "You're missing the point, Chuck. We're talking millions of dollars here. Anything is possible. We're refining the plans. Ethan's making disguises. We're setting it all up. Check it out. We even have code names!" He gestures around the room, "Ethan is Mr. Green. Because, of course, he smokes a lot of green."

Ethan contemplates the name then nods in agreement and reaches for the bong.

Devon opens a hand toward Luke. He colors his voice with an ominous tone, "Luke over here is Mr. Black. Black just like his cold heart." Like a maestro he swings his hand triumphantly through the air to point

toward himself, "And little 'ole me, I'm Mr. Yellow. Like the sun. Or other good shit that's yellow." The maestro hand swings in my direction, "We need the extra help though. We need a fourth, and you're our guy! And guess what your code name is: Mr. Pink!" He lunges for the soccer ball and tears it from my grip. He and the others explode in a fit of laughter as I scan each of their faces trying to understand the inside joke.

I sit forward in my chair, and my body reflexively tenses, "There you go! Laugh it up! I'm not even a part of this stupid shit, but even if I were I definitely wouldn't be called Mr. Pink! I can tell you that right now!"

Luke laughs loudly as he leans in to punch me in the shoulder, "What's wrong, man? You don't like being called Pink?

Devon smiles as he tosses the soccer ball to Luke, "All of the other colors were already taken. So, you have to be Mr. Pink."

My face flushes hot and rage builds inside of me, "Fuck all of you! You're all dumbasses to even be thinking about doing something so stupid anyway! I've got too much to lose to even be sitting here talking with you idiots!" I stand from my seat fuming with anger.

Luke throws the ball at my back and stands from his seat, "What, you think you're better than us or something?

I turn to square my body toward him with my fists clenched, "You're the one talking shit and calling me Mr. Pink!"

Devon reaches over the coffee table with long arms to calm both of our rising tempers, "Boys, boys, settle down. Look there's enough money on the table here for us all to share. We can all live the lives we've always dreamed of. Let's not fight about it. If Chas doesn't want to be called Mr. Pink, he can choose any code name he wants. How's that, Chuck? You want to be Mr. Blue? Maybe a cooler color would help? Maybe a calmer color?" He mockingly shrugs his shoulders with a playful look of innocence on his face.

Footsteps stomp on the hardwood floor above us.

I brush Devon's hand off my chest and turn to Luke, "I'm not even a part of this stupid shit. But if I was, you could call me Mr. Pink. In the movie, he's the only one who comes out on top."

The footsteps pause near the entrance to the basement at the top of the stairs. The door creaks open.

Everyone freezes in silence.

A voice calls down the rickety set of wooden stairs, "Chas? Babe? Are you down here?"

Luke, Devon, and I make eye contact and agree to put the conversation on hold. Then I answer the voice, "Hey, Claire! Yeah, I'm down here! Come on down! We're just hanging out down here." Luke and Devon roll their eyes and return to their seats.

The wooden stairs wobble with each step as Claire descends the staircase. She pulls a pink hanging bed sheet to the side and light from the stairwell glows above her as she enters Devon's domain. Mascara streaks down her freckled cheek in a blur as if she hurriedly dried tears only moments ago. Her red, bloodshot eyes find mine, and she holds a hand to her mouth as she speaks, "Phillip's in the hospital."

TWO DOWN, ONE TO GO

The air hangs stagnant with the stale smell of sickness and death in the hallways of the hospital intensive care unit. The sharp bite of lingering bleach does little to mask the musky scent of disease and despair. Claire and I stand next to each other in the hallway. We look through a glass window into the room where Phillip lies motionless in an upright position on a hospital bed. A respirator pumps oxygen into his lungs. An IV drips from a bag and flows through tubes down into his veins. A heart monitor blips quietly, but steadily next to his bed.

Claire 's shoulders hunch forward. She wraps her arms tightly around her thin frame as if to hold herself together with a tight grip. She stares through the glass to where Phillip unconsciously rests. Her voice sounds weary and strained, "The doctors said his body just shut down. They said his immune system completely stopped working. I guarantee it's from all the partying and drugs." She cuts her eyes cut at me, "Do you know what drugs do to your immune system? Especially cocaine! I told you guys!"

I frown and shake my head as I turn again to look through the glass at Phillip. "Don't look at me. That's Phillip's thing." I reach a comforting arm around Claire 's shoulder, but she flinches against my touch. Then shrugs my arm off her shoulder as she positions herself to stand further away from me. I scoff, "What's that about?"

She shakes her head and refocuses her attention on Phillip's motionless body beyond the glass. Pain clouds the expression on her face. She wraps her arms tighter around her frame.

I lean closer to get her attention, "How did you find out Phillip was in the hospital?"

Her eyes dart toward me. A hint of guilt streaks across her face. She looks away again and masks the truth with a show of disgust. Wrinkling her nose at the audacity of my question.

I lean closer and persist, "Why did someone call you before calling me?"

She reacts quickly, her words cut with a sharp edge, "What does it matter? Phillip's in a coma right now, okay? His heart stopped twice. Can you just be here for your friend and not worry about yourself for once. It doesn't matter who called me."

I watch as pain fills her eyes, "Claire, are you okay? I know you're scared of him, but so am I. What's up? Talk to me."

She stares through the glass toward where Phillip lies. Her eyes seem

lifeless and cold. I inch closer and wrap my arm around her shoulders. She flinches and attempts to shrug my arm away, but I gently persist. Her shoulders feel thin and frail as I linger in the half-hearted embrace. I look into her eyes, searching to find her, but her eyes are drawn elsewhere. My hand slides off from her shoulder, and I take a step back from her.

"Claire, are you hooking up with Phillip?"

She faces me with fury. Her thin nostrils flare with indignation and her eyes burn into mine with anger. I meet her eyes, and for a fleeting second, I finally see her. I feel the pain underneath her glare. I try to join her there, but a pain rises within me. Anger bubbles toward the surface and begins to reach out toward her. Quickly, her eyes dart away dropping her gaze downward, and tears rise to the surface. She turns again to face the glass.

I lean forward longing to regain her attention, but she refuses to meet the judgment behind my eyes. "You are. Aren't you?" I watch the faint image of her face in the reflection of the glass. Her two-dimensional image looks coldly beyond me as a tear streaks down her freckled cheek. I instinctively reach out to embrace her, but she steps back from my outstretched hand, "No, just don't touch me." I reach again for her, and she takes another step away.

"Of all people, Claire? You had to hook up with Phillip? He's one of my best friends! How could you do this?"

"It's always someone else's fault with you! You don't even realize it, but you've changed, Chas."

I point to myself, "You're trying to tell me that I've changed? You hook up with one of my best friends, and you're saying that I've changed?"

She shakes her head angrily at the accusation. Her arms grip tighter around her thin body. "Yes, Chas, you've changed. You may not realize it, but you're not the only one in this relationship. You're always hanging out with your friends or complaining about your family. I didn't sign up for

this. Where's the guy I started dating years ago? You complain about your dreams being on hold all the time because of your dad. Well, what about my dreams, Chas? Why don't you do something about it? Stop whining about it and just grow up."

My jaw clenches. I spit my words through my teeth, "You have no idea the sacrifices I've made. For my family and for us. So that we can have the future we've always wanted."

"What future, Chas? How can I know that? You barely even go to class anymore. And what happened to your lawn care business? Or the auction house? The appraisal business? Or all the houses you and your dad were buying. You don't do anything now but sit around with your friends and smoke weed!"

Frustration rises through me as her words hit home. I feel the sharp pang of guilt pushing to the surface. My own judgment against my actions and my utter lack of motivation strives for expression. Stubbornness and anger prevent me from speaking the truth. I clench my jaw and bite back the words on the tip of my tongue.

She plows forward striking at the uncovered vein of emotion she sees within me, "You say you do things for your family and for me all the time, but all I see is you doing things for yourself! Am I just supposed to just sit around and wait for you to get over this? You're probably just going to turn into your dad anyways. He cheated on your mom, Chas. How do you think that makes me feel? Huh?"

I stare at her with a mix of dumbfounded pain and bafflement. My words explode through my clenched teeth as I lash back at her, "You cheated on me! With Phillip!" My arm waves toward Phillip's motionless body on the other side of the glass.

Claire lets out an exasperated sigh, "Chas, I can't do this anymore."

I step forward and take her hand. She resists and tucks her arms tighter around herself, but I persist. I unwrap the hold she has on herself and pull

her hand close to my heart where it burns with betrayal. "Claire don't say that. Come on. Please. Not now. Not while he's in the hospital. I know it's all gone to shit. But I know we can do this though. I know we can get through this. We can. We can make it through anything. I know we can."

Claire pulls against my grip on her hand, but I refuse to let her go. Emotion wells behind the anxiety on her face. She fights back the tears with her eyes and lips scrunched together toward the shallow breaths escaping her nose. She covers her mouth with her free hand as she speaks, "Chas, please. Just let me go."

My heart sinks down into the bowels of my stomach pulling me down low into hollowness and self-pity. My eyes reach out to Claire, pleading, but she's already gone.

I look through the glass at Phillip and reach for the cold metallic touch of the Saint Christopher pendant hanging from my neck. The machine hooked to Phillip's body churns in rhythmic coordination standing guard between his life and the eternity that lies beyond. I exhale softly.

Her hand slips out from mine. The silky touch of her skin lingers as she turns and walks away. Her hunched shoulders drive her forward down the hallway.

Phillip's mom swings open a doorway to enter the hallway. She greets Claire in passing, but Claire persists forward with only a nod, then turns a corner and disappears. Phillip's mom approaches me with a warm smile. She carries herself with a proper formality juxtaposed against a full-bodied exuberance that reaches out to embrace the world around her. Her eyes sparkle with life and love through puffy tear-stricken eyes and a red nose. Her blond hair holds in place with curls around her head like a soft halo. She observes me kindly, "He's going to be okay, dear. I know he is. He's a fighter."

I fight back the pain languishing inside of me. My head nods in agreement, thankful for the cheerful hope within her. "You're right Mrs. Langston. It's going to be okay. I know it is." Mrs. Langston opens her arms and pulls me close with a comforting hug.

As we pull apart, she raises a finger beneath her eye to wipe away the moisture that threatens to disrupt her makeup. She looks with loving fondness through the glass at her son. "I do worry about you boys though. The three of you were so close." She says looking at me through the reflection in the glass. "Have you grieved Ryan's death?"

My eyes slowly turn to meet her question. She sees through my defensive, rigid exterior with the laser precision of a mother's love. I feel her eyes dig down below the surface into the pain and heartache and turmoil that stirs within me. I know that she sees me, and I know that she understands. No judgment lives behind her eyes as she observes me with compassionate concern. She holds her gaze firm in the face of my suffering, and I feel embraced by unconditional love.

A feeling of peace welcomes me down to the core of my being and invites me in with open arms. The love implores me to give in and give up the fight and let go of the hurt. Warmth grows within me, expanding and expansive. Places inside of me that only remember cold and pain and heartache begin to thaw.

She smiles gently, holding my soul with her eyes. I turn my attention away from her and look inward toward myself. Suddenly, I feel ashamed. Fear, doubt, and judgment slither into my thoughts. The spotlight of her understanding becomes too intense for me to accept. Underneath my clenched jaws and tense exterior, I don't feel worthy of her all-encompassing love.

I exhale deeply and turn again toward the glass. The image of my own face reflects back at me. I see the pain that she saw, but I feel only judgment toward what I see.

LIKE FATHER LIKE SON

Heavy clouds loom dark and full above the towering trees of the quaint neighborhood. Yellow lights glow dimly from the windows of the first rental property that my dad and I purchased together. My hands grip tightly around the steering wheel of my Jeep. Massive tree branches stretch above the roof casting thick shadows onto the property. A real estate sign sways against a gust of wind in the overgrown grass lawn. The sign reads *SOLD.*

I step out of the Jeep and into chill of the wind. Specks of rain drip through the trees as the wind whips through the branches overhead. My arms bundle tighter within my warm all-weather coat and my head drops lower to persevere through the mounting storm. I knock repeatedly on the front door with a closed fist. The door swings open and Tom's presence fills the doorframe. The past two years stands invisibly between us like the repelling force between two magnets.

He greets me with a lukewarm smile, "A little late for a visit, don't you think?"

I look over my shoulder to the *SOLD* sign in the front lawn, "Can we talk? Or not?"

Tom turns his body sideways to let me brush past him into the living room. The door closes behind me. I stand patiently near the cream-colored leather sofa and green reclining chair. Tom eyes me with curiosity. His tall, proud stance appears shorter than when I saw him last. His hair color shows more salt than what once was a pepper heavy mix of black and grey. Bags hang wearily under his eyes. The charm and charisma and vibrancy within his being that I idolized as a child seems dull and beaten down. He gestures toward the couch, "Sit down and take a load off."

I continue to stand, "I'm okay. Thanks."

He grimaces and raises his eyebrows in surprise. He steps into the dining room to approach an antique cherry wood serving station. His voice bounces emotionless off the hardwood flooring throughout the house. "Can I fix you a drink? Crown still your favorite? Like father like son, right?"

"No, not anymore. I just want to talk." I retort, as my nerves begin to dance within me. My heartbeat quickens at the anticipation of what I know must be said.

Liquor sloshes into a cocktail glass. He steps to the kitchen and drops a few ice cubes from the freezer into the whiskey. He saunters into the living room slowly, deliberately, swirling the ice cubes in his drink. Pausing a few feet from me, he sips the whiskey and says, "I don't know what there is to talk about anymore. But let's hear it."

My arms cross as I struggle to reign in the swirling emotions within me. I address him trying to convey no feeling in my words, "So, you sold the house?"

He looks down at me over the rim of his glass as he takes another sip. "It's not sold until it closes, but yes, I accepted an offer on the house. We'll see how things go with their lender."

A wave of relief sweeps through me from the mention of *we*. The comfort in his word of unification doesn't make what I need to say any easier. I start slowly, unsure of myself, "Well, that's good then. I guess that's what I came to talk to you about. I wasn't sure if you already closed on it or not. I was starting to worry you just sold it without me."

Tom jiggles the ice cubes in his glass.

I continue, "But when it does close I was thinking that—I mean, first of all, I really appreciate how things were set up to give me some experience and get me started in real estate. I've learned so much from you along the way."

He watches me in silence with steady eyes above his drink. His prideful expression masks the hint of fear hiding behind his glass.

His silent presence makes me feel uneasy, but I persist, "It's been great, but I just don't think it's working like we planned. I mean, I know the plan was to wait until I graduate college then you'd sign over your half of the ownership equity to me as a graduation present to help me get my life started. But tuition is due again and the fraternity dues are coming up."

He stops me short, "So, what are you saying?"

I look down to the ground then back up at him. I muster my internal strength to project my voice and confront him with confidence, "I feel like we should dissolve our partnership."

The words wash over his features without any sign of impact. He holds his drink steady.

I continue forward, "And sell all five houses. I figure, the equity is around three hundred thousand now, right? We take the money, split the profits and both walk away. And maybe just go back to being Father and son. You know? Everyone just walk away and start over."

He twirls the ice in his drink as words drip from his mouth like venom, "Well, good luck." He tips up the bottom of the glass and swigs the last of the whiskey.

I rock back in my stance, confused, "What do you mean *good luck?*"

Tom turns his back and walks with heavy steps to the dining room. He slams the whiskey glass down on the serving table. An exasperated groan of frustration breaks free from his lungs as his breath deepens. Then he strides back into the room with prideful anger flowing through him. His southern drawl pours words from his mouth like lava from a volcano of deep festering resentment. "Good luck getting any money out of the properties! I refinanced them months ago. All the equity is gone. All of it!"

The impact of his words slices through my pride and sense of self-worth like a saw-toothed razor blade. My fists clench at my sides. My voice rises from low within my chest, "You can't do that! It can't be gone! I didn't agree to that! Where's my half of the profits?"

Frustration and anger clenches within Tom's face demanding expression. He spits his words toward me, "You never had a half. You don't own anything, and I don't owe you anything either! I never did. You kids and your mother, always looking to me with your hands out! *I need I need!* Well what about *me* damn it?"

My pride lashes out, "But my name is on the company! I'm a co-owner!"

Tom shakes his head, "That's where you're wrong. *My name* is on the company. *Mine.* And I'm the one who gave you *my name.* Charles Thomas Allen. I'm the one who built this! I'm the one who gave you everything! Hell, I gave you life! Isn't that enough? I put the clothes on your back and the food in your stomach for the last eighteen years. Almost nineteen now! And this is the gratitude that you have to show for it!"

I fight to hold back the pain rising to the surface. My throat feels thick, "My name is Charles Thomas Allen II. It's my name too. And it's my name on the properties. Fifty percent. Dad you promised me. You promised that we're partners in this."

He stares back at me, searching for something. I show him only stone-faced resistance and opposition to his choices. He breaks his stare and looks away. His frustration hangs thick in the space between us as he shouts, "Well it's gone! You're not my partner... You never were! You're my son! And you should show some damn appreciation for the life you have thanks to me! I did what I could to give you a leg up, but things changed! Deal with it."

The weight of his words crumbles me down to nothing. I feel shattered, helpless, hopeless, betrayed, and ashamed at my own blind faith.

Everything that I trust and hold to be true rushes to the forefront of my thoughts and demands a new label—*Liar! Cheater! Thief!*

He exhales sharply, "You sided with your mom and you wanted to take it all away from me, so I did what I had to do to survive. That's just business! So get over it!"

A hollow feeling expands within my chest as my fists unclench by my sides, "I built my life on this dream, Dad. This is everything to me. I turned down scholarships and stayed in town to grow in this business. You promised me that you would sign your ownership over to me when I graduate. You promised."

The fight fades from his features. His words reach out to me like outstretched arms, "You're not entitled to anything in this world, son. You have to work for it and earn it on your own. But you're only nineteen! You have your whole life ahead of you. Be a kid and enjoy college. You'll make your own success one day. And I'll be here to help you along the way. You're my son and as long as I'm doing okay, you'll have a roof over your head and food to eat."

My pride flares like a roaring flame seeking to devour everything in its path, "I don't want your fucking leftovers! I worked for this and you stole it from me! I wish I wasn't your son!" I turn my back on him and rush to the door stepping into the dark and cold of the storm slamming the door on him behind me. Rain whips through the branches of the trees looming overhead and the water pelts down against me. My feet slosh in the matted and muddy earth of the front lawn. The *SOLD* sign flails in the powerful gusts of the storm.

The clouds overhead gather in two billowing masses and explode with electrifying natural force. Lightning strikes, a white-hot bolt streaks furiously across the sky. The force of nature illuminates the darkness on outstretched limbs, clawing for expression, stretching toward existence. The

bolt lashes forward without aim. The energy searches for a polarizing connection to ground itself. To restore balance. To destroy anything and everything in its path.

COUNT ME IN

The rickety set of wooden stairs creak with each step as I descend into Devon's room in the unfinished basement. I push a hanging pink bed sheet to the side and enter his hideout. A thin fog of marijuana smoke fills the air. Devon, Luke, and Ethan lounge in armchairs around the coffee table. They lazily turn their heads to greet me.

I plop down in a tangerine armchair beside Luke, "Fuck it. I'm in."

Devon and Luke lean to the edge of their seats. A broad toothed grin flashes across Devon's face and his eyes light up with excitement, "Wait, you're in? Like, you're in?"

I meet his question with a subtle nod in agreement, "Yep, count me in. Fuck it, let's do it."

Devon jumps to his feet and wraps his arms around me for a hug, "I told you! I knew you'd change your mind!" He dances a little jig above a soccer ball as Luke and Ethan reach out to me for quick one-shouldered hugs, officially accepting me into the fold.

I hold a pointed finger in the air and speak with conviction, "But. If we are going to do this, we are going to do it right."

Luke leans back in his chair like a seasoned Mafioso boss, "Of course, we're going to do it right. We all know what's at stake here, Chas. You're the one who needs to catch up. We've already been working on this for over a year."

My words cut across the short distance between us, "From what you've told me so far it sounds like you guys have been wasting your time."

Luke glares at me as Devon diverts our attention by flailing his arms above the coffee table, "That's okay! We're all in this together now! We can work it out. Whatever we need to do, that's what we'll do! We can make anything work for three million apiece, huh, boys? Am I right, or am I right?" He bounces his eyebrows above his grinning face like an excitable professional wrestler about to deliver his coup de gras.

Ethan clears his throat, and then interjects, "Let's show him the plans."

Devon snaps his fingers, "Right! Great idea Eth!" He scavenges an area of the basement near his bed sheet enshrouded mattress. He returns and drops a stack of papers onto the coffee table.

Luke shoulders forward to the edge of his seat to hunch over the plans. He scratches the stubble on his chin as he observes the strewn about papers, "You'll see we've made some changes, Chas. Devon, why don't you run him through it from the top?"

Devon stands with one foot propped on the coffee table like a ship captain navigating the high seas. He messily shuffles through the stack of papers on the coffee table and then hammers down a bony finger next to a crude drawing of a car. "The four of us start here. At the GTAV, the get to and away vehicle. We park in the horseshoe-shaped parking lot at the front of Transy's campus. All four of us enter the building wearing disguises. Ethan, how are you coming with the disguises?"

Ethan lifts a nonchalant shoulder toward his ear.

Devon claps his hands together in excitement, "Come on, Eth! We're talking about millions of dollars here! Twelve. Million. Dollars. Where's the excitement, huh?"

Ethan nonchalantly crosses a foot over his knee. His foot bounces with jitters, "I've been reading a few books about stage makeup in the library."

Devon cheers with excitement, "There we go! That's what we're talking about! You're an artistic genius, Eth. I know they're going to be brilliant.

Brilliant!" He refocuses the telling of his story in my direction. A single light bulb hangs from the exposed ceiling beams above Devon's head. The lone light casts long shadows across his animated face as he speaks, "The four of us enter the library together wearing disguises. We pass through the library undetected, thanks to Ethan's artistic wizardry, and make it to the spiral staircase. That leads us up to the special collections room. Anita Boner enters the security code, then bam we're in the room. We take her down hard and fast."

I interrupt Devon's recitation of the plan, "Hold on a second. You said to take her down hard and fast? Take who down? The librarian?"

Devon appears unfazed by the question, "Yeah, so just hear me out here. We have to make certain sacrifices if we're going to pull this off. Right guys?" He diverts his attention to Luke and Ethan for support.

Luke takes Devon's cue to chime in and speaks with a soft and reassuring tone, "Chas, we're talking about stealing a collection of paintings that a black-market buyer is already willing to pay twelve million dollars for. We just got to get these four books. And yeah, we gotta make some hard choices. I don't want to take this woman down any more than you do. But if it's what we got to do to make it happen..."

Devon jumps at the opportunity to continue Luke's thought with intensified fervor, "Right. We got to do what we got to do to get ahead in this world. And if that means taking this librarian down, then that's what we're going to do." He watches my face for a reaction, but I hide my true feelings behind a blank expression. Devon continues, "No real security system protects these books. It's just one woman, and she's in the way. So, we're going to take her out of the picture; however we have to. The faster, the better. We do that, then we load up the four Audubon books into our backpacks. We get the elevator key from Boner. Take the elevator down to the first floor. Hurry through the library and get out to the GTAV. Then we're home free! All we have to do after that is to make the swap with the

Amsterdam buyer. And then we're twelve million dollars richer!" Devon stands in anticipation expecting a round of applause.

I wave a hand in the air to clear the marijuana smoke clouding the space between us, "Hold on. Hold on. So, you're planning to run out through the whole library? Without anyone chasing you? And you think you can do that carrying all of these books? Aren't they heavy?"

Luke brushes the question aside, "They're heavy, but we can handle it."

I shake my head unconvinced, "What about the car? What are you planning on driving as the, what did you call it? The GTAV?"

Devon grows impatient with my questions, "The get to and away vehicle. I saw it in a heist movie once. But who cares? The car's a minor detail. We'll steal one for the day if we need to."

My head rocks back in surprise, "Just steal a car for the day? Are you insane?"

Luke cuts a sideways glance in my direction and scoffs, "Come on, Chas. Are you in or not? You said it yourself. If we're going to do this, we've got to do it right? So then if you're in, you got to be all the way in, like we already are. We're willing to do whatever it takes. Are you? Can you handle this?"

I sit back in my chair as my pride rises within my chest. I stare blankly back at Luke, then turn to both Devon and Ethan in turn, refusing to appear weak in front of them. My words spill from my mouth without emotion, "You know, I just don't really care what happens anymore. If we do this thing together, I know things will be different after that. One way or another." Silence hangs heavy in the space between the four of us.

Devon prods me forward with a wave of his hand, "So…"

I lean in, "So, okay… Let's get to work."

PICTURE PERFECT

The autumn air bites with a brisk chill as I step out of my Jeep. A dreary layer of grey clouds hangs low in the afternoon sky. I tuck my hands down into my Columbia jacket pockets and tilt a baseball cap brim down against the coming wind. My white Air Max sneakers glide across the smooth concrete campus walkways with forced ease. Underneath my outward casual exterior my heart races with exhilaration.

A flourishing red rose garden rises proudly into the sculpted shape of the letter T amidst the well-manicured lawn. Standing on the campus grounds feels both historical and bustling with modernity. The red brick and ivory architecture speaks of generations past, of prowess, and of stately refinement. From what Ethan tells me, I know the university dates back to the 1700's as the first school for higher education in Kentucky and as one of the oldest universities in the entire country. The campus now pulses with activity as students and faculty stride along the pristine pathways, presumably between classes.

A grand staircase climbs upward to my left from the horseshoe parking lot. Four massive ivory pillars stand in support of a towering awning above the entrance to the Beck Center, a gigantic three-story red brick building. I climb the steps and nestle into a seat amidst the cold concrete staircase. From the heightened vantage point, I see students and faculty pulsing through the heart of campus, each going about their own business for the day. I settle into my vantage point, feeling like James Bond on a reconnaissance mission, and begin my own business for the day.

I withdraw a digital camera from the breast pocket in the lining of my jacket. I focus the lens beyond the green lawn inside of the horseshoe-shaped parking lot to the Gay/Thomas Library building. The grand structure stretches a high ceilinged three stories tall. Sizeable rectangular glass pane windows add relief to the imposing red brick building. Occa-

sional streaks of sunlight shine down through the veil of clouds overhead and stream freely through the windows. I snap a picture of the building.

Click.

A four-story red brick building towers to my left, the Haupt Humanities building. A white bell tower perched high atop the building as rolling grey clouds loom beyond.

Click.

The camera scans across campus, observing the number of parking spaces in the lot. The lack of available spaces can prove to be a problem.

Click.

Multiple handicap parking spaces remain empty near the library entrance.

Click.

Concrete pathways lead the flow of students and faculty who walk between the three colossal campus buildings. Possible on foot escape routes.

Click.

The camera lens sets sight on three windows of the library building third floor. Behind the unassuming glass windows and billowing ivory curtains lies the Special Collections Room. According to Ethan and Devon, the room houses millions of dollars worth of rare books and paintings.

Click.

Positioned near the roofline of the library building, I notice the dark tinted sphere of a bird's eye security camera mounted on the corner of the red brick building.

Click.

Another bird's eye security camera hangs from the red brick wall above the main entrance to the library. I aim my camera lens at the wall of sliding automatic glass entry and exit doors.

Click.

A landing beyond the entrance, followed by a set of stairs, spills down into the horseshoe-shaped parking lot. A possible escape route from the library.

Click.

Satisfied with my reconnaissance, I stand from my seat on the cold cement staircase to change my perspective. I stroll down the stairs toward North Broadway. Cars whip past me as the autumn breeze in the wake of the speeding vehicles cuts through my jacket with icy fingers forecasting winter's approach. I pause near the road and observe Transylvania's campus. My grandfather once walked the hallways of this prestigious school and graduated with a doctorate degree. I feel at odds with my own stirring emotions. A sense of pride wells within me, but also something unsettled, and darker.

I feel an instant connection to the grandiose history stretching with immensity before me. The honor and tradition of the school date back to the earliest days of American History. From my own ancestor's family folklore, I know my ancestry dates back to the American Revolution all the way back to the original settlers voyage alongside the Mayflower. My ancestors carried on through the generations to amass thousands of acres of land and become prominent business proprietors in Kentucky's early days.

Growing up with the family folklore of grandiosity empowers my own ideas of what my life and future and legacy should look like, should be. I even feel an air of entitlement, as if the world owes me a birthright and I expect to be paid in full.

Yet as I stand on the green lawn and pristine pavement of Transylvania's campus, I feel disconnected from my heritage. I feel cut off from and unwelcome by the promise of privilege that stands in red brick buildings towering before me, but no longer seems to be for me. I feel cheated and

betrayed by my own hopes for a future worth living and a legacy worth continuing. Heat rises through me, and my face flushes hot. The cold breeze bites against my cheeks as I look out over Transylvania and clamp my jaw down against the pain from the heat and the numb ache from the cold.

I envision a fire among the rose bushes. Small at first and kindled to life with great care and only a single spark. I envision the fire growing, consuming the bushes, and devouring the bright red roses. The wind blows and fans the flames like a wildfire. The lawn bursts into flames and the fire stretches its rosy hands far and wide. The fire grabs hold of the buildings and climbs the walls. The burning flames lick against the ancient red bricks, and the mortar begins to melt as the flames climb higher. The fire grows massive like an unleashed inferno and the ivory white tower atop the Humanities building chars into black as ashes rise on the wind. The fire reaches upward as if shaking a righteous hand of fury, triumphant toward the clouds above. The towering buildings crumble brick by brick down into rubble and back into ashes and dirt.

The cold wind cuts through my jacket and stirs me back to reality. There is no fire. There are no flames. But a heat still stirs within me. I resume my task of playing James Bond. I notice a small door facing North Broadway. An emergency exit sign hangs above the single frame doorway. Empty handicap parking spaces lay a mere stone's throw away from the emergency exit door.

The perfect escape route.

Click.

TESTING

10:59 AM.

I sit behind the wheel of my parked Jeep in the Transylvania parking lot. Luke checks the clock on the dash and leans forward in the passenger seat. My eyes strain across the lawn toward the library building.

Backpack totting students walk through the campus pathways with their eyes glued to the phones in their hands. The campus seems to pulse at an unhurried, but steady pace. Cars crawl past the parking lot in traffic on North Broadway. The school appears no different than any other days during stakeouts.

An emergency exit door swings open for the library building. An alarm sounds from within the massive red brick building. I check my phone.

11:00.

Ethan emerges through the emergency fire door. He allows the door to swing shut behind him. Ethan walks a few steps forward and quickly returns to the pristine campus pathways as if nothing happened. He stuffs his hands in his pockets and ducks his head low against the cold of the afternoon. The alarm siren wails for attention. The campus continues to pulse at the same slow, uncaring pace.

11:01.

I turn to Luke, "One minute."

A car honks in the stalled stream of traffic on North Broadway. Two students exit the library main entrance walking side-by-side, heavily engrossed in conversation. They don't seem bothered in the least by the wailing of the alarm bell.

11:02.

Luke shrugs his shoulders and turns to me, "Maybe no one's coming this time."

"No, they'll be here."

We watch and scan the campus for any signs of security. Straining our

ears through the open windows of my Jeep for the distant sound of police or fire sirens wailing in response.

We see no hurry and no change in the pace of anyone on campus. The students, the teachers, and the faculty who walk by don't seem to care.

11:06.

A man hustles around the corner of the humanities building. We recognize the dark-skinned security guard from earlier trial runs. He wears the dark navy uniform and hat of campus security as he walks briskly toward the library building. No weapons hang from his black belt other than a single canister of mace. He walks as if expected to move with haste, but the casual look on his face shows little concern for whatever tripped the alarm this time.

I point the man out to Luke, as he watches the man enter through sliding doors of the library, "Check it out, it's James this time. Eleven o' six. It took six minutes to respond! Six minutes after the alarm."

Luke chuckles and reclines in his seat, "That's even slower than last time."

I shift the transmission to reverse, "Let's rerun the escape route."

Luke straps his seatbelt across his chest, "Think you can do it under a minute this time?"

THE SPECIAL COLLECTIONS ROOM

The brim of my hat conceals my face from the camera looking down on me as I approach the Transylvania library main entrance. Devon walks beside me. He lowers his chin and scratches the long scruffy brown hair on his head to obscure his face. We pass through the sliding glass doors of the entryway and stroll through the metal detectors without pause.

The smell of aging paper, oak shelves, and the well-worn fabric of school carpeting lend a comforting and homey feel to the inside of the library. A redheaded student with freckles and a welcoming smile nods to us behind the information desk. Devon and I politely return the smile and make a sharp right turn toward the Special Collections Room. We walk with purpose in our stride as we pass rows of tall bookshelves. Our eyes dart from corner to corner within the expansive room. Studying our surroundings as if we are cramming for the test of our lives. The two of us pass by students who study in silence or listen to headphones plugged into their ears as they sit at oak tables and chairs with books spread before them.

Devon and I reach a broad spiral walkway. We apprehensively ascend upward until we reach a glass door set inside of a glass wall. Beyond the glass, we observe a small sparsely furnished meeting area. An oak table surrounded by eight chairs neatly abuts the glass wall overlooking the spiral walkway. An open book sits perched atop an oak bookstand near the door. Two massive mahogany doors with ornately carved inlays and arched tops that curve toward the ceiling dominate the tiny meeting room and block the doorway leading into the Special Collections Room.

I lift my eyebrows and slant my gaze toward Devon, "You ready for this?"

A crooked smile turns up one corner of Devon's mouth as he pushes his shaggy hair away from his eyes, "I was born ready."

Devon and I simultaneously wrap our knuckles against the glass door. A woman appears from around a corner beyond the meeting area. She wears a tweed jacket and a modest burgundy skirt well past her knees. Closed toe brown loafers and tan stockings cover her feet and lower legs. Her brown hair tied back in a short ponytail highlighted with streaks of grey. Rectangular purple-rimmed glasses rest atop the bridge of her nose, and a thin gold chain extends from the arms of the glasses down behind

her neck. She greets us with kind eyes that gather in wrinkles near the edges and offers a quick wave as she approaches the door. She pauses on the other side of the glass and observes us, "Hello. Do you have an appointment?"

I wave kindly with a slight nod of my head, "Hi, ma'am. Are you Mrs. Bonner? Yes, the art department scheduled a visit. I'm Ethan."

A puzzled expression furrows her brow, "I was only expecting one visitor."

"Yes, ma'am. This is my friend. I hope you don't mind him coming along with me today?"

Her lips purse into a thin line and wrinkles cluster at the corners of her scowl, "I suppose that's alright." She lowers her glasses and peers into the small security system near the door. She punches a few keys to disarm the system then turns a key in the lock of the glass door. The door swings open. She waves a tweed-covered arm toward the bookstand, "Sign in to the log book, please."

Devon shoots a smirk of victory in my direction as she turns her back to us. I scribble Ethan's name into the logbook. Devon scrawls an illegible moniker onto the pages.

Mrs. Bonner swings open one of the large mahogany doors.

"Feel free to browse as you like, but I ask that you, please do not touch any of the collections. If you would like a closer look at anything, please let me know."

She enters the Special Collections Room and Devon, and I slip into the room behind her.

Light spills through the high mounted windows along the back wall and illuminates glass display cases proudly positioned in the central space of the room. Opulent paintings of various landscapes adorn the walls of glass-enclosed bookshelves. A colossal cherry wood cabinet occupies a sig-

nificant portion of the far-left wall. A colorful painting of a bird in flight hangs above the cabinet.

Mrs. Bonner beams with adoration as she guides us through the room, "We have been fortunate over the years to amass quite a collection. Our alumni program offers endowments for the arts, which as an artist yourself I'm sure you can appreciate."

I smile softly, "Yes, ma'am."

"We receive visitors traveling from all over the country and even internationally to view our special collections. Especially from the ornithological society. Our Audubon collection is considered one of the most prized collections in the world."

Devon coughs, "Really? Can we see it?"

Mrs. Bonner withdraws a keychain from her waistband, "We had this cabinet specially built for the Birds of America collection." She slides open a drawer from the cherry wood cabinet. A metal casing covers the top of the drawer. She inserts a key into a lock and folds the metal casing back to expose a massive leather-bound elephant folio. She turns open the enormous cover of the book to showcase the artwork contained within the pages. A long-billed bird cranes its black-feathered neck toward the sky.

"Isn't it absolutely stunning?" Mrs. Bonner allows Devon and I to admire the artwork from a distance over her shoulder as she huddles close to its pages.

I smile politely, "It is. It really is."

She carefully flips to the next page, then to the next again.

I turn away from the pages in the Audubon book and scan the walls of the room, searching for cameras. No cameras. No security. Nothing, other than a librarian and her keychain.

Devon points his finger toward the other side of the room to divert Mrs. Bonner's attention away from the Audubon books near where she

lingers crouched beside them. "What are these books in the display cases?"

She turns her head and cranes her neck, not unlike the blackbird of Audubon's painting. "I believe you are referring to our medical dictionaries that once were housed in the private library of Thomas Jefferson."

Devon urges me with his eyes to lift the Audubon book. I cut my eyes back toward him insisting no, returning a gesture of my own down to where Mrs. Bonner hovers beside the Audubon books. He implores me again as he steps toward the glass display case across the room, gaining Mrs. Bonner's complete attention.

I slide my hand under the corner of the leather binding of the elephant folio. Hefting the edge of the book, the book feels much more substantial than expected. One corner lifts as the other three corners slump laboriously within the cabinet drawer. Mrs. Bonner turns her attention back toward the prized Audubon books and I quickly slide my hand out from under the edge of the elephant folio, barely avoiding her watchful eyes. I step toward the glass display case where Devon stands.

Over my shoulder I see Mrs. Bonner observe us warmly.

"It's such a breath of fresh air to see young men such as yourselves interested in history and the arts."

Devon leads her deeper into the room toward another glass display case, "Thank you, ma'am. We appreciate you taking the time to give us the tour. We do appreciate the value that art can bring." Devon rolls his eyes away from Mrs. Bonner's gaze and smirks in my direction.

I follow up his sentiment.

"Yes, Mrs. Bonner, it means a lot, thank you."

Excited to showcase more of her collection, Ms. Bonner leads us deeper into the Special Collections room. While her back is turned, Devon and I ravenously scour the details of our surroundings.

No locks on the windows.

No security cameras.

No locks on the glass display cases.

No locks on the glass bookshelves.

Locked cabinets for the Audubon collection.

A keychain jingles at Mrs. Bonner's waist as she walks.

Having seen enough, I clear my throat to regain Mrs. Bonner's attention, "I wish we could stay longer, but we should get going now. Thank you, again."

Mrs. Bonner glances at me over the rim of her purple horn-rimmed glasses with disappointment, "Are you sure you wouldn't like to see more? I would be happy to show you."

"No, ma'am. We really appreciate it, but I have an assignment that I have to finish."

She unenthusiastically leads Devon and me through the grand mahogany doors to exit the Special Collections Room. We step into the small foyer, and Mrs. Bonner closes the heavy doors behind us like the gates of Eden.

I notice a short hallway to the right side of the glass wall that overlooks the spiral staircase down to the main floor of the library. At the end of the hall stands an elevator. The elevator has no button, only a key lock on an access panel. I tap Devon on the shoulder and nudge his eyes toward the elevator with my own.

A smirk lifts one corner of his mouth. He turns to Mrs. Bonner as she punches in the security code to show us out of the locked room and his smirk bends into a smile. "Thank you for all you've shown us today. Your tour was even more informative than we hoped."

OLD MEN

Ethan's hand hovers in front of my face holding a paintbrush. He flicks his wrist with precision adding the next layer of make-up to my disguise. A mask made from facial putty, attached to a bald cap, molds to the contours of my face and head. Artificial grey and black hairs weave into the thick layers of facial putty to form a beard along my jawline and around my mouth. Eyebrows gather above my eyes, and a thin strip of hair covers the side of my otherwise bald-capped dome.

Ethan leans his head back and maps my face with his eyes to glean the natural progression of wrinkle lines on my face. He gathers much of his attention on the worry lines of my forehead, the marks of troubled thoughts bunched near my brow, and the bags of restlessness under my eyes. "Close your eyes," he says.

I shut my eyes and the paintbrush flitters under and around my eyelids.

Ethan pulls the paintbrush away from my masked face and steps back to admire his work. "Not bad. Let this coat dry. Maybe one or two more coats and it should be good."

I open my eyes to see Devon and Luke wearing masks of their own in front of me. Their faces sag with age and line with deeply entrenched wrinkles cut into their skin like the ravages of time. Luke's scowl lines stretch down around the corners of his mouth under partial cover of a fake grey-haired handlebar mustache. Devon's eyes crinkle with crow's feet and layer with laugh lines. Ethan wears no mask while he works. His now clean-shaven face looks naked and strange without the mustache for him to twirl.

Devon and Luke lean close to my face to inspect Ethan's artistry. Devon's fictitious elderly eyes light up with joy, "Eth you're a genius! Absolutely brilliant! I knew it! I told you. Didn't I tell you?"

Ethan shyly brushes the compliment aside with a demure smile like a swift stroke on a canvas.

Devon snaps his fingers and shoots a pointed finger into the air, "Ah! Almost forgot." He steps over the coffee table of his basement hideout sitting area.

Luke notices Devon's sudden movement from his seat in one of the tangerine armchairs and lunges an arm out toward Devon. "Did you forget these?" Luke quips.

He backhand swat smacks Devon in the groin, "Watch your nuts, old man!"

Devon topples over the coffee table and doubles over in pain onto the floor. His moans of pain blend with waves of wild laughter. Devon shakes his fist in playful rage. "You bastard! Bollocks, you got me good!" He leaps to his feet and springs across the room, still holding his groin. He hefts a brown cardboard box and drops it onto the coffee table. Looking through the eyeholes of his old man mask he waits for our reactions, then pops open the box top.

Beneath layers of bubble wrap, Devon withdraws a black heavy-duty stun gun. The handle forms in the shape of a thick handgrip. Two metal prongs protrude violently from the top of the device. Devon flips a switch. A blue bolt of electricity crackles like hot bacon on a stove between the two prongs. He watches the bolt crackle. A devious grin curls at the corner of Devon's mouth as he lunges the bolt in his hand toward Luke.

Luke leaps out of his seat and jumps back behind the armchair, "Hey! What the fuck, asshole?"

A maniacal smile stretches across Devon's face, "How do you like it now, Luke? How about I zap those nuts? Huh?" He steps menacingly toward Luke with electricity arcing in front of him. They square off like

two old men in a western with their hands out to their sides, each ready to make a move.

Luke walks backward carefully, the handlebar mustache of his mask glowering with a scowl. "Devon, stop fucking around!"

Devon cackles wildly with pleasure and Luke makes a leap for safety. He jumps over the coffee table, but Devon leaps forward like a crazy old man gone mad with vengeance. He leaps over the coffee table and lunges at Luke with the Taser. Luke dodges the bolt of electricity and ducks behind an armchair. Devon hurries around the tangerine chair flailing the Taser in front of him, hoping to catch Luke, but he scrambles away knocking the tangerine chair down to the floor to block Devon's path. Devon races after him with wide eyes flashing with laughter and the madness of the chase. Then he runs toward me. The bolt of electricity crackles dangerously in front of him.

I jump over the coffee table to distance myself from Devon's madness. I hold my hands out in front of me and shout at him, "Hey! Don't you fucking do it! I'm warning you!"

Devon pauses on the other side of the coffee table waving the stun gun in the air. He flicks the switch again, and the bolt jumps to life with sound and fury of violence. "Ahh, come on! Have some fun. Don't be pussies! Let me tase you! It's not bad, I swear. Here, look. You can even tase me." He holds the stun gun in my direction above the coffee table. I hesitantly reach my hand toward the Taser. Devon flicks the prongs to life and flashes the bolt of electricity. He smiles then shuts off the power.

I take the stun gun from Devon's hand. The stun gun reads, "500,000 Volts" near the prongs and "Police Grade Non-Lethal Deterrent." "You sure about this? This thing looks heavy-duty." I ask.

Devon rolls up his sleeve as he steps around the coffee table, "They did it on Jackass. If Steve-O can do it how bad can it be?"

I flick the bolt of electricity to life. It sparks and crackles in a thin blue arc between the prongs. I turn to Luke and Ethan to make sure they agree with what's about to happen. Their faces light with anticipation and urge me forward. Devon breathes deeply in front of me, relishing the anticipation of pain and torment about to be inflicted on him. I press the stun gun forward and touch the blue arc to Devon's shoulder.

His eyes roll back in his head. Pain contorts his masked face. His body tenses violently then he drops like a bag of meat onto the basement floor. He twitches and convulses, writhing with electricity coursing through his body. I drop the taser onto the coffee table and lunge down to the floor near Devon's body. Luke and Ethan lean close to where he lies.

Devon's eyes snap open, and he screams victorious from the thrill of the shock, "Woohoo! That's my mama! That's what I'm talking about!" He does a martial arts worthy flip from his back onto his feet. "What a rush! Who's next? Come on, boys. Don't be scared!"

Ethan inspects the stun gun on the coffee table. "Guys, did we got four of these?"

Devon strides toward the open box, "Check it out, Eth! There's one with your name on it too."

Ethan grips the handle of the stun gun, and then places it back on the coffee table, "I don't want one."

Devon's masked face contorts with surprise, "Eth, it's too late to be backing out now. Fourth periods over! We're in PK's now!"

"I'm not backing out. This is too much though. It says 500,000 volts. What if something happens to Mrs. Bonner?"

Laughter sputters from Devon's masked mouth. "Like what? What could possibly happen to the big Boner? Have you seen these things? It says police grade! Non-lethal! If the cops can use it so can we!" He points to the label on the Taser touting the police grade rating.

I gently wrestle the stun gun from Devon's hand, "Did you not see yourself just now, Devon? I barely touched you with this thing, and you dropped onto the floor in convulsions! What if this woman has a heart attack?"

"She won't have a heart attack. At least, I hope not..."

Luke lifts another Taser from the box. He pulls the trigger and observes the arc of blue lightning crackling between the four prongs, "I'm all for doing whatever we got to do, but I agree. There has to be another way."

Devon shakes his head in disgust, "Boys we don't have to use them. They're only for emergencies. And what, are you telling me you're all too scared to use it if we have to?"

I pull the trigger on the stun gun in my hand. The blue bolt arcs to life. "This is a bad idea, Devon. Look, we're all in, but Luke's right. This isn't the way. Just use zip ties if you have to. She'll cooperate. The point is to get the books and get out. That's all."

Luke seconds my suggestion, "Yeah, I like the sound of that way better. Zip ties. We can cuff her hands and feet. We can even put a toboggan over her eyes like they do in the movies. That way she won't see shit either."

Devon doesn't seem convinced. He assesses each of our faces in turn and then waves a hand dismissively about the whole concept. Then he regains his vigor and excitement as he strides toward the coffee table. "Whatever. Sure, zip ties. It will be all four of us in the room together, so maybe we won't even need the Tasers."

I scoff at Devon's statement from behind my mask, "I'm not going into the room. I went once to scope it out, that's it."

Devon, Luke, and Ethan all turn to glare at me in surprise.

I repeat myself, "What? I'm not going into the room. It's stupid. She's seen me, and I'm not going back in there, even with the mask! We need a lookout and a driver. That's the only way we're getting away with this.

We can't all go in, and I don't care who does go, but I'm telling you right now it's not going to be me."

Devon smirks in disgust, and then changes his wrinkled masked face to empathy, "I know you're new to this heist, Mr. Pink."

Ethan and Luke chuckle as Devon continues, "But all four of us are going in the room. That's the deal. That's the way we all agreed to do it. Right guys?"

Ethan and Luke both agree in harmony. Luke takes over the conversation from Devon, "Chas, you said it yourself. The books are heavy. Too heavy to carry by ourselves. We already tried bringing a fifth person in. Phillip said no, so we've only got the four of us. And you were in the library months ago. You'll be impossible for her to recognize. I'm with Devon on this. We all need to be in there together." Luke crosses his arms.

I cross my arms in response. I look to each of them. They stand close together in solidarity and purpose. I feel like I'm jockeying for position against them in a race to avoid an approaching cliff.

I don't respond. I hover above the coffee table and peer into the depths of the cardboard box. I withdraw a key ring filled with jigsaw shaped keys. The ring contains dozens of variations and sizes each designed to fit into car locks for grand theft auto. I drop the keys onto the table. A small machine with a microscope, black light, highlighter, and a money counter rests at the bottom of the box. I remove the counterfeit money scanner from the box and place it on the table.

I make a sucking noise with the air between my teeth, stalling before I respond. Observe the tools of a criminal laid out before me, I look out through the eyeholes of my mask and to my friends hiding behind disguises of their own. Bed sheets drape from the exposed ceiling beams of the unfinished basement home that I once owned and now only dwell within, living in hiding and in fear of an uncertain future. I hate what I

see. I hate what I feel. I hate what I have become. I hate everything, and I want everything to change.

Everything.

I lift my bald-capped and masked head with resolve, "Fine. I'll go into the building, but I'm not going in the room. We leave the car running, and we don't steal a car. We can come up with a better plan. And we're not using the stun guns either."

Luke nods his head in agreement and claps me on the back.

"I'll help with the car."

Devon's wrinkled face crinkles with delight.

"Then we're all agreed?" He asks.

Ethan, Devon, Luke, and I all look into each other's eyes that hide behind our masks. We nod our heads in agreement, sizing up one another for the tasks still ahead and wondering where this path will lead us. We share a mutual knowing that together we are irrevocably shaping our futures and binding our fates. For a brief moment, we are, as they say, thicker than thieves.

I extend an open palm across the coffee table toward Devon. He greets my open palm with a firm handshake.

I look him in the eyes, and we share a smile, "Set the appointment."

EARLY ONSET DEMENTIA

Four young men, disguised as old men, hobble across the winter-frosted lawn of Transylvania University. We each hide behind our individually molded facial putty masks, bald caps, and stained thrift store tweed suits, dress shoes, and wool brimmed hats. Leather gloves that were stolen from a department store warm our fingers against the biting cold. Luke's light

green SUV idles in a parking space on the opposite side of the horseshoe parking lot from the library. A falsified temporary license plate hangs in the rear window, and the brackets where his license plate should attach sits bare.

Our geriatric disguised foursome ambles across the campus lawn like a posse in a slow-motion film scene. We each stroll with our own personalized limp or ailment that slows our pace to an embarrassing crawl. Each hobbled step that we take across the frostbitten lawn brings us closer to the library and to a reality we're in no hurry to reach.

Steam rises like a cloud of fog from my breath as I whisper from behind my mask, "We parked too far away. This isn't going to work."

Devon strides forward to the head of our pack with a remarkable fake limp. "We have to do it now. It's finals week. This is our only chance."

Luke catches my arm with a gloved hand, "Chas, did you cut the alarm on the emergency exit?"

"Yeah, I told you it's good. But don't use my name anymore."

"My bad."

Ethan breathes warm air into his gloved hands as he speaks, "What's everyone's codename again?"

Devon glares over his shoulder at Ethan, "Come on, Eth! Don't tell me you don't know the names!"

Ethan laughs nervously, "Just kidding."

The four of us exit the campus lawn, and our thrift store dress shoes clack against the parking lot pavement. We amble up the cement steps of the main entrance to the library building. I tuck the brim of my hat low as we hobble through the sliding glass doors. A gust of warm air greets us, smelling of aged paper, cheap carpet, and wooden furniture.

We make a quick right turn, avoiding the information desk near the

entrance, and stroll toward the spiral staircase that leads to the Special Collections Room. Several students glance up from the pages of their schoolbooks and observe us—four men in cheap tweed suits walking side by side with bizarre limps—with curiosity. I feel their eyes lingering on us as we continue forward. The approaching staircase to the Special Collections room feels a thousand yards away.

A tall, high-cheeked blonde walks toward us. The girl carries books idly at her hips as she approaches. I make eye contact with her and her eyes widen in shock as she observes my wrinkled, masked face. She veers nearer to us for a closer look and a hint of laughter dances across the features of her face.

Instinctively, I veer further right. Like a pack of birds in flight, the others follow the pattern and make a hard right. We slip behind a short bookshelf and collectively duck our heads below the shelf to avoid the judgment of the girl's eyes.

I cover my masked face with a gloved hand as I whisper, "These masks aren't working. Bonner is never going to open the door. This isn't going to work. We need to fall back."

Devon ignores me and strides out from behind the bookshelf and into the open of the library. Ethan follows Devon's cue. Devon whispers over his shoulder, prodding us forward, "Mr. Black, Mr. Pink, come on. Our appointment is waiting."

Luke and I make brief eye contact. He looks to me with desperation in his eyes, and I assume my own emotions reflect the same back to him. I drop my chin to hide beneath the brim of my hat and step forward.

The four of us enter the spiral staircase on wobbly legs. We all hesitate, not wanting to take the next step up toward the glass wall that awaits us. I want to turn back, to call it off, but I don't want to be seen as a coward in front of my friends. I sense they feel the same way, but we each place one

hesitant step forward followed by the next, emboldened by the actions of our friends walking beside us. We steadily climb higher on the staircase as my heart pounds within my chest. Then we curve around the first bend of the stairs. The glass wall looms above us, and beyond the wall, an oak table and chairs abut the glass. Four women sit at the table engrossed in conversation.

I freeze. Devon, Luke, and Ethan instinctively freeze too.

Devon hurries me forward in a hushed tone, "What are you doing? Come on!"

I grit my teeth and stand my ground, "Are you fucking stupid? Look!" I wave my gloved hand toward the meeting-taking place beyond the glass wall. "We didn't plan for this! There's too many. We have to get out of here."

Ethan and Luke look back and forth between Devon and I then up to the women gathered around the table above us.

Devon hisses at me, "Face it! This is happening. Whether you like it or not!" He marches higher up the spiral walkway.

One of the women at the table notices Devon's approach. A quizzical expression clouds her face, then a smile. She nudges the woman sitting next to her. I take a step down the walkway. All the women at the table turn their heads toward Devon. They glance further down the spiral walkway to Luke, Ethan and I huddled together. One of the women points at us and laughs. Mrs. Bonner stands from the table. She walks toward the glass door to meet Devon.

I frantically whisper to Devon and will him back down the walkway, "We have to leave! Now! Don't do this! Let's go!"

Devon takes another step toward the door then pauses.

I nudge Luke and then Ethan, "Guys! Come on! We have to get out of here!"

They hesitate, and I don't. I turn my back on my friends and rush down the spiral path. In my wake, I hear grumbling between them followed by the sound of their footsteps trailing behind me. I make a quick turn in the library and enter a narrow hallway with multiple doors on one side that leads to conference rooms. I hurry toward an exit ramp, maintaining my artificial limp.

Luke calls out to me in a hushed tone, "Over here!"

I turn with exasperation and step into the conference room as Luke shuts the door behind us.

Devon throws his arms in the air with a huff, "What happened? Why'd you bail?"

Rage builds behind my voice, "Are you trying to get us caught? Or are you just fucking stupid?"

Devon's masked and wrinkled face turns to anger, "Fuck you! I'm trying to get us paid! You bailed on us!"

Fury rises higher within me, and my voice grows to match my anger, "Fuck you! I'm trying to keep us from getting caught."

Luke steps between us to diffuse the tension. He pushes Devon and me away from each other with gloved hands. "Fucking chill out. Both of you."

I turn my anger toward Luke, "Don't fucking touch me!" I stare long and hard at Luke as my breath pounds within my lungs. I then turn my hateful gaze back to Devon, "That's enough of your way! It's stupid, and it's going to get us caught!"

Devon scoffs, "Fuck off! Like you're so fucking smart. If you weren't a pussy, we'd be driving off with the books right now!"

I step closer to Devon, pushing forward against Luke's hands that hold us at arm's length, "We'd be in fucking handcuffs right now if we listened to you!"

Ethan glances over his shoulder toward the door, "Guys, we need to get out of here."

Luke pushes and creates more space between Devon and me, "We can't stay here. And now we can't go through with it. We got to bail. Fuck!"

Devon wags his head in denial, "We're here now. We have to do it!"

I push Luke's hand away and step back from them both, "No, we don't. Not like this."

Devon takes a step back from Luke's hands, stomping away in anger, "Let me guess. You want to do it your way. Always your way! Your way! I'm tired of this shit! Let's just do it and get it over with already!"

Luke glances over his shoulder at the door. We hear footsteps passing by. Luke continues in a whisper, "I'm tired of this back and forth shit. Are we doing this, or not?"

I wave them all closer so that we can speak in softer tones. "We don't have to do it today," I say. Silence hangs heavy between the four of us. "We don't have to go through with it at all. Guys, we can just walk away." Each of us looks at the masked faces that surround us. I feel a collective sense of relief wash over us. The silence continues, and the reprieve turns sour into restlessness and frustration.

Devon spits his words through gritted teeth, "We're already in it this far! We can't back out now!"

I glance down at my outfit and tug on the mask covering my face, "This whole plan is a fucking disaster. I know you don't want to hear it, but if we're going to do it, we should have two people go in the room. One lookout. One driver. No masks and costumes. Whoever goes in the room wears disguises. But they have to be believable."

Ethan agrees with a shrug of his shoulders, "He's right. The masks don't work up close."

I continue, "If we can reschedule the appointment for tomorrow I can

get us a van. My aunt sold her van, and a buyer is coming in from out of state to pick it up tomorrow afternoon. We can use that as the getaway car. It's a lot better than using Luke's car."

The three of them slowly nod their heads in agreement.

"I drive the van. Ethan is the lookout since he's recognizable here on campus. Devon and Luke, you guys, go in the room."

Luke steps away from the huddle in frustration, "If you're not going in the room, why should I?"

I dismiss his question with a raise of my eyebrows and smirk, "Then don't. Screw the whole thing then. We all just walk away now and don't go through with it."

The three of us consider the possibility, again.

Luke disrupts the silence, "Fine. We'll do it your way. But I'm not going to the room either."

Devon jolts with outrage boiling behind his mask, "I can't believe this! We're here! We're literally here, and everyone wants to back out now? Let me guess, you too Eth?"

Ethan scratches the back of his neck, then steps closer to Devon, "I mean, I'm not bailing. I'd rather be the lookout though."

"Great! Just fucking great. I'll do it all then! I'll go in the room. I'll take Boner out. Then I'll signal you to come up, Lu-." Devon catches himself, "I mean Mr. Black. How's that? I at least need help getting the books. Can you at least do that? Is that better for everyone? Everyone but me!" Devon laughs in disgust at the absurdity of his own proposition.

All four of us connect with brief eye contact affirming our mutual decision.

I turn in a hurry toward the door, "Let's get out of here!"

THE VAN

The drawer slides open with a creak. I cringe at the high-pitched squeal of the wood and double my haste. My gloved hands shuffle through the contents of the drawer, pushing pens, old key rings, coupons, and rubber bands aside.

The door to the kitchen opens, and Lynne pauses in the doorway. She wears a grey turtleneck sweater and a light dusting of make-up. "Well, Charlie. Didn't expect to find you here. What are you doing here so early?"

I close the drawer and turn to face her with a forced smile. "Hey, Lynne. I'm looking for the keys to Aunt Laura's van. Where are they?"

"They should be right over here. Why? What do you need her van for?" Lynne's slippered feet scrape across the floor to a key holder on the side of the refrigerator. She extends the keys toward me, and I quickly reach to grab them. Lynne pulls her hand back and searches to find my eyes as she holds the keys at a distance from my outstretched hand. "What do you need the van for, Charlie?"

I avoid her eyes and reach for the keys again, "I just need it. I have to move something today. I'll bring it back in like an hour. Two hours tops."

She leans her head and whole body down toward the path of my eyes to meet my gaze. "What's up with you, Chas? Are you okay?"

I huff with exasperation, "I'm fine, okay. I'm just in a hurry."

For a split second Lynne relents, and I take the keys from her hands. She watches me with a troubled expression. I kiss her on the cheek and hustle toward the door. Over my shoulder, I hear her call after me, "Charlie, whatever you're doing, please be safe!"

The side door to the house shuts behind me as I run toward the driveway. Behind me, I hear the faint sound of Lynne's voice calling after me with desperation, "I love you!"

THE MORNING OF

The slate grey minivan slows to a halt in my driveway. Devon and Luke stand in the driveway bundled with heavy winter coats. Devon's long wavy brown hair no longer hangs down to his shoulders. Instead, he has bleach blonde, short buzzed hair hidden under a black baseball cap. A red scarf, Devon's "lucky" red scarf, drapes around his neck and covers his chin and jawline. He wears a heavy brown corduroy coat and jean pants.

Luke stands by Devon's side wearing a wool ski cap. A large bandage stretches across one cheekbone to cover an identifiable mole. He wears a black jacket with a high collar that he tucks his chin beneath for warmth against the icy grip of the winter morning.

I step out of the van's driver seat and join them in the driveway. I stuff my gloved hands into the pockets of my leather jacket and breathe heavy into the cold air, watching my breath billow like smoke.

Devon's body rocks back and forth in his stance, "This is it, boys. Today is the day."

I continue watching my breathe in the air as I talk, "You set the appointment from a pay phone?"

Devon smirks, "Of course."

"At least a mile from here?"

"Yeah."

"What about you, Luke? You get the new temporary tags?"

Luke nods his head and then touches the bandage on his cheek with a black-gloved hand. "Yep. I'll swap it out before we go."

"Good." I lift my head toward the sky. The light from the sun hides behind streaks of grey clouds that spread across the sky like rolls of stained cotton. The clouds drift quickly on the wind. I touch the Saint Christopher necklace beneath my grey sweater and brown leather jacket. The silver feels warm against my skin.

Devon interrupts my distant thoughts to speak with passion, "When we step into that van today, there is no turning back, boys. Our lives as we know them will never be the same again. Ninety-nine percent of all people out there don't have the balls to do what we are about to do. That's what makes for a life of mediocrity. We were never meant for that. That fucking nickel and dime lifestyle. The fucking rat race of the nine to five world. We're above that! We deserve to be among the elite of society! Boys, take it in. Take it all in. "

Devon pulls in a breath that expands his lungs beneath his corduroy coat. He releases the breath with a loud sigh of relief, "Boys, these books are a part of American History. And after today, we will be too. This is a once in a lifetime chance, and we're going to reach out and take it!" He shakes his fists in the air, then smiles with a goofy grin of exhilaration as his eyes dart back and forth between Luke and me with a mad brilliance watching for our reactions.

Luke and I share a glance. Luke's eyes convey his determination, but he seems unsure of himself. He stands with his shoulders slouched forward and looks down from my glance to the ground.

A pang of sorrow tugs at my heart. "You guys are like my brothers. We've been through so much together." I reach out to embrace Devon and Luke for a brief hug. Then I take a deep breath and step back to my place in our small circle. "Just be safe today. Okay?"

They both smile from the brief touch of support. My friends nod thoughtfully in agreement as I continue, "No more names from here on out. Code names only. Keep your gloves on and your faces covered. Especially under the camera on the way in. Only get what we came for and leave nothing behind. Got it? Nothing."

Devon claps his hands then slaps us both on the back as he hurries toward the van, "Let's go make history!"

Luke follows behind Devon, "No, fuck that. Let's go take history."

DRIVER

My heart drums rhythmically against the wall of my chest, steady and robust, like the flow of cars in traffic in front of Transylvania's campus. My hands grip the leather steering wheel with white knuckles beneath my black-gloved hands. A polarized bronze tint colors my vision through Maui Jim sunglasses as I scan the horseshoe-shaped parking lot for an empty space. A black baseball cap covers my head, and the low tipped brim casts a shadow over my vision.

A green sedan reverses out of a parking space on the opposite side of the lot. The opening space is the nearest space to the emergency exit door at the side of the library building. My expression conveys no emotion as I point out our good fortune to Mr. Black and Mr. Yellow, "Check it out. The perfect spot."

Mr. Yellow, a.k.a. Devon, sits on the edge of the front passenger seat. His attention resides somewhere deep within himself. His breaths come in forcefully restrained bursts. He peers beneath the brim of his hat to the opposite side of the parking lot as I pull into the space.

Devon points a gloved finger across the campus lawn toward the rising steps of the Beck Athletic Center. Ethan, a.k.a. Mr. Green, sits atop the steps with a sketchbook on his lap and a cell phone by his side. "Mr. Green is in position." He turns in his seat to face Luke, a.k.a. Mr. Black, in the back seat behind him, "Make sure your phone is turned on."

Mr. Yellow proudly produces a cell phone from one of his coat pockets and pushes a laugh through his nervousness, "I stole this one this morning, so keep an eye out for a random number."

Mr. Black shakes his head with disapproval of Mr. Yellow's penchant for petty thievery. Mr. Black touches the bandage obscuring the mole on his face. "Just make sure you have her out of the way before you call me.

I'm not touching that woman."

Mr. Yellow bats the comment away with an errant gloved hand. He produces a small black pen-shaped object from his pocket. "Don't you worry. I'll do all the hard work no one else wants to do. But I am bringing this."

"What the fuck is that?"

Mr. Yellow hands the thin black object to Mr. Black and withdraws another for himself from his coat pocket. "It's called a stun pen. Way less voltage than the police grade Tasers we have back at the house. I figure, why not? It won't hurt her, and it might help us."

"There is no us in this. You said you'd handle that before I come up to help load the paintings. That's the deal."

Mr. Yellow turns hastily in his seat and reaches for the door handle. "Whatever you need to tell yourself!" He pops open the door with a smile.

I check the clock on the dashboard.

11:14 AM.

I snag a grip of Mr. Yellow's coat sleeve with my gloved hand. "In and out in under five minutes. No stalling. Quick and efficient. I'll be right here with the doors open and waiting. And remember nothing gets left behind."

Mr. Yellow either doesn't hear me clearly or doesn't care. He steps out of the van with his words trailing behind him, "Yep, got it. Here we go! It's showtime!"

The door slams behind him. Two thin collapsible bags bulge within the lining of his coat pockets as he strides purposefully toward the main entrance of the Transylvania library. A cold wind buffets the tails of his corduroy coat, but he pushes forward. He ducks his head beneath the camera and slips through the sliding glass doors and into the building.

11:15.

I turn in my seat to face Mr. Black, "Hey man. You ready for this?"

Mr. Black nods his head in quiet affirmation. He stares in silence for a moment through the front windshield of the van. His eyes hold a familiar gaze into a familiar place that I cannot follow. He exhales, and his shoulders slump in resignation as he turns once again to face me. His voice sounds hollow as he speaks, "He shouldn't have given me this. Shit, he shouldn't have taken one either. He better not fuck me over. He better have it done before he calls me."

I take the stun pen from Mr. Black's gloved hand. I examine the small apparatus. I flick a switch and a thin blue strip of electricity the width of a pencil eraser sparks between two tiny prongs. I shake my head in dismay. "You never know what to expect with him. Hopefully, he just doesn't fuck it up and get us all caught."

"Yeah." Mr. Black takes the stun pen from my hands and observes it himself. A sense of hopelessness clouds his expression.

Bzzzzz. Bzzzzz.

Mr. Black's eyes dart open with the sound like the toll of a funeral bell. He pulls his phone from his jean pocket. He checks the caller I.D., and then we both check the clock on the dashboard.

11:16.

"It's him. This is too soon though. He better not be fucking me over."

I lean as far back toward the back seat where Mr. Black sits without leaving the driver's chair. Reaching both gloved hands out I motion for Mr. Black to raise his hands, "Let's see them. Hold them up. Are they steady?"

Mr. Black raises his gloved hands. One hand holds the stun pen. His hands hover motionless in front of his chest.

I grip his hands as I speak to lend him strength, "You got this. Just get in and get out. I'll be right here waiting to drive us out of here."

Mr. Black winces at the thought of what he must now do. He pauses as his eyes meet mine. "Hey, I usually wouldn't ask this. But I see you touch that necklace you wear sometimes and say a prayer."

I reflexively touch the pendant hanging near my heart as I respond, "Yeah?"

"I guess what I'm saying is, could you say a prayer for me? While I'm in there?"

I nod with a heavy heart, assuring him that I will.

Mr. Black observes the stun pen one last time, then discards it onto the seat cushions of the van. He slides open the side door to the minivan and steps out into the parking lot. The side door slowly locks back into place behind him.

11:17.

Mr. Black disappears through the sliding glass entryway of the library.

CHASE

I open the driver seat door and step out into the cloudy haze of the day. The cold wind grips me with a firm hand as I step to the rear liftgate of the mini-van. I lift the tailgate into the open position. The storage compartment opens toward the emergency exit door merely twenty yards away. I step to the side of the van and pull open the sliding door. The warm air from inside the van rolls through the open door in fumes to join the crisp morning. I return to my post in the driver seat and check the dashboard clock.

11:20.

According to the plan, Mr. Yellow and Mr. Black should appear from the emergency exit at any moment now.

I check my hands. They hover steadily above the steering wheel, waiting to be called into action. Cold still lingers on my skin from the outside air. Strangely I feel nothing. I feel no exhilaration and no emotions resembling fear, or worry, or anxiety. I feel numb and oddly cut off from the experience of being truly alive. As if I'm swimming through each motion I make in a fluid, not unlike water, but somehow thicker and more isolating.

11:22.

Mr. Yellow and Mr. Black are still somewhere inside the library building, already two minutes over schedule.

Bzzzzz.

My cell phone vibrates in the front pocket of my jeans. I quickly withdraw the flip phone from my pocket and read the caller I.D.

Bzzzzz.

Mr. Green's real name, a.k.a. Ethan appears on the screen. I answer the call.

"Hello?"

Silence hangs briefly on the line between us. Finally, Mr. Green speaks, "Have you heard anything from them?"

I check my rearview mirror. The angle focuses precisely on the emergency exit door. The back hatch of the van waits in the open, lifted position.

"No, I haven't heard anything at all. You either?"

"No."

"Have you noticed anything different from up there? Does it seem like any alarms went off? Or anyone called for help?"

"No. Everything seems normal."

"Okay. Call me if you see anything." I flip the phone closed and return it to my pants pocket. My gloved hand reaches for the pendant hanging from my neck. Silently I say a prayer.

"Ryan. Or anyone or anything that exists that can hear me. Please watch over us today. Please keep my friends and me safe. Please protect us and watch over us so that we all get through this unhurt and don't hurt anyone. I don't know if my prayers are even worth answering anymore after some of the things I've done. But please hear me. And please just keep us safe."

11:27.

Seven minutes over schedule.

I open the driver door and step out into the cold. I approach the open rear hatch of the mini-van and pause. The emergency exit door rests untouched. My hand hovers over the rear hatch. No sign of Mr. Yellow or Mr. Black. I close the rear hatch and slowly make my way to the open side door, all the while watching the emergency door.

Nothing.

I close the side door and amble slowly and deliberately back to the driver seat. I grip the transmission with a gloved hand staring into my eyes beneath the sunglasses in the reflection of the rearview mirror. A thought crosses my mind. I can drive away right now. I can put this whole heist right here in the rearview mirror and never look back. I press down on the brake and slip the gear into reverse.

Boooom.

A loud noise startles me from my thoughts.

Through the reflection in the rearview mirror, I see the emergency exit door burst open on its hinges. Mr. Yellow flies through the doorway with a thin leg flailing in the air from a jump-kick exit through the door.

A heavy backpack hangs on his back, and he holds the arm straps tightly with his hands to clutch the filled pack to his body. His wide-eyed panic-stricken expression leads him careening along the side of the building.

I slam the transmission into park and jump out of the van to meet Mr. Yellow. Swinging open the rear hatch I look over my shoulder to find Mr. Yellow. I stare in stupefied confusion at Mr. Yellow as he races away from the van and sprints deeper into the heart of campus, running aimlessly like a wild mule let out of a pen.

A split second later Mr. Black shoulders his way through the exit door. The door flies open again on its hinges and bangs into the brick exterior of the building. A backpack hangs heavy across his back. A third body busts through the open doorway. A large woman barrels through the door hot on Mr. Black's trail. Her arms and extremities bulge and flap at odd angles but seem to propel her forward with determined ferocity.

Mr. Black notices me standing at the rear hatch of the van and speeds toward me. I slam the rear hatch closed and dive into the driver seat. Jamming the gear into reverse, I pound my foot down on the pedal. The mini-van engine squirms in protest but rushes backward. The woman plows forward thrashing at the air behind Mr. Black's heels. I know he won't have time to get into the van with her in such close pursuit. I throw the transmission into drive. The tires squeal against the pavement as the mini-van crawls forward gaining traction and speed. Mr. Black sprints alongside the van. I stomp on the gas pedal and lurch ahead of him. Sticking an arm into the back seat, I fling open the side door. Cold air flows through the open van door in torrents as Mr. Black races toward the opening. He pumps his legs furiously to catch up to the van. The backpack bounces on his back with each stride.

The woman wails wildly as she runs. Screaming at Mr. Black, "Stop him! Someone help!" She claws at him with arms grasping at the air behind him, "Help! Somebody! Stop them! Help!"

Mr. Black thrusts forward with determination and latches an arm onto the side of the van. I release the pressure on the gas pedal, and the van slows for an instant. He dives in through the open door as I slam my foot on the gas pedal. The van rushes forward as the chasing woman swipes at the air in our wake. The van veers around the first turn of the horseshoe bend. From the rearview mirror, I see the woman crunching numbers in her head and mouthing the letters of the fake temporary license plate to commit them to memory.

I toss my words back in Mr. Black's direction as he struggles to regain composure in his seat. "Good luck with the plate lady!"

Mr. Black cranes his neck out of the open side door in search of Mr. Yellow. He points ahead of our position toward an aimless and sprinting Mr. Yellow. I stomp on the gas pedal and rush toward him. The van rolls alongside him as he runs like a gazelle alongside a jeep on a safari.

Mr. Black shouts through the opening at him, "Get in you idiot!"

Mr. Yellow turns toward the van and dives into the open doorway. Mr. Black pulls him into the seat next to him, along with a filled backpack, and slams the door shut behind him.

I grip the wheel with both hands and pound the gas pedal to the floor. The van takes the second turn of the horseshoe lot at thirty miles per hour with all four tires screeching in protest. A short straightaway stretches in front of the van and runs head-on into passing traffic on North Broadway. Quick gaps space between each slow moving car on the road. I take my chances and punch the gas further into the floorboard. The van busts into the gap in traffic at forty-five miles per hour. I crank the steering wheel hard right. The tires squeal, and I spin the wheel wildly to make the hard turn. The van rockets into the flow of traffic weaving between cars at break-neck speed.

Mr. Yellow crawls into the front passenger seat. He mumbles something inaudible. Then finally projects his words, "I'm going to puke!"

I yell at him without taking my eyes off the road, "What the fuck? Don't puke in here!" The van shoots a gap between two cars. A white sedan honks angrily as we pass.

Mr. Yellow rolls down the window. He hangs his head over the side of the van and vomits into the wind. Streaks of yellow smear on the glass and down the exterior of the van.

I take my eyes off the road and turn to him in disgust, "Dammit man! Come on! I have to take this car back today!"

Red lights appear in the corner of my vision. They grow brighter, bolder. I turn to see taillights of a truck. I slam on the breaks. The tires peel against the pavement. The van rocks forward and shutters to a halt inches from the truck bumper.

I smack the steering wheel in frustration, screaming at the traffic stalled at the stoplight blocking our escape, "Let's go!" The stoplight continues to glow red. I check the rearview mirror. No police lights flashing. No sirens. No alarms. My voice barks toward Mr. Black and Mr. Yellow, "So, what happened? Where are the Audubon books?"

Mr. Black notices Mr. Yellow wiping the vomit from his chin with a coat sleeve and answers my question, "They dropped! That bitch ran after us!"

"What do you mean they dropped? What happened in there?"

The stoplight flicks from red to green. The van hovers behind the truck's tailgate. I swerve back and forth and punch the horn, signaling for the truck to get out of our way and let us pass.

Mr. Black continues, "We loaded the books onto a sheet. But this motherfucker called me up to the room before doing anything!"

Mr. Yellow speaks in a frantic voice, his face ghostly white, "What's done is done!"

I punch the horn again, and the truck swerves to the side of the road to let us pass. I speed the van forward on a straightaway of open road. I

watch Mr. Black in the rearview mirror as I drive. "What happened with Boner? And the books? What the hell happened in there?"

Mr. Black hits my shoulder, "Look out!"

I turn the steering wheel sharply left, and the van barely dodges the back bumper of a green sports car.

Mr. Yellow answers for Mr. Black, "We did what we could. I tried to use the stun pen, but it didn't work! Piece of shit! We should have used the other ones!"

A right-hand turn approaches. I jam on the breaks then pound on the gas pedal. The van groans in protest against the sharp corner.

Mr. Black picks up Mr. Yellow's words, "He touched her on the shoulder with it, but nothing happened. We wrestled her to the ground then we tied her up with the zip ties."

I bang my hands against the steering wheel as I talk, willing the van to carry us faster and faster away from danger. "Did she get a good look at you?"

Mr. Black answers, "I don't think so. We put the ski mask over her face."

"Where are the rest of the books?"

Mr. Yellow jolts his head back and forth watching the road ahead for oncoming traffic. "We loaded the Audubon's onto a bed sheet. Then we packed our backpacks with a bunch of other stuff from the display cases and got out of there!"

The van speeds toward four cars stopped at a four-way stop. I pound on the van's horn and keep my foot on the gas. "What took so long?" I demand.

"We got the elevator key from Bonner like we planned, but we pushed the wrong button on the way down!" Mr. Black leans forward from the

back seat of the van and cranes his neck toward the front windshield to watch the approaching intersection. "That bitch saw us on one of the floors! We had to close the doors and try to find another way out."

I swerve left, and speed past a white van stopped at the intersection. A woman turns with a look of terror from behind her steering wheel. The whites of her eyes bulge in shock as we rush past her in a blur.

The van plows recklessly into the intersection. Cars swerve and blast their horns in response. A black sedan slams on its breaks. I wrench the steering wheel hard right. The vans races head-on toward an oncoming car. I swing the wheel hard left. The front bumper of the van narrowly escapes head on catastrophe.

Inside the van, the three of us collectively exhale. A stretch of open road sprawls ahead of us. I slow the vehicle down to cruise slightly above the speed limit as we approach the drop-off point, of which the other two are unaware. I turn to face each of them fully for the first time, "So?"

Mr. Black leans back in the rear seat, "So that bitch caught up to us on the ramp. This dumbass dropped his end of the bed sheet and ran off. The Audubon books dropped on the ramp. I had to jump over them to get the fuck out of there."

Mr. Yellow reaches into the back seat. He pulls the collapsible backpack into his lap and peers inside at the contents. "Who cares? We got tons of stuff from the display cases! And we got away! We did it, boys!"

I make a right-hand turn and slow the van to a stop near a low-income housing project. I point toward the curb, "Alright get out."

Mr. Yellow's excitement slouches from his face into a hard-pressed glare directed toward me, "Don't stop! You have to get us out of here!"

I jam the transmission into park and turn to face them slowly, "Look. We don't have time to go over this right now. The cops are going to be looking for a grey van with three people and stolen merchandise inside."

Mr. Black protests, "This isn't the plan. Get us the fuck out of here!"

"Fuck the plan! I'm changing it, so we don't get caught. You're going to hide out here. I'll drop the car off and come back to pick you up in my Jeep."

Mr. Black crosses his arms in defiance, "I'm not going anywhere."

My temper flares and I lean toward the back seat no longer caring for the protocol of the heist, "Get the fuck out, Luke! Now! Both of you!"

The sound of police sirens wails in the distance, "Let's go! Get out! Trust me. I'll be back."

Luke shakes his head in frustration and gathers his backpack. Devon slings his bag over his shoulder. They both step out of the van and onto the sidewalk.

My foot slams on the gas pedal, and I speed away. I watch them cross the street and slip behind an apartment complex, from my rearview mirror.

THE HIDEOUT

Marijuana smoke hangs thick in the air. The bed sheets that hang from the exposed ceiling beams trap the smoke in the unventilated area like a hot box. A small TV set sits on top of a workbench built into the concrete basement wall that Devon repurposed as a makeshift desk. Images flash across the TV about the Transylvania heist as Luke, Ethan, and I sit in armchairs watching the news report, waiting for Devon to return from contacting the buyer.

The stolen books and artwork lay strewn across the coffee table.

I switch channels with the TV remote. The heist story appears on Channel 8 news, then again on Channel 7. I try Channel 18. I can't get away from the story. Seeing our actions broadcast to the world feels

unsettling. My face feels hot, and an uneasiness crawls under my skin with each public mention of the crime. As I watch a reporter deliver the news, I cling to the hope that no one ever discovers the truth and that our actions remain where they belong, hidden behind the masks that we've grown into.

A tall blond woman stands with a microphone in the lawn of Transylvania's campus, "Authorities report today that two men believed to be between the ages of twenty-two and twenty-five entered the Special Collections library here at Transylvania University around eleven o'clock this morning."

I comment on the news report, "At least they think you guys are older. Hopefully, they won't think nineteen-year-old college students could do this."

Luke takes a rip of the red glass bong. Smoke billows from his lungs with a satisfied smile, "But we did it."

The news reporter trudges ahead with her story, "The two men made a brazen escape in broad daylight. Police say some of the items the thieves intended to steal were left behind in their hurry to flee the scene."

Luke grimaces, offended by the reporter's words, "Yeah, we just needed more people. That's all."

Luke passes the bong around the table to me. I light the bowl and take a hit. My words flow from my mouth with smoke. "I still can't believe you guys dropped the Audubon paintings. How many millions of dollars is that just sliding down the exit ramp?"

The reporter gestures toward the emergency exit door where Devon and Luke broke free, "A member of the Transylvania staff reports chasing the two men on foot before they ultimately sped off in a grey mini-van. The license plate is believed to be MT23-33."

Luke chuckles to himself and shakes his head in disbelief, "They're not even close! And it was a fake temporary tag! You should have seen Devon's face when that big bitch came running toward us! He dropped the sheet and took off!"

Images cut across the screen of police lights flashing against the red brick backdrop of Transylvania's library. A number appears on the screen for citizens to call with any information that can lead to the perpetrators' arrest.

Ethan lounges in the chaise reading one of the stolen books. I offer him the bong. He reverently places the book down beside him in the chair. The cover reads, "On the Origin of Species by Means of Natural Selection" by Charles Darwin. Smoke plumes from Ethan's mouth.

"Where'd you get rid of the evidence?" I lift the book from Ethan's side, flipping through the pages.

"I burned whatever I could. Everything else I spread out in small pieces in dumpsters all over town."

I return Ethan's reading material to him and view the books and artwork scattered across the coffee table. I thumb through two ancient medical dictionaries dated circa 1500, with a cream color binding. The books were once housed in Thomas Jefferson's private library. I turn my attention next to a set of 20 original pieces of art by John James Audubon. Each lithograph strives to capture the personality and peculiarities of a variety of birds within their natural habitat. The details within the bird's eyes are striking, and the bird's beautiful feathers stand from the page in a grey pencil rendition of their full glory and color. A synopsis of Birds of North America, also by Audubon rests on the coffee table beside the lithographs.

I return the medical dictionaries to the coffee table, "I can't believe you guys dropped the big books."

Luke turns from the TV to glare at me sideways, "Would have been different if we had more help." He continues to glare at me, allowing his insinuation to sink in.

I choose not to meet his eyes and lift an illuminated manuscript that dates back to the early 1400's from the coffee table. Raised ink stands from the page and shines brilliantly beneath the hanging light bulb within Devon's basement hideout. "Would have been a lot better if we actually got the big Audubon's. That's all I'm saying."

Ethan looks at us from the pages of the Darwin book in his hands, "These books are valuable. I don't know how much. But they're rare."

I open the binding of the ancient book within my hands. The colorful calligraphy paints the pages in swaths of vibrant gold, silver, green, red, yellow, and blue. A sense of awe grips me as I hold the book, knowing it once rested in the hands of kings. After six hundred years of existence, the book still survives in pristine condition, passed down generation by generation through the hands of time to now be in my possession. To hold something so rare and priceless feels akin to touching an unattainable level of old world wealth and success. I feel as though my life story is intertwining with the history of the book and with all the great men and women from past generations who once held the same treasure in their hands. The sensation feels like being a part of history, now, in the present.

A hollow, empty feeling creeps into my sense of awe and wonder. I didn't earn my place in history. I stole it.

The news reporter continues on the TV, "It is believed that the thieves got away with more than one million dollars of rare books and artwork."

Luke, Ethan, and I share a shocked look of pleasant surprise. Luke scrunches his face with a smug sense of satisfaction and rests his hands behind his head as he leans back within his tangerine armchair, "I had my doubts. But we're good! A million. We can work with that."

I nod in agreement, "Let's just hope the buyer's willing to pay us for it all though. When's Devon supposed to get back anyway?"

The rickety set of stairs leading to the unfinished basement creaks with footsteps.

I turn to the bed sheet that blocks the staircase expecting to see Devon pop into the room with exuberance.

A hand pulls the hanging bed sheet back from the room's entryway. A light glows behind a slim silhouette. Claire pushes the bed sheet aside and steps into the marijuana haze of the room.

My heart drops. I hastily pass the Illuminated Manuscript to Ethan. He fumbles with the book in shock at Claire 's presence.

She waves a hand in the air wafting away the marijuana smoke, "What are you guys doing down here?"

I scramble across the room toward her, trying to hold her attention and distract her from observing the stolen books scattered across the coffee table. With each step closer to her I realize that she is the one holding my attention and not the other way around. My heart floods with excitement at the sight of her. A hope for reconnection builds with each step I take. She looks beautiful standing there. Her bright blue eyes hold mine as I cross the room. I feel her tender embrace and loving warmth charged in the distance between us. I reach out to her and hug her. Holding her close I feel the warmth of our bodies beneath our clothes, then I pull away, worried she may see stolen books over my shoulder and discover the truth.

I stand in front of her, blocking her vision to what lies behind me. The sound of the news reporter plays in my ear. Her words describe the robbery and label my friends and me as criminals and outcasts of society. Her words strike like lashes across my heart. Guilt rises within my throat, and a sense of shame shades the pallor of my skin.

She smiles and tucks a few strands of black hair behind her ear, "Hey, sorry to just barge in like this after so long. I was hoping we could talk?"

Luke jumps to stand beside me, awkwardly blocking Claire's view and attempting to wrangle her attention away from the stolen books scattered across the table beside us. "Oh, hey Claire! I like that t-shirt, what is that Polo?"

Claire looks down at the logo on her shirt, "Uh, yeah. Obviously."

I interrupt and take Claire's elbow to steer her toward the staircase, "Claire. I'm sorry I can't do this right now." I guide her through the hanging bed sheet, continuing to block her field of vision into the room. We climb the rickety stairs, and when we reach the top, I stop her. Swallowing my pride, I force myself to tell her the truth. "Claire, I can't tell you how good it is to see you. But I can't talk right now. I'm sorry, but you deserve better than this. Please just trust me. You deserve better than me." Confusion clouds the expression on her freckled face. I feel the pain building behind her eyes and feel it burning behind my own. I open the basement door and guide her out of the staircase.

She refuses to go. "Can't we just talk?" She softly purrs only inches from my face. I can almost taste the touch of her lips.

I realize I'm holding her in my arms. I long to embrace her fully and pull her close and never let her go. Shaking my head, I break the contact between our eyes. "Just trust me, Claire. It's for the best. I love you but just leave. Okay?" I let her go and turn my back on her. Then I close the door between us and descend the basement steps back into the haze of smoke. I plop down into one of the two tangerine-colored armchairs as Luke and Ethan stare at me wide-eyed.

Luke stands from his chair and searches up the staircase. Finding the stairs empty and our secret safe, he spins toward me and shouts through clenched teeth, "Whoa! What the fuck? Why didn't you tell us Claire was coming?"

I let out a slow sigh, feeling deflated and depressed, "I didn't know, Luke! I haven't seen her in weeks. It doesn't even matter. She didn't see anything. And now she's gone, alright? Everything's fine."

Ethan protectively tidies the books on the coffee table, "Devon was the last one to leave. He should have locked the door."

Luke drops with relief into one of the tangerine armchairs again. "He needs to hurry his ass up. We need to get these books out of here and sold to this Amsterdam buyer. Like now." The door to the basement swings open. Footsteps resound on the rickety set of stairs. Luke leaps to his feet and races to the hanging bed sheet entryway to block the path. The footsteps continue downward. Luke steps aside, and Devon enters the room in silence, his eyes far away.

Luke follows after him and prods him to speak up with a nudge, "Well? What did the buyer say? How much is he willing to pay for all of this?"

Devon props an elbow down onto the makeshift wooden bar top near the furnace and water heater in the center of his room. He leans on the bar with a forced casual demeanor, "Here it is, boys. We've got good news and bad news."

I point to the TV news anchors regaling in the top story with continued commentary, "We've got enough bad news, Devon. How about something good?"

Devon bunches his face together in contemplation, "So, I'll just come out and say it. The buyer backed out."

I explode with outrage, "What? He can't do that!"

Devon quickly retorts, "They only wanted the Audubon collection. It was the whole collection or nothing. But we can still sell what we got! I researched a thing called private sector sales for high-end items like these. They even have non-disclosure agreements, so the cops can't find out. It's perfect! It's this place in New York called Christie's Auction House."

Luke rubs the scruff on his face and stares at Devon incredulously, "You're trying to say we should go to New York now? Not Amsterdam? Because you lost the buyer."

"I didn't lose him! We didn't get the Audubon collection!"

A heavy sinking feeling falls in the pit of my stomach. "Christie's? Devon, what the fuck are you talking about? That's one of the biggest auction houses in the world!"

Devon snaps his fingers and enthusiastically points in my direction, "Exactly!"

I stand from the chair and step toward him, "That won't work! Guys we need to find another buyer. We can't take stolen property to an auction house! Especially not one of the biggest in the world!"

Devon points his finger at my chest, "We're doing it my way now! I already researched the private sector sales and sent an email to set up an appointment. But we have to do this quick before the FBI registry flags this. If we leave tomorrow, we can sell these books and walk away millionaires before the FBI even knows about it!"

I push Devon's chest and his body slams back into the wooden bar top, "We're not doing it your way! My family owns an auction house dumbass. Here's how it works. You walk in there with stolen property they're going to do an appraisal before finding a buyer. Even if it's private! And you think non-disclosure agreements will protect us? How stupid are you? That's out the window when a crime is involved! If we show up at Christie's auction house with these books, they're going to trace it back to Transy and then back to us! Doing it your way is only going to get us caught!"

Devon steps forward and shoves me backward, "Fuck you, Chas! We have to make the best of what we've got. And this is it. It's now or never guys!" He turns his attention toward Luke and then to Ethan, mustering

his innermost charisma. "We only have a window of a few days! We can drive to New York tomorrow and sell the books the day after that. Get our money, split it up, and start living like we fucking deserve! Either we act now before the FBI knows what hit them, or we sit back with our thumbs up our asses and wait. For what? For another buyer that we may never even find? It's right now, boys. Now or never."

Luke and Ethan consider Devon's words.

I hurry to inject my own views, "He's wrong. Look I know what I'm talking about! I worked at an auction house for years. They will track the last sale of these books, and then that's it! This will get us caught. Guys, we just need to be patient. We can't fall for the get rich quick scheme Devon is trying to sell us. We take our time and find another buyer. We found a buyer before. We can find another one. It's just going to take some time, that's all!"

Luke and Ethan shift their eyes back and forth between Devon and me.

Devon nudges Ethan with his elbow, "Eth, what do you think? Huh?"

Ethan looks down to the AstroTurf covering the cement floor, "I've never been to New York. Why not?"

Luke's chest swells as he inhales sharply. He looks to me apologetically, "I'm with Devon on this one. I don't want to wait around. Let's go to New York."

NEW YORK

Steam rises from the sewers carrying the stench of hot molding garbage beneath the city pavement. Taxicab horns honk from the near-standstill traffic of 50th street in Manhattan. Ethan clutches the extended handle of a red suitcase walking side by side next to Devon, Luke, and myself

on the cold, hard, sidewalk pavement. The suitcase contains six carefully packaged stolen rare books valued at more than a million dollars. A bed sheet separates each book from touching or damaging any of the other prized books.

Our youthful strides career us forward on the heels of hubris. Together we pass the glowing neon lights of Radio City Music Hall on our left and NBC Studios on our right, advertising tickets to see David Letterman's The Late Show live. We each bundle ourselves tightly beneath suits, ties, and overcoats. Our juvenile attempt at professional attire does little to combat the blistering cold winds whipping between the towering city buildings that surround us.

I adjust the knot of my tie and button the highest clasp on my overcoat to shield against the push of the increasing cold winds. I feel a strange sense of déjà vu`. I glance back at the red suitcase rolling behind Ethan's heels, "Guys this is a terrible idea. We're about to roll into Christie's, literally roll in there with stolen books, wrapped in bed sheets!"

Luke stuffs his hands in his overcoat pockets and observes his breath in the air, "Get over it, Chas. We're already here."

Devon strides several paces in front of our pack to walk backward and address me face-to-face, "We did it your way at the library. Now we're doing it my way. If you want to come in and help us with the appraiser meeting, then great! Otherwise, let's be positive! We're in New York City for fuck sake! Come on! Lighten up!"

Devon leans in close to my shoulder and nudges me, then gestures to the books rolling in tow.

"We have millions of dollars – right there. This is going to work. Trust me!"

We turn right and stroll into Rockefeller Center. People bustle through the busy plaza toting last minute holiday shopping bags at their sides. The

bright lights and chaotic foot traffic of passersby overwhelm our senses as we walk.

I push Devon away from me and feel the weight of a wood grain handled chrome two shot derringer sway inside the breast pocket of my coat. I fasten a front button of my overcoat to shield me against the coming wind. "Did you set the appointment from an untraceable number?" I ask.

"Of course! We even made fake I.D.s for this. Isn't that right, Eth? I'm Mr. Williams, and Ethan is Mr. Stephens. Right?"

Ethan chomps on a wad of chewing gum as he nods his head in agreement, "Yep."

We pause in front of the Rockefeller Christmas tree. A gargantuan, Norway spruce evergreen adorned with colorful lights and ornaments on every branch, limb, and twig rises like a monolith nearly nine stories tall. A shining five-point star at the treetop pierces bright white against the gloomy sky above.

Devon gawks at the tree then scans the ground beneath the branches. "What the shit? No presents? A tree that big and not even one present! Thank God we're about to become millionaires."

I roll my eyes at Devon and jab back at him sarcastically, "Poor baby. What's the matter? You didn't get enough Christmas presents as a kid?"

"Doesn't matter now, does it? With what we've got in that suitcase I can buy myself all the Christmas presents I ever wanted!"

"Like what? What do you want that you never got?"

Devon's eyes dance in the direction of the towering tree. He turns his head back to me with a sheepish grin, "I always wanted a Millennium Falcon."

Luke finds this hilarious and laughs into the cold wind that separates him and Devon. "An action figure? That's what you're going to buy with your cut of the money?"

Devon jabs his words back at Luke. "Not just any action figure. This was the original 1979 Millennium Falcon with the do it yourself sticker decals where you can design it however you want."

Luke stares at Devon, biting his tongue to hold back his laughter.

Devon glares at Luke, "Whatever. Fuck you, Luke!"

Luke bursts into laughter, "Easy, I'm just fucking with you. Do whatever you want. We just have to get this money first. Then you can buy all the little toys you want."

I pat Devon on the back as we all stand at the mezzanine railing to look down at the ice skaters circling below in the small rink. "There's nothing wrong with loving Star Wars. You know I back you on that like Revan in the lost episodes. But hear me out. You're about to take these stolen books to an appraiser. I'm telling you, they're going to trace the books."

Devon jumps onto the railing that overlooks the swarm of people skating below. "You don't know that. Just like you get to choose Revan's path. Life is whatever we make it. Look around you! Look at the immensity and wealth all around us! We are exactly where we need to be! We're supposed to be here! Just go with the flow for once."

"That's easy to say when you don't know what you're talking about. Devon, I'm a licensed appraiser! I know how this all works! I'm telling you this is going to get us caught."

"But what if it doesn't? What if it makes us millionaires? And all we have to do is take one more meeting to make it happen..."

Luke peers down from the railing by Devon's side. The excitement of the busy and thriving environment swarming around us infuses Luke with enthusiasm. He turns from the railing and catches the attention of a man passing by. The middle-aged man carries a leather satchel strung across his body atop of a well-tailored suit and overcoat. The man shakes his head and continues walking. Luke flags down an Asian man standing

nearby with his wife and two children. The man smiles kindly beneath a wool cap and accepts a camera from Luke. He steps back toward the railing and waves for us to bunch together. "What the hell, why not? Let's take a picture. How many times are we going to be in Rockefeller Center with our best friends."

Devon, Ethan, Luke, and I stand in front of the railing as the wind whips against our exposed faces. Devon wraps his lucky red scarf tighter around his neck. Ethan tugs the red suitcase in front of him to position it proudly before the camera.

The cameraman squints through the lens, "Okay, ready? 1-2-3!"

The four of us smile, and for a moment we're all happy together, at least in appearance. The man returns Luke's camera then returns to join his family.

I point across the plaza to a stone building on 49th street. The smooth stone walls of the building rise high into the city skyline like a fortress, a pillar of society. Thick clear gloss windows trimmed in black reflect outward into the city. A massive wall of gold-trimmed glass doors open to the sidewalk where pedestrians pass by and gawk at the artwork encased in cylindrical glass display towers near the streets. An American flag and a British flag proudly flank a red Christie's banner above the entryway. The building emanates a sense of old world power, prestige, and unshakeable tradition.

Devon admires the building with a smile, "There it is. Our ticket to a new life."

I turn my back to the building and lean against the glass railing above the ice rink, "After this doesn't work, we're going back to doing things my way."

"Just watch me and Mr. Stephens work our magic! Right, Eth? Why don't you two go back to the hotel and jerk each other off or something while we do all the dirty work."

Luke slams his fist into Devon's shoulder, "Fuck you, Devon. Just don't screw this up."

Devon recoils in pain from the punch and rubs his shoulder as I further Luke's sentiment. "Seriously, Devon. Don't give them anything that can trace back to any of us."

Devon laughs to ease the tension between us all, "Come on, boys. Have some faith. We've made it this far haven't we? Look at us. We're four kids from Kentucky standing in the heart of New York City about to meet with one of the biggest art dealers in the world. And we're carrying a suitcase with rare books and artwork worth more than a million dollars that now belongs to us. We did this! And this is the last step! Have some faith in me! I've got this. Well, we've got this. Right, Ethan?"

Ethan positions the red suitcase between us all. He looks up at the immensity of Christie's towering above us and musters a slight shrug, "Sure. Yeah, I hope so."

The four of us look up to the stone fortress of Christie's. I feel small, powerless, and insignificant standing in the shadow of the immensity that looms ahead of us. Reflexively, I reach inside the lining of my coat. My fingers touch the chrome barrel of the derringer feeling the instant power of death over life at my fingertips. Such power pales against the immense power of the system before us. The cruel inevitability of time destroys us all, but the profoundly entrenched establishment reaches back through time immemorial and thrusts forward with mechanized force into the future yet to come.

Releasing my grip on the derringer, I pat Devon on the shoulder for support, "We don't stand a chance in hell up against this place. But for what it's worth, good luck, Devon. You too, Ethan. Be safe in there."

Devon seems touched by the sentiment and for a moment pauses to accept the possible catastrophic nature of the actions ahead of him.

"Don't you worry about us. We got this, boys. We'll see you back at the hotel with good news!"

He grabs Ethan by the shoulder and pulls him forward. The red suitcase rolls behind them as they approach the gold trimmed entryway. Luke and I watch as they step inside the glass doors and the building swallows them whole.

DROP THE HAMMER

Floor to ceiling windows in our room in the Manhattan Hilton looks down on the cars and pedestrians that stream through the streets below. From the height of our room, the noise of people and traffic below becomes only hushed tones on the wind. I turn away from the window and drop lazily onto one of the beds still wearing my grey suit and red tie. The derringer hangs heavily in the breast pocket of my suit jacket. I bunch pillows near the headboard of one of the two queen beds and lounge back into the comfort.

Luke lies back on the other bed flipping through channels on the TV. He pauses on a movie—a tall, slim black man wearing a Jerry curl and a black suit paces the room with a chrome pistol. The man towers like a harbinger of death above a cowering young white man who sits in a chair. He yells at the young man, his voice rising with anger and intensity with each syllable.

"So, there's this passage I got memorized, Ezekiel 25:17. The path of the righteous man is beset on all sides by the inequities of the selfish and the tyranny of evil men. Blessed is he, who in the name of charity and goodwill shepherds the weak through the valley of darkness, for he is truly his brother's keeper and the finder of lost children.

A white man with long black hair hanging in streaks above his shoulders stands behind the young man cowering in the chair. The man wears an identical black suit and draws back the hammer of a chrome pistol as the black man's voice continues to rise.

"And I will strike down upon thee with great vengeance and furious anger those who attempt to poison and destroy my brothers. And you will know my name is the Lord when I lay my vengeance upon thee!"

Bang. Bang. Bang.

Gunfire erupts on the screen. The suited men squeeze the triggers with calloused hearts and stone cold faces as bullets rip into the body of the cowering young man. Blood flashes red across the screen.

Bang. Bang. Bang.

A knock pounds against the hotel room door.

I jump to my feet and walk cautiously to the door, fearing the police. Through the peephole, I see the distorted image of Devon and Ethan standing on the other side of the doorway. Swinging open the door, I rush them inside, "So, how'd it go?"

Ethan rolls the red suitcase into the room at his heels.

Devon beams with pride as he rushes toward the window to look out into the day, "It worked! We did it! They got us a buyer!"

I glance out into the hallway, ensuring they weren't followed, then close and lock the door behind them.

Luke jumps from the bed and hurries toward Devon to congratulate him with a one-shouldered hug. "That's great news, Devon! What happened in there?"

Devon dramatically pauses, then turns from the window to address us for enhanced effect, "We walked in there, and we were smart about dodging the cameras." He glances in my direction to silence my worries

before I can voice them. "We met with an appraiser, and she took a look at the books. She about died when she saw them! She absolutely loved the books! She wanted to know where they came from and I fed her a line about how our employer inherited them. So that squashed that! Then she guaranteed us that she could find us a buyer!"

My face contorts in disbelief, "So, what you're saying is, they didn't find a buyer they told you they will find a buyer. Am I hearing that right?"

Devon bounds forward into the room with excitement, "Yes! Don't you understand? Our work is done! It's in their hands now! They stand to make a lot of money off this deal too! Now we have the world's biggest auction house working for us! That's the kind of power we have, boys! I told you!"

He rushes to high five Ethan in celebration, "Tell them, Eth! Tell them what we just pulled off, or should I say Mr. Williams and Mr. Stephens pulled off!" Devon cackles with joyful laughter.

Ethan loosens a yellow tie from around his neck and removes his custard colored overcoat. "It went good. We laid the books out on a table, and some woman examined them. Then it was over. Now we just wait for them to connect us with a buyer."

Luke plops back down onto the bed, "How long did they say it should take?"

Devon regains control of the conversation, "Not long, maybe a week or two. They said they'll call us when they find our buyer."

A chill cuts through my core and my heart sinks into the pit of my stomach, "Wait. What do you say?"

Devon's smile curls into a smirk in one corner of his mouth as if challenging me for threatening to sour his moment of triumph. He repeats his words deliberately and with emphasis as if I'm slow on the uptake, "They're. Going. To find us. A buyer."

I walk across the room to where Devon stands and clarify my own words. My eyes flare wide with disbelief and barely bridled anger lurking beneath the surface. "No, the other part. You said they're going to call us."

Devon's smirk droops, and he looks away from my gaze toward the open expanse beyond the window. He slowly steps away from me. "Yeah, they're going to call us when they find our buyer," he clarifies.

My entire body tenses with rising anger, "Call us where, Devon? On what number?"

"They're going to contact us on Ethan's phone. Why?"

The rage within me ignites, "Why? Are you actually asking me that? Are you that fucking stupid? Give me your phone Ethan!"

Ethan mutters something inaudible. I hold my hand out in waiting, and I shout again, "Give me your phone, damn it!"

He produces his phone from his pants pocket.

I slam the phone down on a work desk near the window and withdraw my own phone. I furiously pound Ethan's cell number into the keypad and press call. Ethan's phone buzzes to life on the table.

Bzzzzz. Bzzzzz.

I press the speaker button on my phone. The recording attached to Ethan's number blasts loud into the silence within the hotel room.

"Hey, this is Eth! Leave it!"

Beeeep.

Devon sits casually in own of the armchairs near the desk. He dismisses the recording, "So, we change the message! No big deal!"

I set my jaw furiously and clench my teeth fighting back the rage inside of me. I stalk toward Devon on heavy footsteps to where he sits beneath me, "That phone is registered to his name! They're going to give that number to the cops, Devon! You killed us! That's it! You fucking killed us!"

Devon shakes his head and raises his voice in protest, "They're not going to call the cops."

I reach into the lining of my jacket pocket. My hand grips the wood grain handle of the pistol. I withdraw the gun from the jacket, and point the barrel at Devon's face, screaming at him in furious anger, "You don't know that!"

Devon recoils in fear as he stares into the barrel of the gun. His voice speaks softly, "Chas, you can't control everything. We did what we could. Now we have to hope for the best."

My arm shakes with fury as I bite down against my own clenching teeth, "No! There's no hoping in this! It's your fault! You have to go back in there and get that number! I don't care if you have to take this gun and rob Christie's! You have to get that number back!"

Luke stands from the bed with his arms out by his sides. He steps slowly toward me, "Chas, just calm down. He can't do that. That's crazy. We can't go back in there. Just put the gun down and relax. Everything's fine."

I swing the gun toward Luke, "It's not fine, Luke! It's over!"

I turn to face Devon again, pointing the gun at his eyes. "It's all your fault."

Devon swallows hard and stares into the darkness within the gun. "You can't blame me for this. We're all in this together. Now if you want to get your cut just put the gun down."

My breaths come in quick short bursts. My blood flows like fire within my veins, and Devon's words hit me like a punch to the chest. I shake my head in unwilling disbelief as the walls around my thoughts begin to collapse like ancient buildings imploding from within. What I believe to be true, and right, and real begins to crumble. Underneath the rubble of the structure that I built around me, all that I am left with is myself, and my choices, and my actions. I look straight at what I see within myself, and I hate it.

I shout in a fit of fury, "Ahhh! Fuck!"

The patchwork structure built with misguided promises and deceitful actions committed during times of shared suffering burns within the fire of my own anger. My breathing heaves within my chest.

The façade of my clouded judgment begins to clear. I lift my eyes toward where Devon sits. I speak from the smoldering ashes of my own understanding and bore inside of Devon with my eyes as I point the gun at his face, "You're right."

Devon watches me perplexed as I continue. My anger rises in intensity with each syllable I speak, "It's not your fault. It's my fault! I was so stupid! I should have never gotten involved with you idiots! I am so stupid! I ruined my life listening to you fucking morons!"

Luke steps forward to console me. I turn my anger toward Luke and point the gun at his chest, "Back up, Luke! You should have listened to me! I told you! I told you all that this would happen. But no, Luke. You want to be a big man someday. Don't you? You think you're so fucking tough? Like you can just strong-arm your way into what you want. But you can't! You're fucking small! You're weak, and you don't think for yourself! You'll never be your own boss like you want!"

Luke clamps down on the words at the tip of his tongue. He stares hard at the barrel of the gun and then chooses not to speak.

I lower the gun and step toward him, challenging him with nothing more than my eyes. Luke's chest deflates, and his shoulders slump as he chooses to say and do nothing in response. I spit my words at him in disgust, "That's what I thought."

I turn toward Ethan, the gun down by my side, pointing at the carpet below. "And the same goes for you, Ethan. Always doing everything that Devon wants! You should have listened to me! Or at least to yourself! I've never heard you stand up for yourself, not once since I've ever known you! Man up! Stop following this idiot!"

Ethan looks down to the floor. He lifts his gaze toward Devon with shame in his eyes in search of solace.

Devon offers nothing in return.

I turn to face Devon, "And you. You're so busy keeping track of all your lies you can't stop yourself from making simple mistakes! You gave them Ethan's real phone number! Everything up to this point was done with fake I.D.s, untraceable emails, and phone calls from pay phones. We even walked around disguised as old men! And you give them a real phone number. You're pathetic. And I'm even more pathetic for not noticing it sooner."

Devon rises from his chair with a gleam in his eye, "You think I'm pathetic. You think I fucked up. No, you had it right the first time my friend. You fucked up. You have no idea what I'm capable of."

I tuck the gun back into the lining of my jacket pocket.

A smile tucks into the corners of Devon's snarl, "I had your life in my hands, and you didn't even know it. I talked to Lincoln's dad."

Luke and I look to one another in disbelief, unwilling to believe Devon's words. My anger subsides into my own doubts and worry. Devon senses my trepidation and drives forward with relish.

"That's right. I called him. He wanted to know who robbed him."

Luke interrupts, "What the fuck, Devon? You ratted us out?"

"He really wanted to know who took that money. But don't worry. He didn't go to the cops. He said he wanted to teach the people who robbed him a lesson himself."

I watch Devon's grinning figure as if I'm seeing him for the first time in my life.

He continues, "He was willing to pay five grand for your names."

Luke steps to my side. He squares his body toward Devon and sets his jaw.

Devon smiles at the two of us, "I needed the money to get to Amsterdam."

Luke raises his voice, "What? But you said you took my money to pay for Amsterdam."

Devon smiles, "That's right. You cut me in, even though I had to force my way into the deal. And because you cut me in, I didn't give up your names. I didn't tell him anything."

Devon cuts his eyes toward me, "You want to call me pathetic. All it would take from me is one word to the right person, and then your life will really be over. Who's the pathetic one now?"

Luke throws his fist into Devon's stomach. Devon buckles at the waist and drops to his knees. I look down at his face contorted with pain, writhing in his own anguish. A wave of pity flows through me. Deep sadness impacts me as I look into Devon's eyes. In him, I see a reflection of my own shameful actions and the expression of the pain locked inside of me. I hate what I see of myself in him.

Devon transforms the pain into laughter. He stares up at Luke and me in delighted defiance relishing in the release that the wave of pain brings as Luke punches him again. Devon laughs in the face of his own self-destruction as his body curls down to the floor. I look down at him in disgust.

I pull my foot back and kick him violently in the ribs while he's down. I kick him again. His body squirms like a snake with each kick. He laughs in response, not fearing the next attack, but longing for it. Stepping away from Devon, I feel more disgusted with myself than ever before. I shake my head in disbelief toward Luke and shoulder past Ethan as he stands and watches Devon's anguish. I throw my coat onto my shoulders and bolt out of the room uncaring where my steps carry me next.

BACK IN LEXINGTON

Birthday cards stand on my dresser wishing me a happy twentieth birthday.

I feel no happiness. My body languishes lethargic in bed as I watch the flicker from the TV screen. A blond haired woman swings a samurai sword in vengeance and gory violence to rectify her past. The screen sprays with blood with each swing.

I hear footsteps on the main floor of the house below me.

Knock. Knock.

Knuckles wrap on the door to my room. I yell toward the bottom of the stairs, "Yeah! Who is it?"

A voice I recognize answers.

"It's me," she says.

I pause the movie and jump out of bed wearing only boxer shorts. I walk around the railing and down the straight flight of stairs to unlock the door. It swings open, and Claire stands in the doorway. I welcome her with a look of sorrow.

She looks back at me with smiling bright blue eyes, swimming with hope. I don't feel worthy of that loving look, but her presence strikes me with a feeling of hope like a blind man seeking light at the end of a tunnel. She looks up at me and tucks several strands of hair behind her ear. She doesn't say anything, but she doesn't have to.

I reach out to her, and she wraps her arms around me. Her warmth embraces me like a long-lost blanket from childhood. I take in a deep breath, savoring the moment, then pull away, awkwardly blocking the doorway, "It's so good to see you. Here, sorry, let me get out of the way." I stand aside as she brushes past me and climbs the straight set of stairs that opens to my room. I lock the door and hurry up the staircase.

She notices the movie on the screen, then turns to face me.

I step toward her and smile softly, "I need to."

She interrupts, "Hold on, can I first just say something."

"Sure."

She places her hand inside of mine, "I shouldn't have walked away like that when Phillip was in the hospital. I'm sorry. I just —"

I interrupt her, "Because you hooked up with him."

She pulls her hand away, "Just let me finish. Please."

"Sorry."

She rubs her neck as she continues, "I just don't know what I want, sometimes. You know? I'm scared that I'll miss out on the whole college experience because we've been together so long. But I know I want to be with you too. I love what we have. Or what we had? I guess what I'm trying to say is, I'm sorry."

I want desperately to tell her everything. I want her to know the secrets that are burning a hole inside of me. "I'm sorry too," I say.

Her face clouds with confusion, "For what?"

I look away, unable to see myself within her eyes. I see only my own darkness reflected back at me. Memories flash through my mind at the speed of thought.

Lincoln says, "You should rob my dad."

A cigar box rests in my gloved hands. I open an envelope stuffed with hundred dollar bills.

I take a green pill from Devon's open palm.

Snakes hiss and slither at my feet.

A SOLD sign sways in the wind.

The reflection of my masked face stares back at me, aged, wrinkled, and defiant.

———

I lift the corner of the Audubon book in the Special Collections Room.

My hands grip the steering wheel as my Aunt's van careens through traffic.

The Illuminated Manuscript gleams gold and green atop the ancient pages.

I stare up at the enormity of Christie's auction house.

My eyes swell with sorrow and shame as I attempt to meet her gaze. She looks steadily into my eyes and holds my pain with patience. I want to tell her the truth, the whole truth, but I'm afraid. I fear her rejection. I fear her judgment. And I fear the pain. I'm scared that she will see me, truly see me, and despise what she sees.

I want to share my truth with her, but I can't. I know I can't.

I don't trust her.

My lips break the silence and kiss her lips gently. I allow our mouths to part and look into her beautiful eyes. "You're here now. That's all that matters."

Her face softens and her lips part. My mouth hungers for her touch as my arms pull her slender body in close to mine. The warmth of her body radiates into my chest giving new life and hope to my heart. Our lips collide with passion and force like two magnets kept apart for far too long.

She pulls away and looks into my eyes. The heat from her soft breath flows against my lips as she speaks, "I just want us to go back to the way we used to be."

The hope within her words speaks the truth of my innermost desire. But I know we can never have that again. "Me too. I want that so bad. But there are some things I have to do first."

Mischief flashes across the freckles of her face and dances within her blue-green eyes, "Like what?"

I hold her close, not wanting to let her go as I pull our bodies down onto the bed. Our lips embrace, and my hands explore the curves of her body as if for the first time all over again. Her hands wrap around my back and pull me tighter into her. I can barely tear my lips apart from hers long enough to speak more than one word at a time, "I. Have. To fix some things. I'm going. To have to. Go away for a little while. But I'll be back."

She pushes me away. Her eyes widen as they search my face, "Where are you going?"

I pull her close and kiss her, letting my lips linger on hers before we part again, "It won't take long. I promise when I get back, we'll be able to go back to the way things were."

Her lips part to speak, but my lips catch the words on the tip of her tongue before they can escape her mouth. My lips move from her lips down her chin and onto the soft, sensitive skin of her neck. The words on her lips escape her mouth in the form of breathless moans of pleasure. I pull her body closer and closer to mine with every breath that escapes our lips.

My thoughts drift into her and out to the worries and stresses that lie ahead. In three days Luke and I plan to move to Charleston South Carolina. From there we plan to take our half of the stolen books across the United States border into Canada to meet with a new buyer.

Our bodies roll across the bed sheets with desperate, reckless abandon. We relish in the loving connection that we share with each and every touch and caress of our bodies.

The evening turns into a dark night, and eventually, we fall asleep in each other's arms.

WAKE UP CALL

"Chas! Wake up! Wake up!"

Claire violently shakes my arm, "Someone's in the House! Get up!"

My eyes squint open do total darkness within my bedroom. I rub my eyes, struggling to see. My ears strain to hear the noises crashing from the rooms below. "Huh?" I grumble.

The front door to the house crashes open with a bang. Footsteps stomp on the hardwood floor of the living room. A bedroom door opens. A girl screams. A guy shouts something I can't understand. A door opens.

Claire grips my arm like a vice, "Oh my God! Oh my God! Someone's here!"

Against the backdrop of darkness within the room, I squint to make out Claire's face. I can only see the terror-stricken whites of her eyes.

I throw back the bed covers and jump out of bed. I fumble through the darkness until my hand feels the pull-string of an overhead light illuminating the bedroom in dim light.

Footsteps grow louder and more rushed as they race through the house below. The intruders shout indistinctly to each other in hurried voices.

"Chas! What's happening? Oh my God!"

"I don't know!" I do know though.

Devon lied. Lincoln's Dad knows we stole his money. He wants his money back, or worse.

I scramble through a drawer in a nightstand beside the bed. My hand grips the spiked steel knuckles of a WWI trench knife with a seven-inch double-edged blade. I hold the heavy weapon of war in my hand, and the commotion below grows louder.

My ears strain to understand the sound of boots stomping through the living room below. The heavy footfalls grow louder and double in number. The muffled voices become angrier, more violent. Wood cracks and splinters. Locked doors break and crash open on their hinges.

I drop the trench knife and rush around the bed to the closet. My hands dive under a pile of laundry. Cold steel brushes against my fingertips. My fingers wrap around the handle of the double-barreled two shot derringer. I break open the chamber with practiced precision. In the dim light of my room, two hollow point bullets gleam silver and gold.

Bang. Bang. Bang.

A heavy-fisted hand slams against the door at the bottom of the stairs that leads to my room. I lock the pistol chamber, ensuring the gun is loaded and ready to fire. My eyes dart toward the stairs but fall first on Claire. She kneels on the bed bolt upright. She clutches the sheets close to her chest, and her eyes plead for everything to be okay. Her lips quiver as stares at the gun in my hand. "What are you going to do?"

I look down at the weapon in my hand, then back to her as the banging on the door to my room grows louder, more insistent. "I don't know! Here! Come over here, hurry!"

She hurries toward me. Her body looks so small, and frail gripped with fear in the dim light.

I hold open the closet door, "You have to hide! Get in here!" She shakes her head, no, but I guide her into a dark corner. "Hide, Claire! And don't come out! No matter what!"

Shouts grow louder from the bottom of the stairs. Boots clomp on the hardwood below, and bodies gather near my door.

Claire's body shivers in the dark of the closet. Tears of pure terror flow from the corners of her eyes and snot runs from her nose. She sniffles and her lips quiver as she speaks quietly from the dark. "What are you going to do with that gun?"

"I don't know," I say as I begin to close the closet door. Our eyes meet, sharing in the terror. I rush forward and kiss her. Our lips linger, never wanting to part. Then I back away from her with the cold wetness from her tears drying on my face.

"Whatever happens, don't come out! Promise me!" I insist.

She doesn't answer. Her eyes stare at the gun in my hands.

"Look at me! Look at me! Promise me!"

She lifts her eyes to meet mine. Her voice shakes as she speaks, "Okay, okay, okay. I promise." Her body calms, and her voice steadies as her words resonate with her.

I look into her eyes, and I see the face of death clearly in front of me. Presented with the possibility of death ahead I feel the pulse of life and love within her, and within me, and the power of the bond and connection between us. I know that if I have to take another life to protect her, I will. We lock eyes and lips together one last time.

"I love you!" We both say as I close the closet door.

SHOWDOWN

Bang. Bang.

The pounding on the door booms like a cannon throughout my bedroom. I race across the long shotgun-style room with the derringer in my hand and pause at the top of the stairs. Each step down leads to further darkness and the noise from the banging on the door grows louder, more insistent.

A deep voice beckons from the other side of the door at the bottom of the landing, "Open the door!"

I respond with silence. My stance widens, and I plant my bare feet down into the carpet. I raise the double barrel of the gun toward the darkness below. The door rattles on its frame as the intruder bashes the butt of a shotgun against the wood. My heart pounds against the walls of my chest as violently as the intruder banging on the door.

The wood cracks.

The door splinters.

The butt of the shotgun breaks through an opening in the door. A gloved hand forces its way through the splintered wood, searching for the lock.

My breath comes in slow, deliberate waves to steady my hands that grip the handle of the gun. My finger pulses on the trigger. My eyes stare down the barrel and through the bead of the weapon, aiming at the gloved hand as it searches for the lock. Voices boom from beyond the door, shouting incoherently. I only have two shots, and I know I need them both. My thumb pulls back the hammer readying the gun.

The gloved hand turns the lock.

The doorknob spins, and the door crashes open.

A bear of a man bursts through the open doorway covered head to toe in black. His enormous figure fills the darkness at the base of the stairs. I steel my resolve and aim the derringer at the exposed side of his face. My finger tightens on the trigger, and my eyes adjust to see the man, the human being, centered in my sights. His eyes widen as he stares into the face of death. Shock freezes his body and paints his face with fear.

I yell down into the darkness the only words that come to mind, "Freeze!"

Black protective gear and a bulletproof vest cover his hulking figure. He holds a shotgun in his hands and wears a hat that reads F.B.I.

My world screeches to a halt.

I can't move.

I can't react.

My mind and body freeze, lifeless, staring into the face of my fate. A thousand yards away, but undeniably close.

The man reacts to my hesitation. He swings the shotgun at my chest with his finger on the trigger.

We lock eyes.

For an instant, we connect, and he sees me as the human being that I am. He hesitates, and his finger hovers above the trigger. He shouts to his team, "He's got a gun!"

The man rushes up the set of stairs. His bulletproof vest reads S.W.A.T. Two members of his team rush up the stairs behind him. Their bodies flow up the staircase like a dark blur, unstoppable and determined. My hands drop down to my side, and the man knocks the gun from my hand. He tackles me and slams me down onto the floor. Pinning me down and pressing my face into the carpet. Another body leaps down on top of me, driving an elbow into my spine and shooting hot white pain throughout my entire body.

The man who pins my face to the floor shouts a command, "Don't move! Don't resist!"

My words come muffled with my attempts to breathe through the fibers of the carpet, "I can't. I can't. Breathe."

The man on my back wrestles my hands behind me. He pins my shoulder to the floor with his knee. The cold steel of handcuffs clutches around my wrists. A firm grip clicks the iron tighter into my skin. Every cell inside my body recoils against their captivity. I struggle to move, but their combined weight holds me down.

From the vantage point of an insect smashed down into the floor, I see a swarm of black vests ascend the staircase and fill my room. A man wear-

ing blue jeans and a tactical vest approaches me. His hat that reads, F.B.I., covers red hair trimmed to his scalp. He crosses his arms over his chest and looks down at me with the beady black eyes of a serpent. "Charles Allen?"

I breathe a strained sigh of resignation through the fibers of the carpet, "Yes."

The beady-eyed man signals the men holding me down against my will to release me. "My name is special agent Markum, and I'm task leader of this operation. We have a warrant to search the premises."

The men unburden their weight from my back. I groan in pain as I plant my feet down on the carpet and stand tall wearing only a pair of boxer shorts. I hold my head high and attempt to regain my dignity as I meet agent Markum's gaze, eye to eye.

I gesture to my nearly naked body and my hands pinned behind my back with cuffs, "Can I at least put some clothes on?"

Markum assesses me with eyes like daggers, then looks to his men, "Uncuff him."

The steel cuffs release my hands, and I find the nearest clothing to cover myself. I remove a pair of pajama pants and a sweatshirt from a wicker laundry basket.

Satisfied, Markum signals to his men. They pin my arms behind my back, and again the cold bite of steel binds my hands. Two men grip me above the elbows and force me toward the stairs. When we reach the stairs, I take my first step down toward the darkness below. I struggle to lift my eyes toward the light above as we descend lower.

Across the bedroom, Claire stands outside of the closet. Her hands pressed against her chest, holding her heart as if to prevent it from spilling down to the floor. She looks to the black uniformed men and then to me, not willing to believe her eyes.

———

I meet her eyes, and she pleads silently with me to give her a sign, a signal, anything that will let her know that everything will be okay. She begs for me to provide her with a nod, a wink, anything that denies the truth, the fact that I am a criminal.

My eyes only confess my shame.

A single tear falls from her eyes, and something shatters within me. A hollow, empty feeling consumes my chest, and I can barely breathe as the S.W.A.T. team forces me deeper down the stairs. I struggle to reach out to her, but she is too far away, and the unflinching steel pins my arms behind my back. I hang my head in sorrow and descend lower into the darkness. The image of her face streaked with tears burns brightly within my mind.

D-BLOCK

Artificial fluorescent light glows from above. I sit on the edge of a bunk in an eight by twelve-foot concrete block cell. A glass and steel wall looks out to a communal pod where seven other jail cells meet for lunch and dinner. Another glass and steel wall beyond the pod looks out to a control station with a central vantage point to observe the other four pods of D-block, a cellblock-housing unit of Lexington's most severe criminals. Most men held captive in D-block face murder or rape charges. Luke, Devon, Ethan, and I gained the privilege of such esteemed company due to our crime receiving a federal classification, meaning our criminal charges rank higher in severity than any of our neighbors in D-block.

One fat male guard picks his teeth as he lounges in an office chair within the control station. The inmates inside of their glass, concrete, and steel containers of D-block sleep, pace, or stare blankly at the consequences before them.

I stand from the edge of my bunk. A dark hunter green jumpsuit covers my body. Rubber soled green slippers and threadbare itchy socks cover my feet. Goosebumps stand on my skin against the frigid forced air temperatures of the block. The jail resides underground, and I haven't seen the light of day for nearly a week.

I shuffle to the stainless steel toilet and sink combination. My thumb presses a steel button, and cold water trickles from a spigot. I fill my hands with water and drink quickly before the water trickles off. A cold shiver runs through me. I fight back the cold and rub the excess water from my hands onto my face. A pale reflection stares back at me from a stainless steel mirror bolted to the concrete block wall. My face looks thin and gaunt. The usual warmth of my cheeks seems grey and drab. Heavy sleepless bags hang under my eyes. My green, hazel, and yellow irises stare back at me void and lifeless.

Clink. Clink. Clink. Clang.

Mechanical sounds rebound through the cellblock as electric locks to the cells click, and the thick steel and glass doors slide open. I turn away from my reflection and exit the cell. The inmates in the neighboring cells shuffle through the pod wearing green jumpsuits similar to my own. I spot Ethan in line ahead of me. All the inmates of D-block form a single file line in the central area. One by one an inmate takes a plastic meal tray from a metal cart and fills a Styrofoam cup with their choice of high-fructose corn syrup fruit juice, red or purple. I take one of the stacked trays and choose red juice.

After receiving our meals, we all migrate back to our assigned pods. I make eye contact with Devon and Luke as they wait their turn in the line. Devon's blonde-tipped tied hair is grown out and shaggy around his ears with dark roots. His angular face droops with defeat. Luke walks on sturdy legs, but his shoulders slouch forward. He looks frail inside the green jumpsuit. I attempt to hold my gaze firm in their eyes, and they each do the same, lending one another our strength.

I return to my pod and take a seat at a steel table with four individual steel stools bolted to the floor. Ethan places his tray on the table and sits next to me. His slumped shoulders huddle tightly together, and he blows hot air into his hands as he rubs them together for warmth.

Ethan turns to me with a half-hearted smile, "Is this seat taken?"

I gesture toward the central area, "I made a reservation days ago. They could have at least given us a table with a better view."

Two inmates drop their trays onto the table and slide into the available stools. A wiry dark-skinned man of about thirty sits across from me. His hair rises several inches from his scalp in an unkempt Afro. A young light skinned guy near my age sits across from Ethan.

Clink. Clink. Clink. Clang.

The metal and glass door to the pod seals closed and mechanically locks us inside.

I remove the plastic lid from my tray to expose one piece of stale bread, a hotdog, and a slathering of wet, runny beans, and chocolate pudding. My stomach churns at the miserable sight.

I remove the pudding from the tray then push it toward the wiry guy in front of me, "You want it?"

He glares at me in stupefied shock, "Hell, yeah I want it! You not going to eat it?"

"Nope. Have at it."

He lunges across the table and grabs the bread and hotdog and drops it onto his tray. I gesture toward the beans, and he shakes his head no. I turn to the young guy next to him, "You want it?"

He gently shakes his head no and speaks softly, "Nah man, you gotta eat. I can't take your food like that." His eyes hold back a dark sadness within him. He looks like a vicious dog that lost his will to fight.

I scoop a Spork full of pudding into my mouth, "I'm still recovering from the last meal I ate. We should be getting out of here soon anyway. My attorney said the judge is going to let us out on bond while we wait for sentencing."

A small smile lifts one corner of his mouth, and then disappears, "You're lucky. In that case, then yeah, I'll eat it."

The wiry dark-skinned guy claps his hands and points a finger across the table at me with a menacing smile like a fox in a henhouse, "I know you." He points his accusatory finger toward Ethan, "Both of y'all! I seen y'all on the news!"

He jumps back from the table to point at both of us and make an announcement to the cellblock, "These those white boys from the news y'all!"

My heartbeat quickens. My nerves dance with fight or flight instincts throughout my body.

The guard shouts from the control station, "Sit down, inmate!"

The wiry guy claps his hands and yells to the block as he stares back and forth between Ethan and me, "They famous y'all!"

The guard stands from his chair, "Inmate! Sit the fuck down!"

The wiry guy drops down onto his stool and leans over the steel table with excitement flashing in his eyes. "Y'all white boys crazy! You the ones that stole them books! Aren't you?"

I exhale with an uneasy sense of relief as I turn to Ethan, "Yeah, guilty as charged."

The guy continues redoubling his excitement as if he stands on stage performing a comedy act. He leans toward us conspiratorially with eyebrows dancing as he speaks, "And they charging you for that? Like it's a crime?"

Ethan and I nod in agreement as he plows forward, "That ain't no crime! Y'all stole some books! That's the difference between white folks and black folks. I stole plenty of things in my time. Money, drugs, cars, you name it! But ain't no black muthafucka I know ever steal some books! That's gangster! That's some Brad Pitt Ocean's Eleven type shit!"

Ethan and I share a look of relief and laughter as he continues his rant, "See, y'all were smart. Y'all stole books! Y'all stole knowledge! You over here just trying to learn!"

He claps his hands in excitement, "Y'all shouldn't be locked up for that! Y'all should get a medal or something'! Stealing knowledge… look at you two! Smart ass muthafuckas. Just out here trying to learn. Damn." He shakes his head, smiling at the audacity of Ethan and I sitting across from him as he takes a bite of a hotdog rolled inside a piece of bread.

Feeling safer with my surroundings I continue eating my chocolate pudding, "What are you in for?" I ask.

The wiry guy shakes his head and sucks air through his teeth, "A bunch of bullshit, I can tell you that much! But for real I can't really be talking about it, 'cause I'm just here waiting for my trial, you know?"

"Yeah, I know what you mean. How about you?" I gesture to the young guy sitting across from Ethan.

He sighs heavily and looks off into a familiar distance that I now recognize, "I'm waiting for trial too."

"Trial for what?"

He stares down into the food on his tray, then looks up with eyes lost and searching for a home. "Murder."

I take in the magnitude of his truth and nod my head letting him know it's okay to continue.

He finds the strength to look me in the eye and share his story. Pain paints his words with sorrow and misery as he speaks with deliberate in-

tention, "I was stupid. That's what I was. I just turned eighteen, and I got a fake ID. It worked a few times to get me in the club. So, I took a girl with me this one night, and I was strapped. I was really feeling her, you know? But this guy kept eying her. I knew his little brother, and it just bothered me. You feel me, Fam? So, one time he bumped into me, and he stepped on my shoes."

He looks up from his tray of food to look me in the eyes.

"So, I pulled out a gun and shot him in the face."

RISE AND SHINE

Clink. Clang.

The steel and glass door to my cell slams open. A bald headed guard with a barrel chest and a beer gut shouts from the control station, "Allen! You got a visit!"

My eyes open to see bright light as if looking up from rock bottom, squinting at first, but widening with profound gratitude. I toss the thin fabric covers to the side from where I huddle shivering beneath them. I slide my green slippers over my socks. The rubber soles smack the concrete floor as I press the water button on the sink. My hands dip under the frigid water and I splash my face, ignoring the reflection that stares back at me from the steel mirror bolted to the concrete block wall. I briskly dry my face with a faded orange colored washcloth and stride a few paces to step out of my cell and enter the central area of the small eight-man cell pod. The guard presses a button from the control station in the main room.

Clink. Clang.

The steel and glass door to the pod slams open. I stride into the high ceilinged main room that observes the five eight-man pods inside Cell

Block D. Three pods reside on the lower floor. Two pods house lives on the second tier.

A scruffy headed middle-aged inmate mops the floor of the main room with his eyes glued to a TV screen. I cross the high ceilinged room to the stairs and hustle up the steps two at a time. I turn left and continue walking where windows look out from the confines of D-block and into a small white room. I pass the first two windows and see only the white room.

Behind the third Plexiglas and steel window I see my family. My mom sits in a plastic chair on the other side of the window. My brother and sister stand at her sides. They crouch down and huddle together to see up through the window as I approach. I sit on a cement block stool and look at my family through the window. Their faces all line with long streaks of tears.

My heart shatters. I press my hand against the window, seeking their warmth and love. Their three hands press against the glass, but the glass remains cold to the touch.

My head drops in self-pity and defeat. I look down toward the cement floor and away from their eyes, "I'm sorry, guys. I'm so sorry."

Lynne sniffles as she wipes the eyeliner from her eyes with a knuckle, "It's okay, honey. You don't have to be so hard on yourself. I'd say you're going through enough punishment already."

I fight back the tears rising in my eyes as I lift my chin to see them, "I know. I just, I don't know. I'm just sorry."

Blake sees my pain and steps toward the glass window. He brushes aside his tears and lifts his shirt reenacting a Jim Carrey scene from Cable Guy.

Blake smashes his exposed nipple into the Plexiglas.

"Oh, Billy!"

A laugh cuts through my pain and we both push down our tears through nasally sniffles.

Sydney smiles at our laughter and one by one we remove our hands from the cold glass.

My mom's eyes search into mine to find her words, "Never in a million years. I just couldn't ever imagine my son in jail. But we're here and we're here for you. No matter what. We love you."

Her words sink in and strike me with profound gratitude, "Thank you, Mom. I love you too. I love all you guys." I lean closer to the glass, "Did you hear anything from the attorney?"

"He said he's working on it. Hopefully tomorrow."

"Okay, thank you. That would be great. Tomorrow would be so great. Did he say what time?"

Lynne shakes her head no, then looks up to Blake at her side.

Blake smiles at her, then looks to me, "When you talked to the attorney did he say how much time he thinks you might get?"

I raise my hand to scratch my chin, unsure of how to answer Blake. I want my family to know how much trouble I'm in, but I don't want them to worry about me. I want to be strong for them and not add to the pain they are already going through.

I let out a heavy sigh with my answer, "Hopefully probation. I talked with the probation guy about the presentence bond and he said we all stand a good shot at getting probation. We all plead guilty and accepted responsibility for everything, so he said that lowers our sentencing guidelines."

My mom shakes her head, "What does that mean?"

I shrug and try to convey as much hope in my voice as I can muster, "Maybe a lengthy probation. Or he said at worst a minimum-security

camp. And camps don't have fences or razor wire and all of that. He said if everything goes well maybe only a year or so. At least I hope."

My mom reaches her arms around Blake and Sydney and pulls them close, "It doesn't matter what happens. No matter what, we're here with you. Isn't that right guys?"

Blake and Sydney both nod their tear streaked faces in agreement.

Bnnnng.

A loud buzzer sounds in the central area of the jail behind me.

The guard shouts up from the control station below, "Time's up! Visitation's over, Allen. Back to your cell!"

I press my hand against the glass. They reach out to press their hands against mine. My other hand touches my heart as I stand from the concrete stool, "I love you guys. It's going to be okay. I promise."

Their eyes follow me as I turn and walk away, refusing to look over my shoulder at them. I roll my shoulders back and lift my chest to show them my strength, and to fight back the fears of what lies ahead. The rubber soles of my slippers slap on the corrugated stainless steel walkway, then down the steel steps. I return to my eight-man pod. A steel and glass door locks behind me.

Clang.

I enter my solitary cell. A steel and glass door locks behind me.

Clang.

I stumble across my cell on weak knees and plant my hands on either side of the stainless steel washstand and toilet apparatus bolted to the smooth concrete floor.

My sunken cheeks reflect my misery back at me in the stainless steel mirror. Bags hang under my eyes heavy with sorrow and my brow furrows with worry and fear. I can feel my skin draw tight fighting to survive. The

image of my own face sends chills down my spine. I study each contour and detail of the reflection that stares back at me. Forcing myself to accept what I see.

With all of my flaws and all of my mistakes,

I accept what I see.

For all of my weakness and all of my striving,

I accept what I see.

With all of my misery and all of my shame,

I accept what I see.

For all of my pain and all of the blame,

I accept what I see.

With all of my sadness and all of my doubts,

I accept what I see.

For all of my madness and all of my bouts,

I accept what I see.

With everything I lack,

With everything I possess,

I accept what I see.

For all that I am,

For all that I was,

For all that I hope to be,

I accept what I see.

Because what I see, is me.

A stillness falls over me. I take a deep breath, filling my lungs and expanding my chest. I exhale and release my breath with a deep sigh looking into the eyes of my reflection. Truly looking, I see myself. I am a reflection of every choice I have ever made in my life. I stare into the pale pupils

before me and tears rise from my heart and spill from my eyes. My face shutters with a wave of relief that morphs into a deep-hearted laughter.

I look, and I laugh, and I accept myself for who I truly am. The scars and the marks of life make me who I am. Every passing moment I can choose to redirect my reflection toward any way of life I choose. Each moment can be a blessing or a curse, an opportunity or a burden. I can be a criminal, or I can be a saint. I can choose. We can all choose. The power lives within us.

I look into my reflection and I laugh. I laugh at how hopeless I felt. I laugh at how I felt the need to be powerful when I felt powerless. I have everything I need when I have nothing at all. I have a sound mind that advises me. I have an able body that carries me. I have a spirit that guides me.

My hand grips around the Saint Christopher medallion hanging from my neck. I lift the medallion to my tear streaked lips. Then whisper through quivering lips pressed against the medallion, "It's all going to be okay. It's going to be okay."

HAVE YOU HEARD THE NEWS?

My eyes open to bright light. I stretch my arms wide and extend my legs to the furthest reaches of my king-sized bed. Sunlight streams in through the blinds of the first-floor bedroom in my family's house. The alarm clock on the oak nightstand reads 11:02 A.M. I toss back the covers and get dressed wearing a pair of blue jeans, Air Max sneakers, and a pullover.

My mom stands at the kitchen countertop sorting through the day's mail. She greets me with a cautious smile, "Hi, Charlie. Good morning."

I wipe the sleep from my eyes as I swing open the refrigerator, "Good morning. Are we out of milk?"

"We must have just run out. I know Blake had some this morning."

I gently close the refrigerator door, "I'll go pick some things up from the store. What else do we need?"

"Nothing, Honey. We're fine."

I peek over Lynne's shoulder as she flips through the mail in her hands, "Anything in there for me?"

Her hands stop moving, and she places the mail carefully on the counter. She turns to face me, and the sadness in her eyes scares me.

"What is it?" I ask.

"I didn't want to upset you, but I knew you'd probably hear about it anyways." She gestures down to the countertop at the newspaper. Big and bold the headline reads:

"TRANSYLVANIA UNIVERSITY BOOK HEIST: A BRAZEN PLOT DOOMED TO FAIL."

Beneath the headline my mug-shot stares defiantly back at me, positioned next to Luke's picture, then Devon's, and then Ethan's.

My blood writhes with shame coursing through my veins. A primal sense of dis-ease, abandonment, and disconnection from my community thickens my throat. My eyes feel warm with self-pity. Painted big and bold for the community to see, I am branded a criminal.

My eyes look up from the page to my mom, "Again. Really? Can't they just leave it alone?"

She holds back tears as she reaches a comforting hand over the counter to hold mine, "Don't pay any attention to what they say. You know who you are, and the people that love you will always love you."

"I don't know, mom. They don't even get any of the facts right. And, look, here." I press an enraged finger down to the words on the page, "They're trying to make it look like it was all me since Dad owns the auc-

tion house. Like it was my idea to steal the books in the first place. And look! They're even trying to draw a connection to the auction house and why we went to Christie's!"

Lynne moves closer to me at the counter and wraps an arm around my shoulder, "That's what the courts are for, honey. They're just trying to sell papers, that's all. Don't buy into all of their hoopla."

"It's just not right, mom. Any of it. None of my friends act like they even know me anymore. They don't return my phone calls. Even Phillip! I saw him at the grocery store last week, and he pretended not to see me."

My mom lifts her hands to my face and looks into my eyes, "Sweetheart, they just don't know what to say. Sometimes life gives us problems that are just bigger than some people can handle. But I know you can handle this. You're strong. So, you don't worry about what anyone thinks, okay?"

Air fills my lungs in gasps as I struggle to keep my head from drowning in the rising currents of self-pity. I shake my head and turn away from her love. "Even Claire. She left me when I needed her most. She said it was too much going on, especially with how they keep dragging me through the mud in the news. I've been waiting for months now. I just want to get this over with and move forward with my life."

"You have to let go and let God, honey. This too shall pass."

"God doesn't give a shit about me. He hasn't for years."

She extends a hand and smacks my cheek. The sting from her hand resonates on my skin as the blood rises to warm my face. "Don't you ever say that! Now you can be right with yourself and with your family, but you better find a way to get right with God. You are too blessed to be talking like that! Even with all of this going on, we have a roof over our heads, and food to eat. You hear me? We are too blessed! As a matter of fact, we're going to church this Sunday, and I expect you to come."

My shoulders brace against her words. I hang my head and break our eye contact to look out the window. Sunlight shines through the blinds onto the white Corian countertops and tile floor.

A slow sigh slides from my lungs as I respond, "Say a prayer for me, then."

REUNIONS

The frosted and brittle landscape crunches beneath my footsteps as I meander through a memorized trail of headstones. The cold slabs of granite stand stark against the bitter winds of winter. I approach a familiar site.

I read the inscription of a low, stout headstone, "In loving memory of Ryan Bowen." I exhale deeply, and my breath scatters into steam on the wind.

The tree line beyond the hills of the cemetery sways in the breeze and the sky looms grey overhead. I stuff my hands deep into my pockets, unsure what to do next.

My eyes drop down to the earth, and words begin to roll from my chest, "Why'd you have to do this, huh?"

I laugh softly, and the wind consumes my words.

I look up to the sky. "And you, up there. Why didn't you do anything? I thought you're supposed to be all-powerful. And you couldn't even stop him from dying. He didn't deserve this."

I bite my lower lip to hold it steady as my chest heaves with each breath, "He was too young to die. And too good. But you took him. If you're all powerful and all good like they say you are in all the books and Sunday school and church, then why do you let bad things happen to good people? Huh? Why?"

The wind stings my eyes and moisture escapes my eyelids.

"You took Ryan, then you let my family fall apart, and now look at me! Look at what I've become! I deserve this! Me! Not Ryan, not my family. I'm the one who deserves this!" I thrust my hand down to the earth and envision the lifeless body that lies in a box six feet beneath the headstone.

A heavy feeling creeps into my chest, and I struggle to breathe. I turn my head toward the sky. The light from above hits my face and tears burst from my eyes. The cold trails of tears trickle down my cheeks as I strain to look upward, but my gaze falls down to the earth, and I drop to my knees sinking down into the cold, wet grass. My head hangs heavy on my shoulders. "I can't do this. It's just too much. I can't take it anymore. Please. I can't do this."

I stare at the backs of my hands. Veins stand against my skin pumping life throughout my body. My head falls into my hands, and I sob. My chest heaves with pain as each breath escapes my lungs as if dredging up a heavy burden from deep within my soul.

I attempt to lift my head upwards, but can only see the headstone before me. I sniffle and wipe my nose, "It all changes so fast, doesn't it, Ryan? Senior year of high school we were going to make all our dreams come true. And now look at us. I only made it to sophomore year in college. I did get that house on campus we talked about though. But my dad sold it and took the money. And now you're here, and they're saying I'm going to prison. Can you believe that? Prison!"

I shake my head against the wind as tears continue to flow, "I go in for sentencing next week. The probation department says I might only get probation. My attorney thinks I'll do some time in prison, but hopefully not that much. Maybe three years or less, and hopefully not a real prison with the razor wire and fences, but a prison camp. That's what we're hoping for. But you never know."

My hand feels damp against the cold earth beneath me as the frost on the grass melts into the warmth of my hand. "Ryan, I miss you, man. It's been a long time since I prayed to anyone or anything but you. So, help me out here."

I pat the earth gently and bite my lip as I struggle to find the words, "God, it's been a long time. I'm sorry. I'm sorry for everything. I'm sorry for who I've become. I don't know how things turned out this way, but I'm sorry." I shake my head and drop my gaze down to the ground, "I hated you. I felt like you turned your back on me. And I turned my back on you. Please forgive me. And please forgive me for what I've done. This isn't the life I want. God, please come back into my life. Jesus, if you can hear me. In your name, I pray. I ask that you come back into my life. Please, I can't take this anymore. Please. Fill my heart again and let it overflow. I'm ready to let go of the pain and the hate. Please bring love back into my life. God, please, come back into my life."

I lift my head toward the sky. I squint against the light of day and struggle to open my eyes. The sun forces its way through the veil of clouds, and I feel the warmth from the sun seep into my pores. The gentle heat soaks down beneath my skin, radiating throughout my body. I strain to open my eyes to the power of the light shining down on me.

Brilliantly beaming bright golden white light is all I see. Tears force their way from my eyes and a smile breaks free on my cheeks. I feel laughter rise from my heart and waves of relief roll through my body, releasing tension that I didn't even know existed within me. My heart opens, and suddenly, floods with feeling like water breaking free from a dam. I open my eyes wider and stare directly into the light that illuminates the clouds from within.

I feel a similar illumination happening within me. Light bounces from the frost on the ground beside my hand and the moisture on my hands glisten in the breeze. My gaze follows the flow of the breeze beyond the

hills where the tree line sways soaking in the light from above. A sense of profound gratitude overwhelms my entire being. I feel connected with the life within the trees and the grass and everything I see, and even the life inside of me.

I feel alive.

I rise from my knees to stand tall. My shoulders feel light, and my breath flows easily within my chest. I rest a hand on Ryan's headstone with relief.

"Thank you."

CRIMES AGAINST HUMANITY

"We have to set an example here, your Honor. It is our civic duty!" Federal prosecutor, John Graham paces as he speaks. He lingers in the center of the federal courtroom, relishing the attention placed on him from the packed room during his closing argument. His greying black hair rolls back from his forehead in tightly coiled waves. He furrows his bushy eyebrows together with disdain like two angry caterpillars as he gestures with a long arm toward the defendant table, where Devon, Luke, Ethan, and I huddle beside our respective attorneys.

Every seat within the vaulted ceiling three-story hall is filled with family members and friends of the defendants. Paintings of prominent judicial figures hang from the walls of the grand room, frowning down on all who sit beneath them. Anita Bonner sits in the front row of the gallery, hovering behind the desk of the prosecution.

John Graham turns his attention to Judge Milner who sits behind her bench on high above the courtroom. Her slim frame sits upright in her chair with lips pursed and a neutral expression worthy of the world poker tour.

John Graham continues his argument, "There's been a lot of talk around this case about 'good boys' from 'good families.' The four defendants here for sentencing today are all of legal age. They are not boys. Let's get that straight. They willingly and knowingly committed this crime. They acted as adults and have all entered guilty pleas, as adults. When deliberating on their sentences, your Honor, I implore you. We must sentence them to the maximum extent of the law. We must set an example here!

Otherwise, what defense do universities, libraries and special collections museums around the country have to deter criminals from similar acts? We cannot make such a heinous crime seem punishable by merely a slap on the wrist! Probation is not an acceptable sentence. Neither is a downward departure below the sentencing guidelines of only a few years. A woman was assaulted and tied up. Assets valued at more than five million dollars were stolen. The office of the United States Attorney requests a sentence at the maximum allowed level within the sentencing guidelines. We demand a minimum sentence of twelve years." John Graham strides triumphantly behind the prosecution desk. He holds his tie to his chest as he lowers into his chair, "Thank you, Your Honor. Prosecution rests."

Judge Milner readjusts within her seat, "Thank you, Mr. Graham." Her posture remains perfectly upright as she turns to face the defendant table. "We will now hear final statements from each of the defendants if you each so choose. Mr. Allen, we will start with you. If you have any statements you would like to make to the court, please approach the podium at this time."

My attorney, a clean-cut man with neatly combed blond hair and a tailored charcoal suit and red tie nods in my direction. I adjust the knot of my tie as I nod to my attorney and rise from my chair. The plush carpet of the grand courtroom feels strangely cozy under the soles of my Oxfords like walking barefoot in my grandparents' house as a child.

My mom, brother, and sister look up to me from the front row of the gallery. Their presence lends me strength. As my footsteps draw closer to the podium, I rush to find my dad. I scan the shoulder-to-shoulder crowd of family and friends who sit within the courtroom gallery. The solemn faces who look back at me are a collection of the people who support me and impact me. Each in their own way they are all a part of me. And I am a part of them.

Tom is nowhere to be found.

I hold my head high and attempt to remain poised in front of the crowd as I approach the podium. I fiddle with the cufflinks of my shirt and adjust the sleeves of my jacket in a way that reminds me of James Bond when he feels rattled under pressure. A microphone awaits me atop a chest-high oak stand. I raise the level of the receiver toward my chin and nervously clear my throat. Covering my cough with a free hand, I take the opportunity to glance once more over my shoulder. I make eye contact with a man among the crowd. He appears tall even while seated. His dark hair scatters with color like salt and pepper blended on a plate. His face lines with concern as he watches me.

My dad.

In my eyes, his presence once seemed larger than life. Now he blends in with the crowd of seated faces throughout the courtroom. He is here for me. My mom and family and friends are all here for me.

But I must stand on my own. I turn to face the podium. The judge sits high above the room behind her towering bench before me. I clear my throat again, "Thank you, Your Honor." The amplified sound of my voice through the microphone bellows forcefully throughout the grand hall from every direction like the unsure voice of God.

Judge Milner looks kindly down the bridge of her nose toward me as she speaks, "Any final remarks, Mr. Allen, please proceed."

I fill my lungs with one last deep breath, lifting my posture to stand tall, and begin hesitantly speaking into the microphone, "Yes. Thank you, Your Honor. I umm. I am overwhelmed here today." I roughly clear my throat again in an attempt to calm my nerves and continue, "I am overwhelmed by the show of love and support from all the family and friends who are here for me today. What I did and what I have done, despite all of their support and love, is wrong. I accept responsibility for my actions, and I know I deserve to be punished. But when choosing a just punishment, a fair and reasonable sentence, I ask that as a representative of the court you please consider this.

"I was given many opportunities early in life. A lot of them due to the people in this room today. If I needed something, I had it or was taught how to earn it or achieve it. I always considered myself lucky growing up. But eventually, things changed. A close friend passed away unexpectedly the day after I turned eighteen. My parents went through a divorce that I found myself in the middle of. And other tragedies not worth mentioning seemed to pile up all at once like a perfect storm. And my family changed. I felt like the people around me changed. My priorities changed. And ultimately, I changed. I didn't know how to stop it. I felt lost, like I didn't know where to go or what to do, just to get things back to normal. I felt hurt, and betrayed, and angry at everyone and everything. I turned my back on God and too often found myself filled with sadness, and hate.

"I felt alone, and I didn't think there was anyone I could go to for support. I was too embarrassed to ask for help, and I was too prideful to think I needed it. In the process, I became someone I wasn't proud to be. I got to the point that I didn't care what happened next in my life. I just wanted it to be different. I lashed out. I rebelled. I did my best to burn it all down. And now I've done things that I'm ashamed to admit, and things that I'm deeply sorry for."

My chest heaves with a deep exhale. I feel a heaviness leave my chest. "I'm sorry, Your Honor. I'm sorry for all the pain I've caused. I'm sorry for the crime I've committed. But I feel I've grown from this. I know I have. I've gone through the darkness, and now I feel like I can finally see the light. As you sentence me, Your Honor, I ask that you please have mercy on me. I plead that you use me. Allow me to be a contributing member of society. I'm twenty years old. Place me on probation until I'm thirty. Please Your Honor. I've learned my lesson.

"Allow me to share my story with other kids and people who are struggling to find their way. The people who feel betrayed, and abandoned, and broken within their own homes and families and lives. The people who feel apart from their communities, and from society, instead of feeling connected and welcomed as a part of society. We all go through struggles in life, and we all have barriers to overcome. Use me as a bridge, Your Honor, and allow me the chance to uplift others and make a positive impact on society instead of banishing me behind prison walls. Please don't throw my life away, Your Honor. Please give me a chance to redeem myself and prove to you, and to everyone, that I can be a productive member of society." I pause for a moment, "Thank you, Your Honor."

JUDGMENT

The Bailiff stands from his chair beside Judge Milner's bench. He tucks his button-down uniform shirt under the bulging belly at his belt line as he projects his voice throughout the courtroom, "All Rise."

I stand. My attorney stands by my side. Devon, Luke, and Ethan all stand with their attorneys alongside them. The prosecutor, John Graham, stands and Mrs. Bonner stands behind him. The people seated in rows within the courtroom gallery stand and the anticipation within the room mounts.

Judge Milner remains seated. She scans a stack of papers within her hands one last time, and I can almost hear the pressure building within the room. She looks up from the documents with resolve and scoots her chair forward to speak into the microphone at the front of her bench, "Would the four defendants please approach the bench?"

I step forward with Devon, Luke, and Ethan. We approach the center of the courtroom, each flanked by our team of attorneys to stand side by side before the federal judge. Sadness enters my chest as I look down the line to each of my friends, who now stand as my co-defendants. We share a knowing glance. Understanding this is the end of our friendship. This is where we each go our separate ways, for better or worse."

Judge Milner addresses the four of us, "I believe that each one of you, in this case, had an important role to play. Even though you had varying roles in committing the crime, I believe you colluded and worked together to conspire to commit this crime. I've received letters from people within this community, and even from some of my own friends, imploring me to show leniency. That you are each 'good boys' from 'good families.' To me, that means that you had all of the advantages of life, and you still chose to commit this crime. I would be more apt to show leniency to an underprivileged child who felt they needed to turn to crime to survive. It seems to me that the four of you wanted to press the easy button in life and take a shortcut. I do believe that you are each sorry for what you have done. I also think you are sorry you got caught."

Judge Milner stares down the bridge of her nose, and her eyes pierce through me. Fear crawls up my spine, and a chill creeps into my open heart.

Judge Milner continues, "Even though you all share identical sentences, I am going to impart each sentence individually. Charles Allen, please step forward and approach the bench."

I do as instructed and step two paces forward on unsteady legs.

"Mr. Allen, some of the hardships you spoke of have also been brought to my attention through letters written to me on your behalf. I respect your desire to help others. However, I feel you first need to experience prison."

My chest closes shut like a steel trap.

"Charles Allen, I hereby sentence you to serve 87 months in a federal corrections facility." Judge Milner bangs the gavel, and her words become law.

GOODBYES

"He's here," Blake says as he turns away from a small window in the entrance foyer where he, my mom, sister, and I stand dreading the truth of the moment.

A long black SUV slows to a stop like a hearse in the street. A feeling of impending doom crawls inside my chest, and I notice the fear that grips my entire body with impossibly strong fingers. I don't want to move.

I know I must.

I fill my lungs with a deep breath, allowing my chest to expand. I look at the solemn faces filled with love that surround me. My heart opens with appreciation, and I understand this moment to be one of the last times I will ever spend with my family in our home, together.

The warmth of gratitude thaws the chill of fear within my chest, and all I feel is love. The feeling fills me with courage, and I step forward.

I approach my little sister, Sydney with open arms. I lift her tiny twelve-year-old body in a bear hug as her feet dangle above the floor. By the time I see her again outside of prison the little girl in my arms will be a fully grown adult.

I squeeze her tighter, "I love you, Syd. Don't you grow up without me, Little One." I say, sniffling back the tears mounting behind my eyes.

Sydney's little arms wrap tighter around my neck. I can feel her body shake with tears as I hold her, and sadness envelopes me like the small arms that hold me close. My heart swells with the pain. I worry about her safety and her future, knowing that I won't be there to protect her, knowing that my dad won't be either.

I place her gently on the floor. She stands tall on sturdy legs as she rubs her wet eyes with the backs of her fists. "I won't. I love you." Her little voice replies.

Blake throws his arms open wide and catches me with a hug. I wrap my arms around his back as he wraps his arms around mine.

"I love you, Brother," I say.

"I love you. You stay strong in there. We're here for you. You know that. And I've got your back."

I grip him tighter and feel the truth in his words, "I know. And I've got yours."

"Brothers in Arms."

"Always."

Blake and I release our holds on one another. We lock eyes like a reflection in the mirror and find strength within each other.

I turn to see my mom. The light behind her petite figure halos behind her as she stands in a doorway. Her rosy cheeks smile in an attempt to remain positive while her eyelids line with tears like a levy on the brink of a breakthrough. She patiently waits for me with her hands clasped before her.

I bend down to hug her. She wraps her arms around me and pats me on the back as if she still holds her baby in her arms. I lean back from

her embrace to look into my mother's face. I blink through the tears that threaten to break free from my eyes. "This is it, Mom."

I drop my forehead down to rest against hers.

She looks into my eyes with a mother's strength, "It's okay, honey. It's all going to be okay." She reassures me. She runs her fingers through my hair as she would when I was a child. Her touch calms me as I give in to the comfort of her words.

"I know. But I worry about you guys."

"Don't, honey. It's not your job to worry about us. I know you took it on when your father left, but you don't have to. We're going to be just fine. You just take care of yourself now."

She wraps her fingers around my neck to hold me tighter, "You hear me? You take care of you."

Her words resonate with me, and I let the fullness of her words sink in as I linger in her love, "I will, Mom. I love you."

"I love you."

I let her go, but she refuses to release her arms from around my back, "We're here for you. We'll be there to visit you all the time. Okay?"

I pat her on the back, comforting her as she comforted me, "I have to go, Mom."

"Okay, you're right. I know. I know." Her arms fall from my back, and she lifts a tissue to her eyes. She dabs moisture and eyeliner that runs beneath her eyes.

I stand in the center of the foyer. Through the glass storm door of the doorway, the long black SUV awaits me.

I hesitate.

I bask in the glow of love that surrounds me and hope to lock in the memory of the warmth of their love. I hold the feeling close, letting it

flow through me until it overflows and gives me the strength to let go and let them go.

I open the glass door and pause within the doorway, "I love you all."

They reply with love as I step through the threshold and into the cold of the day. The brisk winter air pushes against me as I approach the long black SUV. I swing open the heavy black door to where an empty seat awaits me.

THE LONG RIDE

The long black SUV races me through the rain-slicked streets of downtown Lexington. Precipitation drums against the wide front windshield as the rhythmic slide of the wipers pushes away the moisture.

My dad sits in the driver seat, gripping the steering wheel in both hands and his shoulders slump in his chair. His eyes focus on the road ahead, unwilling to make eye contact with me. Reluctant to look in my direction longer than only a moment at a time.

My thoughts drift toward what awaits me at the end of the road.

Prison.

I think about what eighty-seven months in prison will be like for a twenty-one-year-old white kid raised in privilege and private school. Violent scenes from movies and TV shows play on repeat within my mind. I imagine the horrors of murders and stabbings and rapes within the walls of a prison. Guard abuse and violence at every turn. Gangs controlling the underbelly of prison life and extorting and taking advantage of the weak. Scenes of Denzel Washington shadowboxing in The Hurricane flash in silhouettes of inspiration to push back my growing fears. I tap into the subtle strength lingering beneath my worries. I picture the wisdom of Morgan Freeman in Shawshank Redemption as he mentors Andy

Dufresne about how to get by within prison culture. I imagine myself in Edward Norton's shoes from American History X. I picture my tall, thin frame and clean-cut hair instead as Ed's stocky, muscular hate-fueled build with my hair shaved down to my scalp. Then I imagine the shower scene where three men beat him and brutally rape him, only to prove his powerlessness within those prison walls.

Fear lurches upward in my throat. I push the feeling away like the windshield wipers driving away the rain, focusing on the rhythmic sound of the wiper blades.

Up. And down.

My dad turns the steering wheel, and we approach a cemetery. We drive past endless rows of weathered headstones. We cross an overpass above aging train tracks, several factories and warehouses, then come to a clearing.

I stare through the beaded drops of rain clinging to the passenger window toward the grass fields of Masterson Station Park. The beads of water hold tightly to the glass as if not wanting to let go. Beyond the window, horse trails and soccer fields roll with the hills toward the horizon. In the distance, I notice two people enduring the rain. A man watches over a young boy. The boy kicks soccer balls into a goal as the man cheers him on and encourages his every kick. Even when he misses.

From within the car, I hear a sniffling sound. I turn toward my dad, and for the first time in my life, I watch him cry. Long trails of tears roll down his proud face like the wandering rain clinging to the window behind him.

He turns to me with a sad smile, "Can you believe it? It seems like just the other day you were playing soccer out there."

I return my gaze to the rain-soaked field, "I know. I can still see it."

He returns his gaze toward the road ahead, not wiping his tears away, "Back then, did you ever think you'd end up in prison?"

"No. I never thought I would be one of those people."

"Did you even know there was a prison on the other side of these fields?"

"No, but I wish I had."

My eyes gaze off into a faraway place. A lonely, solemn place that once seemed strange on the faces of those I love. I remember the distant, empty look of acceptance in the eyes of Ryan's dad on the day of his son's funeral, Mr. Foster over a shared meal, and Devon before racing for his life in the snake pit. Now that faraway place approaches clearly within my view, unfamiliar yet expected; fate, here to welcome me home.

The dark monstrosity of the prison looms on the horizon beneath the dreary sky. My dad turns the long, black SUV onto a narrow road that leads into the heart of the prison. The massive building grows larger and larger, rising above us like an indestructible force. Six stories tall and built with stone and red brick masonry during an era long ago. Two fences surround the perimeter and tower taller than three tall men. Endless rolls of razor wire bind the top of the fences and climb between the two barriers like bushels of planned suffering.

A sign reads, Receiving and Discharge.

The SUV reaches a parking lot and slows to a stop.

I swallow hard and turn to my Dad, who doesn't meet my gaze. I grab the door handle and open the door. The rain falls on my hand as I begin to step out of the SUV.

My dad stops me with his words, "Charlie, hold on."

I close the door and turn to face him. Our eyes meet, and I feel the depth of the sadness between us. He looks through the rain-battered windshield toward the prison that towers in front of us and shakes his head in disbelief. "I never thought I'd see the day my oldest son went to prison."

Silence hangs between us, intermittently interrupted by the slide of the wiper blades across the windshield, pushing away the rain.

He continues, "I get what you were trying to do. I just don't know why you had to turn to crime."

I break the contact between our eyes and turn again toward the door.

He extends an arm like an olive branch and gently eases me back toward his gaze, "What I'm trying to say is, I'm sorry, son. I never meant for things to turn out this way. I was so caught up fighting your mom for money that I didn't even realize what you kids were going through. I guess that doesn't make me much of a father, does it?"

Tears build within his eyes, and I feel the heat from the tears welling within mine.

I say nothing in the hopes he will continue.

He breaks the silence between us, "I'm sorry you felt like you ran out of options and that I wasn't there for you when you needed me. I know you were trying to do what you could to help your mom and your little brother and sister. This is my fault, and I should have done more to keep it from happening. I'm sorry, son. If I could trade places with you and go in your place today, I would."

I inhale a deep breath and study his hazel green eyes, almost a mirror image of my own. I let the breath go and with it heaviness rolls down my back. "No, Dad. I wouldn't let you do that. This isn't your fault. We've both made some bad choices in the past, but it was my choice that led me here, not yours. I have to be the one to do this. I wouldn't trade places with you even if you could."

He nods thoughtfully and waits in silence, spurring me to continue.

"I just didn't know how to let go, Dad. I didn't want to. I wanted to keep things the way they were, you know? But that's only because you and mom gave us a good life to start with. I loved the way things used to be and the way we all grew up together, as a family. But I get it. Things change. People change."

"They don't have to." My dad reaches an arm between us and rests his hand on my back. "Even though your mom and I aren't together anymore, I'm still your dad. And you, and me we're always going to be on the same team. I know you're not my little boy anymore, but if you need anything, I'm here." He reaches across the distance between us with both arms. I extend my arms to meet him, and we embrace in a hug.

He pats me on the back and speaks into my ear with a hoarse voice and throat constricted with pain, "I'm here, son. I'm here."

Tears roll freely from my eyes. They fall from my chin and drop down onto his shoulders originating from a place that had been pushed down deep within me and locked away and sealed underneath layers of pain and fear. Healing waves of relief roll through me like waves cresting on a long forgotten and deserted island as the tears continue to roll.

After a few moments, I break free from our embrace and reach for the door. I smile a sad smile and wipe the tears from my face with the back of my hand, "I gotta go, Dad. I love you."

He maintains a proud upper lip as he smiles at me with his eyes. The tears dry on his face like a badge of honor, "I love you, son." He watches me with pride and love as I turn to face the prison through the windshield. He turns off the windshield wipers. The rhythmic sound fades, and the gentle drum of the rain lands softly against the window like a lullaby in its own time. I open the door and step into the falling rain. The air smells crisp with a hint of smoke on the wind like drowned campfires and ashes. Each touch from the raindrops that drop to my hands and face tingle cold and soothing against my skin.

I hear my dad open his car door and listen to him step out of the SUV to stand in the rain with me. I want to look back. I want to get back within the warmth of the SUV. I want to go with him. But I know I can't look back. I pull the hood of my sweatshirt to cover my head and continue forward.

———

I enter through an opening in a long carport made from fences topped with razor wire. I am instantly surrounded on three sides by fences, and I feel more confined with each step I take. The walls close around me like walking into the mouth of a whale. I trudge on heavy legs toward a security gate at the end of the carport toward where the impending presence of the red brick prison walls awaits me.

I reach a small metal box that appears to be a two-way intercom. I press a button, "Hello?"

Moments pass, and I press the button again, "Uh, hi? This is Charles Allen. I'm here to self-surrender. Hello?" I hold my breath, hoping the silence will never end. That somehow this is all a mistake. I hear a door open. A man emerges from within the red brick masonry. He strides upward from low within the building and walks in my direction. I recognize him as an officer of the prison coming to receive me.

I look up to the sky and open my eyes wide. Grey clouds hang low and dark, content in their stillness as the rain comes down. I squint against the brilliance above me as light expands in every direction, piercing through the clouds and shining down on me and the prison, the fences, the razor wire, and everything that I see. I open my lungs and open my heart with a smile as the raindrops down against my face. I don't push it away. I feel it soak in and become a part of me. I breathe deeply and feel the rain enter my lungs, and the air sink into the depths of all that makes me, me. I feel connected with all the beauty, the joy, the pain, the suffering, and all life that surrounds me. Is me.

The gate within the chain link fence opens before me.

I step inside.

The gate locks behind me with a click.

Somehow, I feel alive.

*"Do not fear who you are becoming,
it is a part of who you already are."*

EPILOGUE

The struggles and the search for meaning that I attempted to depict through this book are foundational memories that shaped, in part, who I am today. It has been an honor to share this part of my journey with you. In describing past events, even some of which are criminal, I hope those involved understand that this book in no way carries the intention to point a finger in any direction other than my own; in acceptance of responsibility for my past.

Just as my search for personal development did not stop at the end of this composition, the relationships of family and friends described in this book did not stop evolving. My family and closest friends stood with me in support through the most trying times and, thankfully, still support my aspirations today. My brother and sister are both happy, well-adapted, and successful adults; I am proud to be their brother. My mom has since remarried to a kind and loving family man; I find comfort in her happiness. I am grateful to say that my dad and I share a mutually respectful and loving relationship today, not as business partners, but as father and son. I value his guidance as a mentor in my life. The real Devon, Luke, and Ethan each served their time and accepted responsibility for their roles in our crime. After standing in the courtroom together to face our sentences, the next time we all shared a room did not come until many years later when we recently attended the film premiere of our stories portrayed in American Animals at the Sundance Film Festival. Sitting in a theater together, watching our lives reenacted on screen was a unique and humbling experience. Even more spectacular to me than the film, was encountering the individual growth and maturity that each of my former friends now carries in their respective, adult lives.

I have come to understand that, even though this book is a depiction of my journey, the story is older and more universal than Charles Allen II.

This book is my best effort to convey a level of human maturation that, hopefully, we can all relate to in our own ways. In my understanding of experience, I believe that a critical phase of personal evolution comes in our formative years as we test our egos against ourselves and also against familial forces. These years of flailing and often confusing conflicts within this learning ground determine our understanding of, and the meaning we ascribe to, our personal identities and our relationships to the broader realm of experience. Beyond the initial search for meaning, we next find ourselves in the realm of ego versus societal, cultural, racial, and religious forces - to name a few. The sequel to this book, Book 2 in this series, attempts to relate these issues, again, through the lens of my younger self while living behind prison walls. I found myself removed from the world of my childhood and thrown irreversibly into a man's world.

The meaning we each uncover for ourselves when confronted by societal forces further shapes our understanding, which in turn determines our relationship with the next phase of human maturation: the ego versus universal forces - such as love versus hate, connection versus disconnection, and life versus death. It is how we relate to each stage of maturation that shapes who we are, and how we express ourselves in our lives. Book 3 in this series grapples with these expansive yet foundational issues with which we are all intimately involved in our own search for meaning and purpose within our lives.

It is my hope that we can share in this journey together.